LEARN TO DRAW
MANGA WOMEN

KYACHI

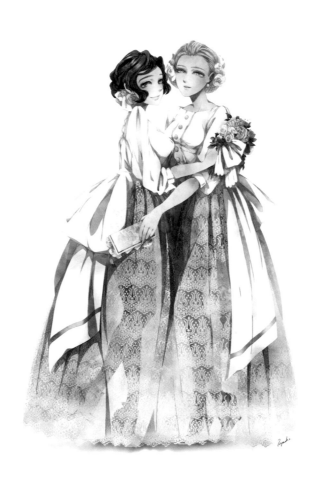

TUTTLE Publishing

Tokyo | Rutland, Vermont | Singapore

CONTENTS

Introduction Things to Know Before You Begin

Part 1 Standing Poses: The Basics

Part 2 Standing Poses: Practical Applications

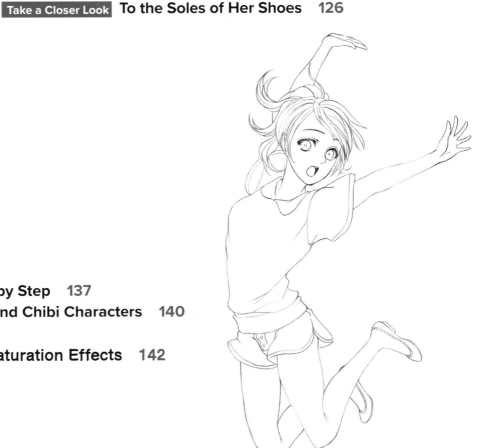

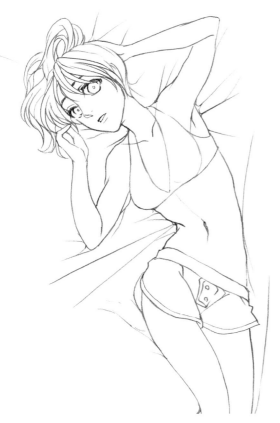

Why I Wrote This Book

Accurately drawing the human form requires a certain degree of familiarity with the skeleton, the muscles, the many structures and systems that make us up. But that kind of specialized knowledge and skill can take ages to learn and discourage beginning artists from attempting to draw people at all.

For those just starting out, making their first attempts at manga or illustration, there's too much to learn, so they're hesitant to draw human characters. I know I was.

This book is meant to dispel those fears, wipe away any hesitations, so you can start with a blank page or an empty screen and begin populating it with people. Soon your simple forms will take on greater detail and your characters will start to come to life before your eyes. I've done most of the hard work for you, explaining and analyzing the most difficult aspects of figure drawing and presenting it to you clearly and simply.

For all beginners, of course there are things that are difficult, techniques you won't be able to master right away. Instead focus on what you can do, tackle what you're comfortable with. Your confidence and ability will only grow from there.

As any artist will tell you, start with what interests you most, and go from there. When you find yourself drawing with greater ease and skill, branch out from there, as it's a telltale sign you're getting it—you're improving!

Finally, I offer my thanks to you, the intrepid manga artist, for taking this journey with me from the first lines and strokes to a fully fleshed human form, alive with movement, dimension and purpose. Everyone has to start someone, and once you learn the basics, who knows where you'll take it from there!

– kyachi

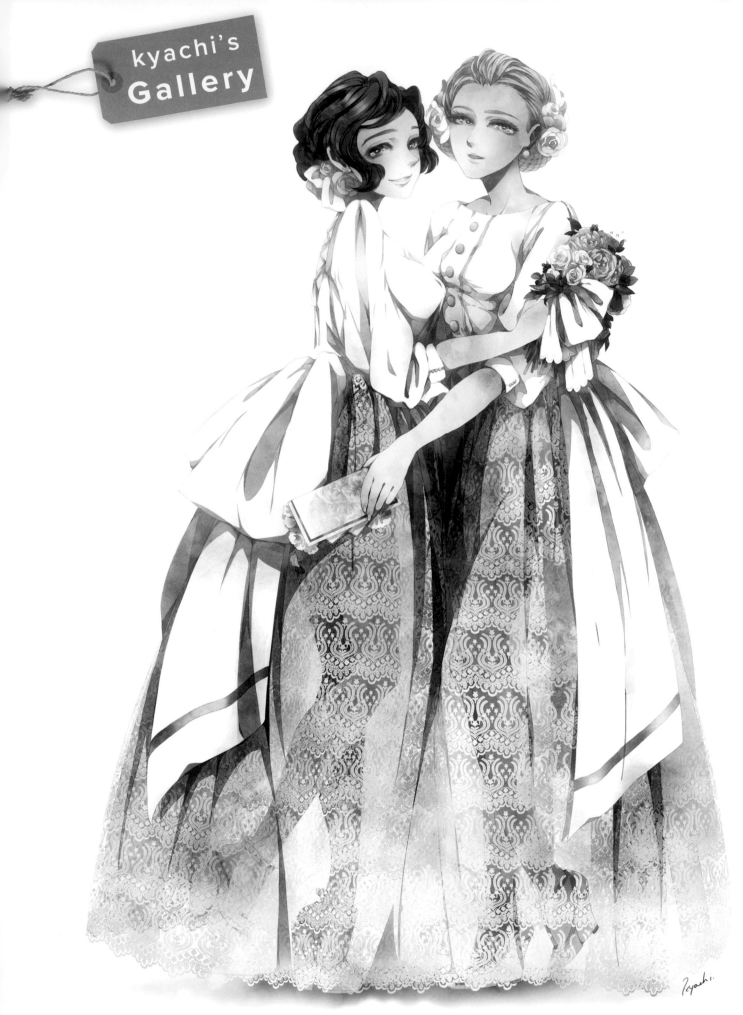

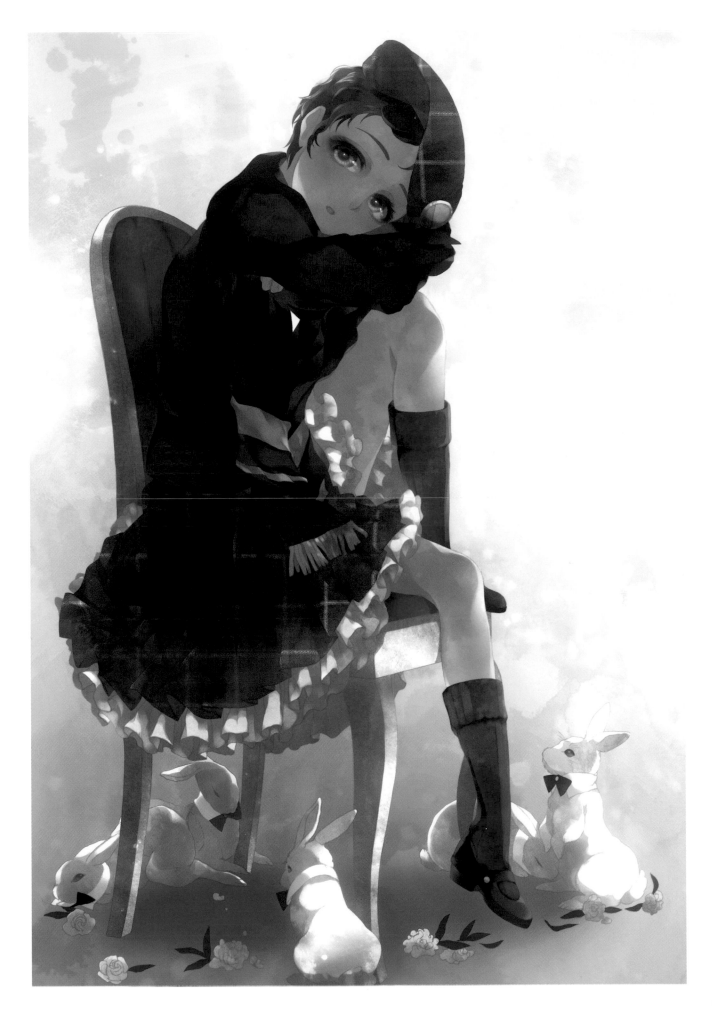

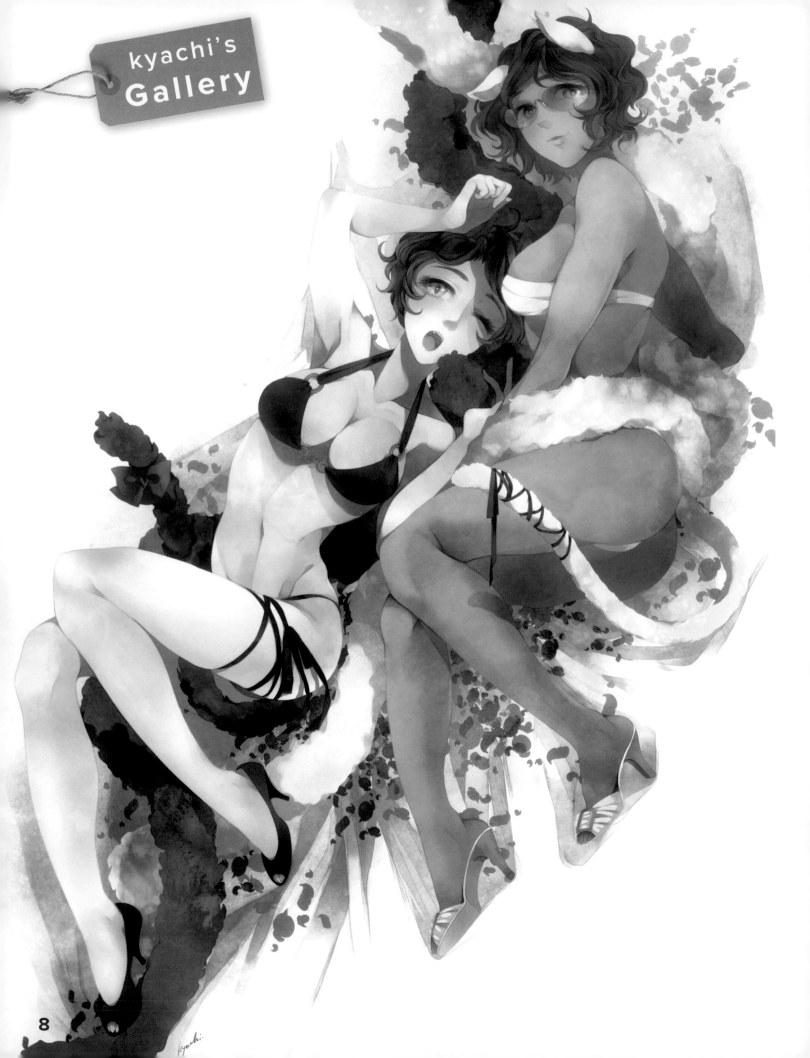

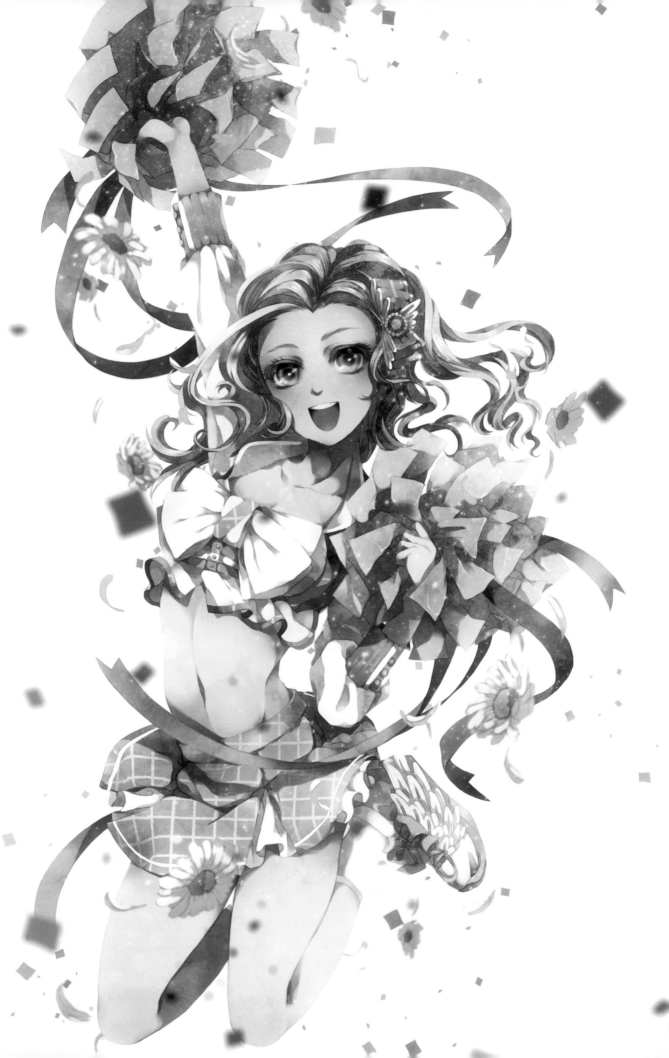

Things to Know Before You Begin

Drawing Characters

When developing your character's poses, in-corporate contrapposto effects to the body line and voila! Your figure will take on movement and flow, a living presence that will leap off the page.

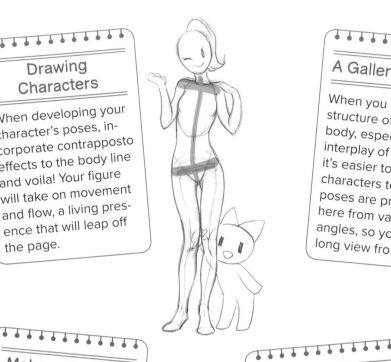

A Gallery of Poses

When you know the structure of the human body, especially the interplay of muscles, it's easier to bring your characters to life. Key poses are presented here from various angles, so you get the long view from all sides.

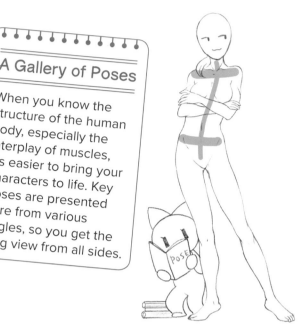

Make a 3D Model

If you want to capture a proper sense of balance, examine your character three dimen-sionally. It gives you a better understanding of how the muscles move and connect, contract and flex and flow.

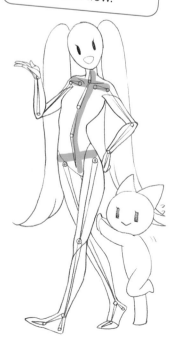

Body and Flow

Sometimes it's easiest to assume the position: strike the pose you're going for yourself to obtain a better under-standing of the body's parts and how they interconnect and move.

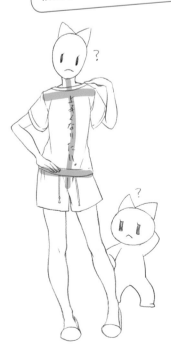

Strike a Pose

A specific and highly defined pose leads to a more realistic and com-pelling final illustration. The details you bring to the beginning of the process will pay off in the end.

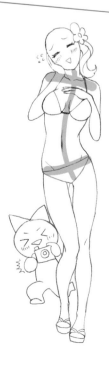

What Is Contrapposto?

Contrapposto is a form of posing used to place the body in realistic or interesting positions. It's a key element of the visual arts.

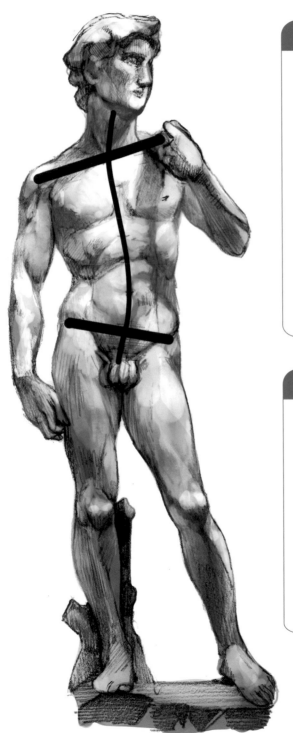

History

Contrapposto is a specialized art term, derived from the Italian word for "counterpose," meaning that most of the body's weight rests on either the left or right leg, achieving an angular or asymmetical stance. It was first applied and defined by the ancient Greek sculptor Polykleitos (who lived from the fifth to fourth centuries B.C.E.) as part of his pursuit of the ideal human proportions and form. The concept was first embodied in works such as *Doryphoros* (the Spear Bearer). It exerted great influence on succeeding art movements, picked up first by the ancient Romans then embraced by Italian artists during the Renaissance. Michelangelo's *David* is perhaps the best known example of a work employing contrapposto.

Features and Effects

By resting weight on one leg, the body's center line shifts. This creates the asymmetry of contrapposto, which is characterized by sloping shoulders slanted in opposition to the bend of the hips. The contrast between the leg bearing the weight (the engaged leg) and the other leg with its gently bent knee (the resting leg) also brings a dynamic dimension of realism and complexity to the form. Emphasizing a body's contrapposto positioning results in an S-shaped backbone and creates a sense of flow in the line of the body, making it an invaluable device when drawing stylish, signature poses.

The Basics of Contrapposto

Let's take a look at the elements of contrapposto and how it's used in a signature pose.

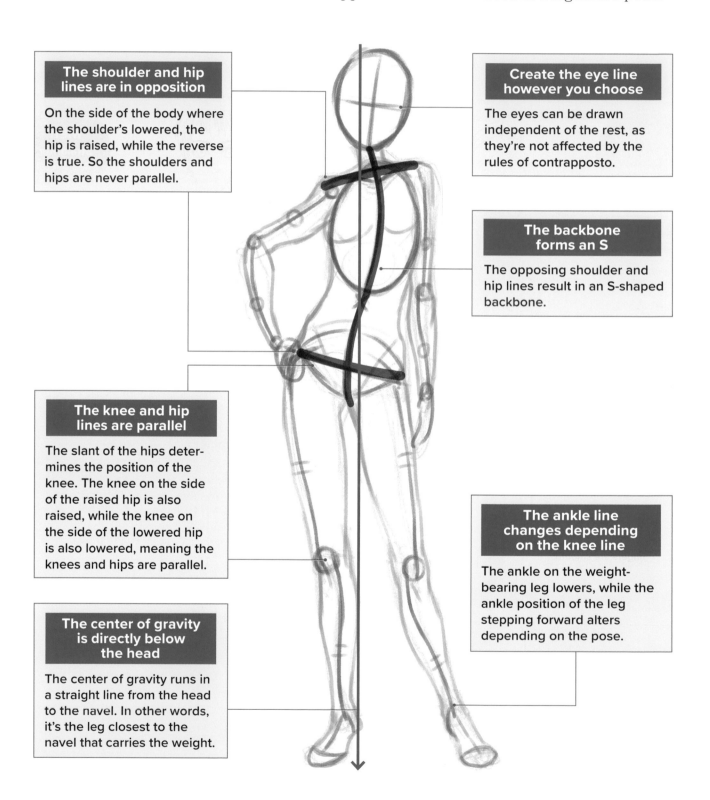

The shoulder and hip lines are in opposition

On the side of the body where the shoulder's lowered, the hip is raised, while the reverse is true. So the shoulders and hips are never parallel.

Create the eye line however you choose

The eyes can be drawn independent of the rest, as they're not affected by the rules of contrapposto.

The backbone forms an S

The opposing shoulder and hip lines result in an S-shaped backbone.

The knee and hip lines are parallel

The slant of the hips determines the position of the knee. The knee on the side of the raised hip is also raised, while the knee on the side of the lowered hip is also lowered, meaning the knees and hips are parallel.

The ankle line changes depending on the knee line

The ankle on the weight-bearing leg lowers, while the ankle position of the leg stepping forward alters depending on the pose.

The center of gravity is directly below the head

The center of gravity runs in a straight line from the head to the navel. In other words, it's the leg closest to the navel that carries the weight.

Differences in Men's and Women's Bodies

There are several difference in the distinguishing features of men's and women's bodies, so be sure to capture them clearly and accurately.

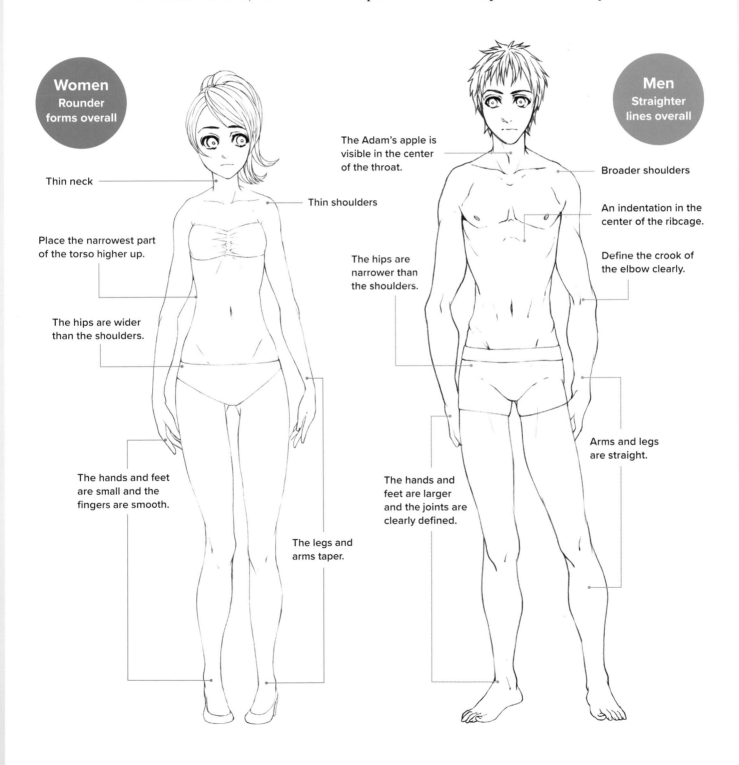

Women
Rounder forms overall

Thin neck

Place the narrowest part of the torso higher up.

The hips are wider than the shoulders.

The hands and feet are small and the fingers are smooth.

The Adam's apple is visible in the center of the throat.

Thin shoulders

The hips are narrower than the shoulders.

The legs and arms taper.

Men
Straighter lines overall

Broader shoulders

An indentation in the center of the ribcage.

Define the crook of the elbow clearly.

Arms and legs are straight.

The hands and feet are larger and the joints are clearly defined.

Differences in Men's and Women's Bone and Muscle Structures

Differences are also visible between the bones and muscles. Learn how to make it easier to distinguish depending on the body size, age and other unique features.

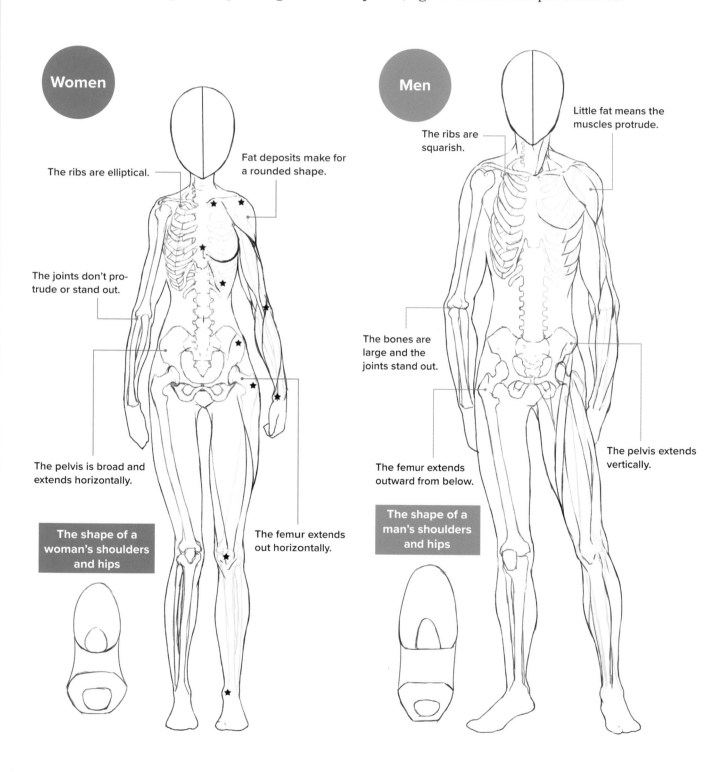

Women

The ribs are elliptical.

Fat deposits make for a rounded shape.

The joints don't protrude or stand out.

The pelvis is broad and extends horizontally.

The shape of a woman's shoulders and hips

The femur extends out horizontally.

Men

The ribs are squarish.

Little fat means the muscles protrude.

The bones are large and the joints stand out.

The femur extends outward from below.

The pelvis extends vertically.

The shape of a man's shoulders and hips

Women's Proportions

On average, women are seven heads tall. There are plenty of variations of course, so adjust your figure accordingly.

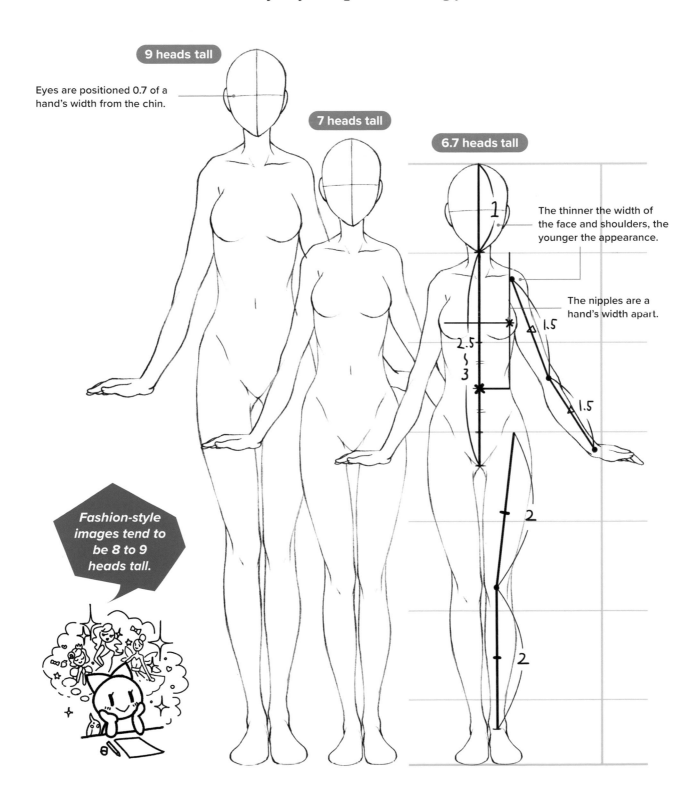

9 heads tall

Eyes are positioned 0.7 of a hand's width from the chin.

7 heads tall

6.7 heads tall

1

The thinner the width of the face and shoulders, the younger the appearance.

The nipples are a hand's width apart.

1.5

2.5
|
3

1.5

2

2

Fashion-style images tend to be 8 to 9 heads tall.

Women's Body Structure

Let's take a more detailed look at the structure of a woman's body. There are several key areas unique to the female form.

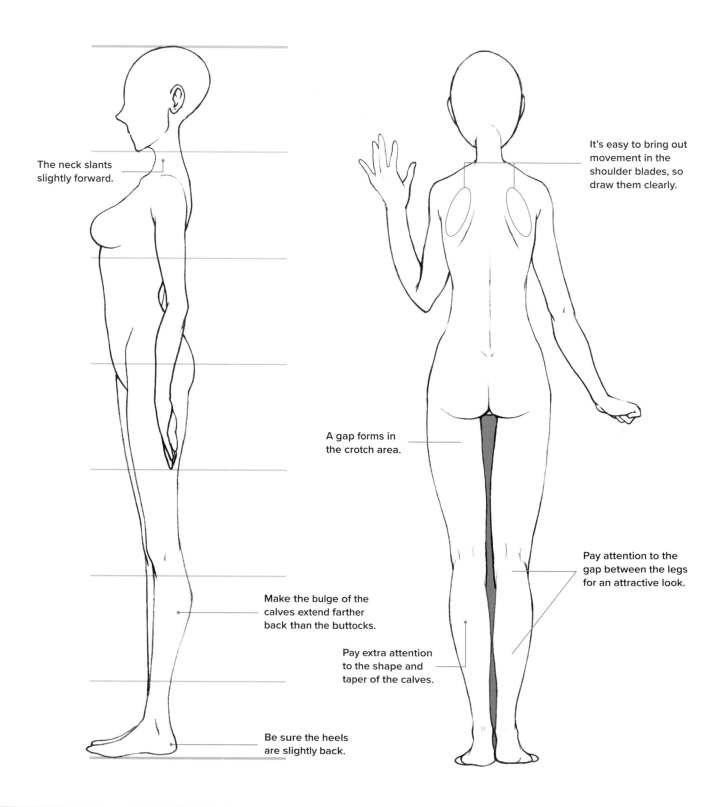

The neck slants slightly forward.

It's easy to bring out movement in the shoulder blades, so draw them clearly.

A gap forms in the crotch area.

Pay attention to the gap between the legs for an attractive look.

Make the bulge of the calves extend farther back than the buttocks.

Pay extra attention to the shape and taper of the calves.

Be sure the heels are slightly back.

Standing Poses:
The Basics

In order to draw appealing standing poses, it's important to have the body leaning at a well-balanced angle. Here's an in-depth look at standing figures, from the basics to examples of attractive and complex posing.

Drawing a Standing Pose

Contrapposto is invaluable for drawing an attractive standing pose. Keep in mind which body parts are lowered and which are raised!

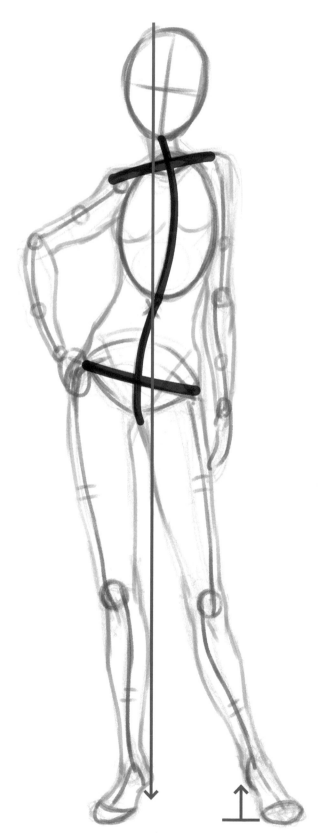

Basic Standing Poses

The leg on which the weight is resting extends straight out, while the shoulder on that side lowers and the hip lifts. The knee line is parallel to the hips, and the heel of the extended leg is raised off the ground.

Standing Poses Check List

☐ Shoulder and hip lines are in opposition.

☐ The backbone forms an S shape.

☐ The leg nearest the navel becomes the axis leg.

☐ Resting the hand on the raised hip creates stability.

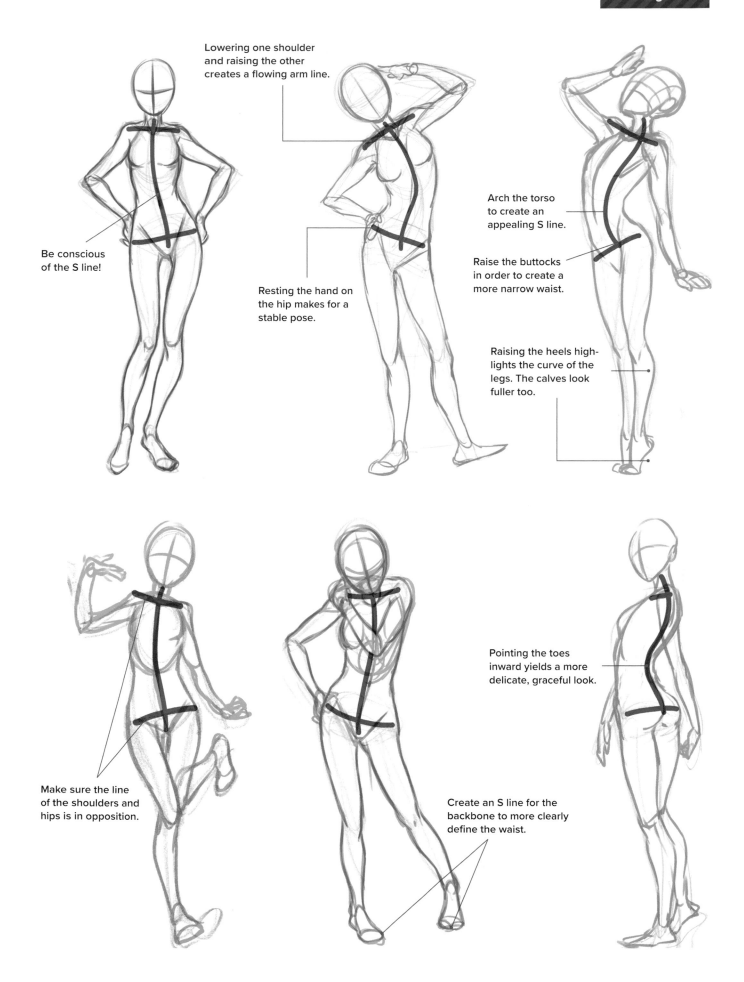

Lowering one shoulder and raising the other creates a flowing arm line.

Be conscious of the S line!

Resting the hand on the hip makes for a stable pose.

Arch the torso to create an appealing S line.

Raise the buttocks in order to create a more narrow waist.

Raising the heels highlights the curve of the legs. The calves look fuller too.

Make sure the line of the shoulders and hips is in opposition.

Create an S line for the backbone to more clearly define the waist.

Pointing the toes inward yields a more delicate, graceful look.

Warming Up

In standing poses, the line of the shoulders, hips and backbone is crucial.
Make sure to draw with these three areas in mind.

Block-In the Figure

Get used to blocking-in the figure (creating a rough sketch for shape and positioning). First of all, decide on the line for the shoulders and hips, then join them with the S-shaped backbone and add the head and limbs to balance the figure.

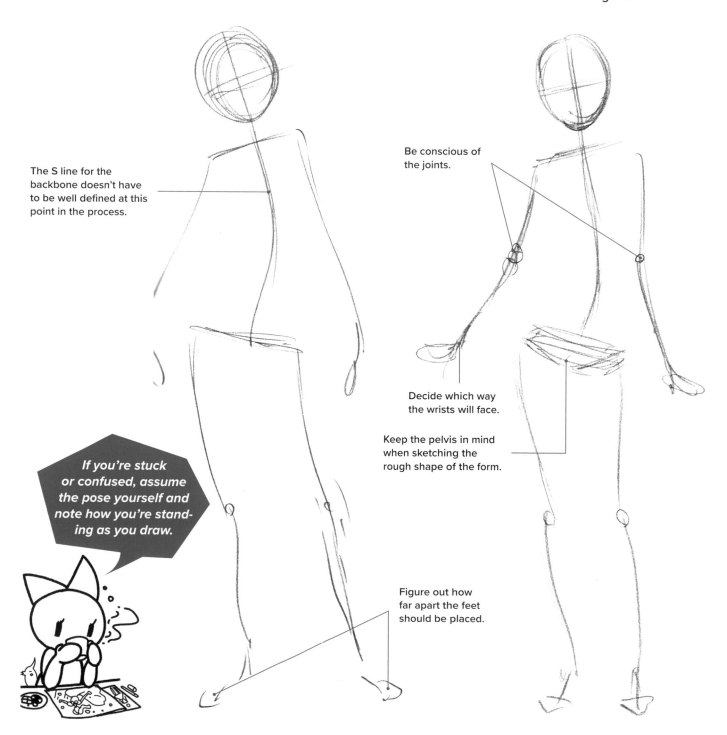

The S line for the backbone doesn't have to be well defined at this point in the process.

Be conscious of the joints.

If you're stuck or confused, assume the pose yourself and note how you're standing as you draw.

Decide which way the wrists will face.

Keep the pelvis in mind when sketching the rough shape of the form.

Figure out how far apart the feet should be placed.

Adding Muscle

Adding clothes straight away is a strict no-no! First, decide on the body line to form a foundation, then, with the character's personality and physique in mind, fill in each body part with the appropriate size and thickness.

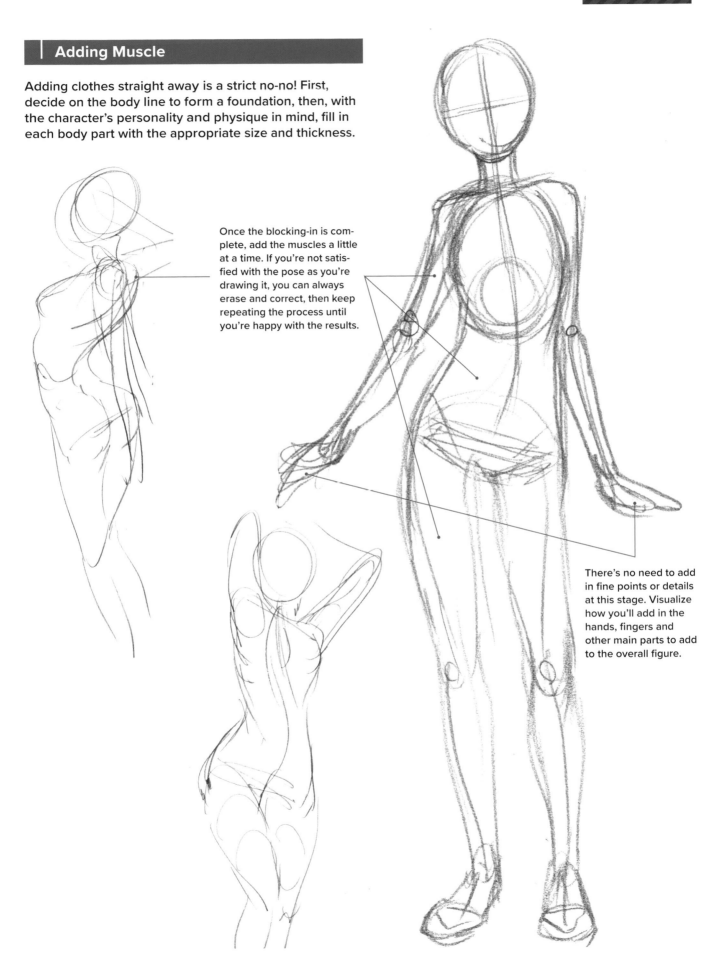

Once the blocking-in is complete, add the muscles a little at a time. If you're not satisfied with the pose as you're drawing it, you can always erase and correct, then keep repeating the process until you're happy with the results.

There's no need to add in fine points or details at this stage. Visualize how you'll add in the hands, fingers and other main parts to add to the overall figure.

Adding in Details

Once the figure has been fleshed out, decide the shape of the muscles, the position of the navel and the size of the joints and limbs and draw them in. Then add details to the face, hair, fingertips, clothing and shoes.

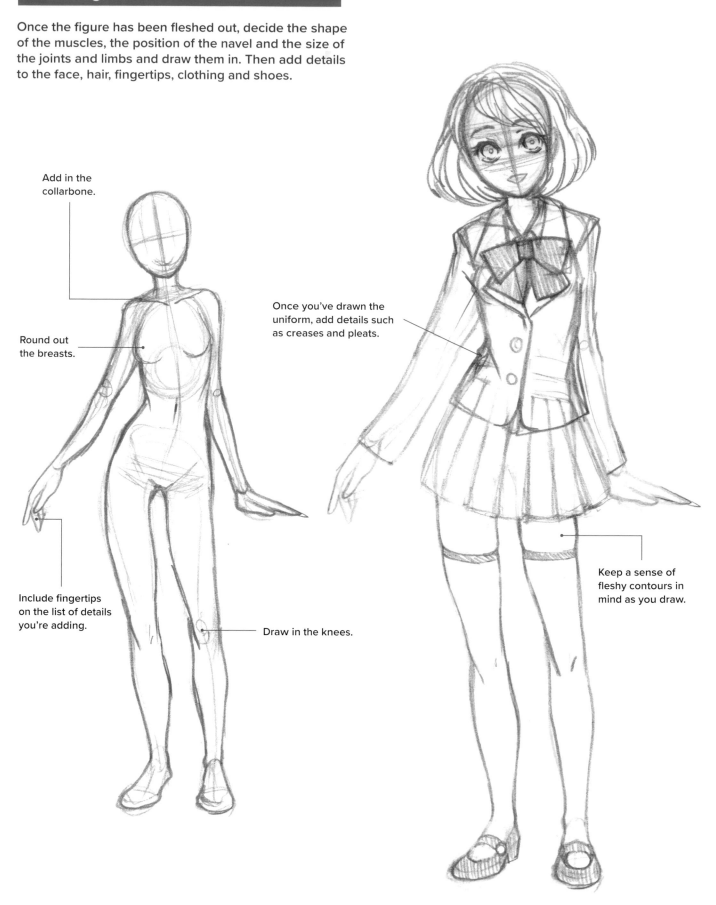

Add in the collarbone.

Round out the breasts.

Once you've drawn the uniform, add details such as creases and pleats.

Include fingertips on the list of details you're adding.

Draw in the knees.

Keep a sense of fleshy contours in mind as you draw.

Creating Variations

Get into the habit of blocking-in whenever you can. Everyone has a different drawing style. Until you find your own, draw as much and as often as you can until it comes naturally.

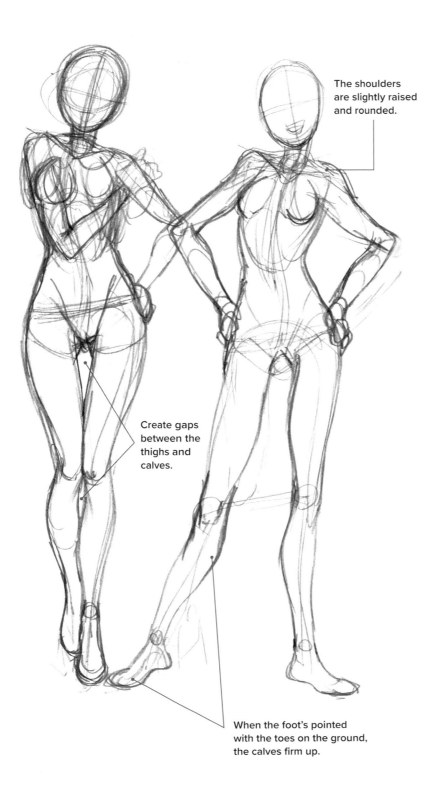

The shoulders are slightly raised and rounded.

Create gaps between the thighs and calves.

When the foot's pointed with the toes on the ground, the calves firm up.

Arms Behind the Head

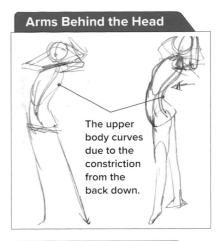

The upper body curves due to the constriction from the back down.

Resting Hands

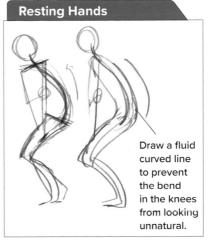

Draw a fluid curved line to prevent the bend in the knees from looking unnatural.

Think of the Torso as Gourd Shaped

When blocking-in the figure, think of the torso as a gourd shape with the narrowest section as the waist to create a sense of tapering. This makes it easy to create a soft, natural line and flow, so give it a try.

01

Drawing a Figure with the Weight on the Right Leg

Now let's learn which parts of the body are raised and which are lowered when drawing a figure with its weight on the right leg.

The Basics

The left shoulder and the right hip are raised. The right leg is straight and upright, while the left extends freely with the left heel slightly off the ground.

Expert Tip

Keep the S line in mind for overall balance

When drawing a standing figure with the weight on one leg, to achieve a strong sense of balance, keep in mind the S line that runs from the head to the toes.

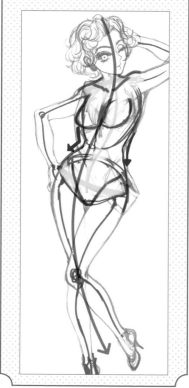

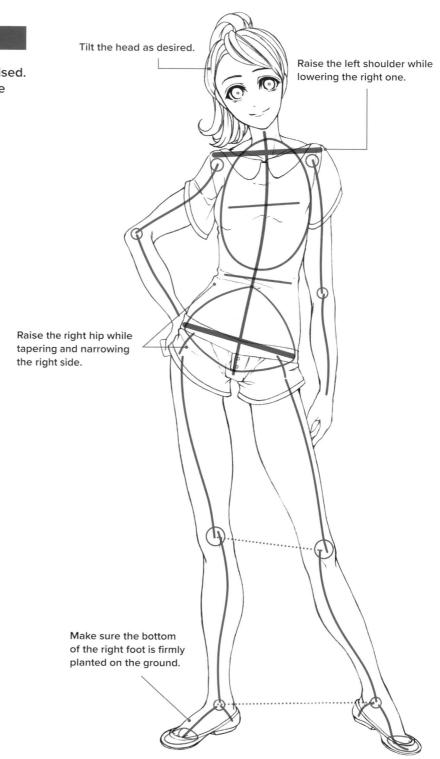

Tilt the head as desired.

Raise the left shoulder while lowering the right one.

Raise the right hip while tapering and narrowing the right side.

Make sure the bottom of the right foot is firmly planted on the ground.

Variations on the Pose

The S curve of the body can be strengthened or toned down. A stronger curve makes for a more dynamic look, while a subtle curve lends the figure a relaxed air.

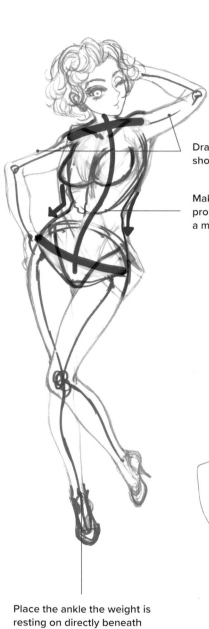

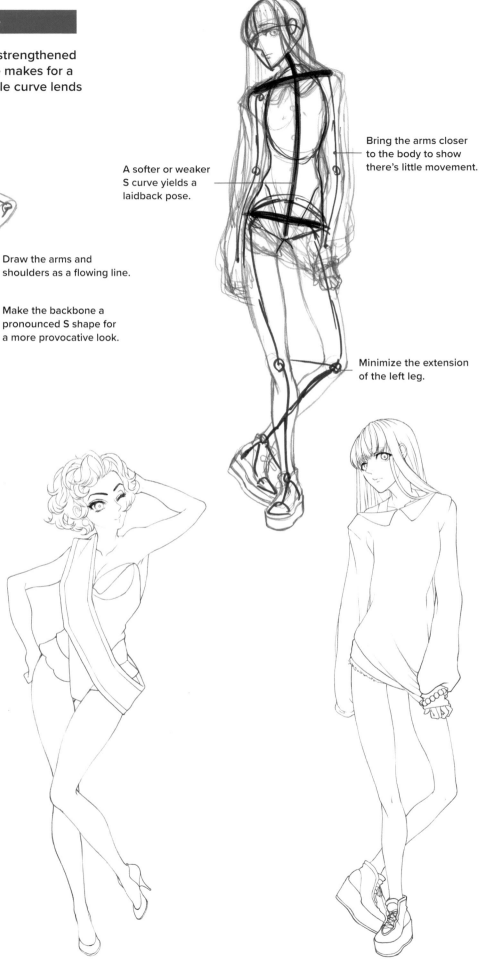

A softer or weaker S curve yields a laidback pose.

Bring the arms closer to the body to show there's little movement.

Draw the arms and shoulders as a flowing line.

Make the backbone a pronounced S shape for a more provocative look.

Minimize the extension of the left leg.

Place the ankle the weight is resting on directly beneath the head to create stability, even with a bold pose.

02 | Drawing a Figure with the Weight on the Left Leg

Now let's switch it up and look at which parts of the body are raised and which are lowered when your character has her weight on the left leg.

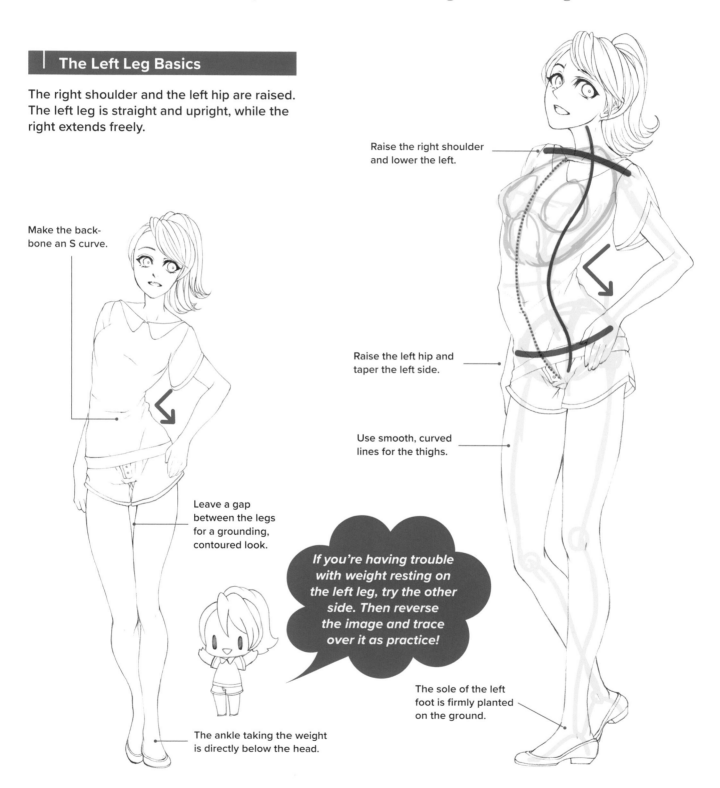

The Left Leg Basics

The right shoulder and the left hip are raised. The left leg is straight and upright, while the right extends freely.

Raise the right shoulder and lower the left.

Make the back-bone an S curve.

Raise the left hip and taper the left side.

Use smooth, curved lines for the thighs.

Leave a gap between the legs for a grounding, contoured look.

If you're having trouble with weight resting on the left leg, try the other side. Then reverse the image and trace over it as practice!

The sole of the left foot is firmly planted on the ground.

The ankle taking the weight is directly below the head.

26

Variations on the Pose

The extension of the relaxed leg can express various psychological states. Boldly extended, it makes for an active impression, while a subtle extension looks graceful.

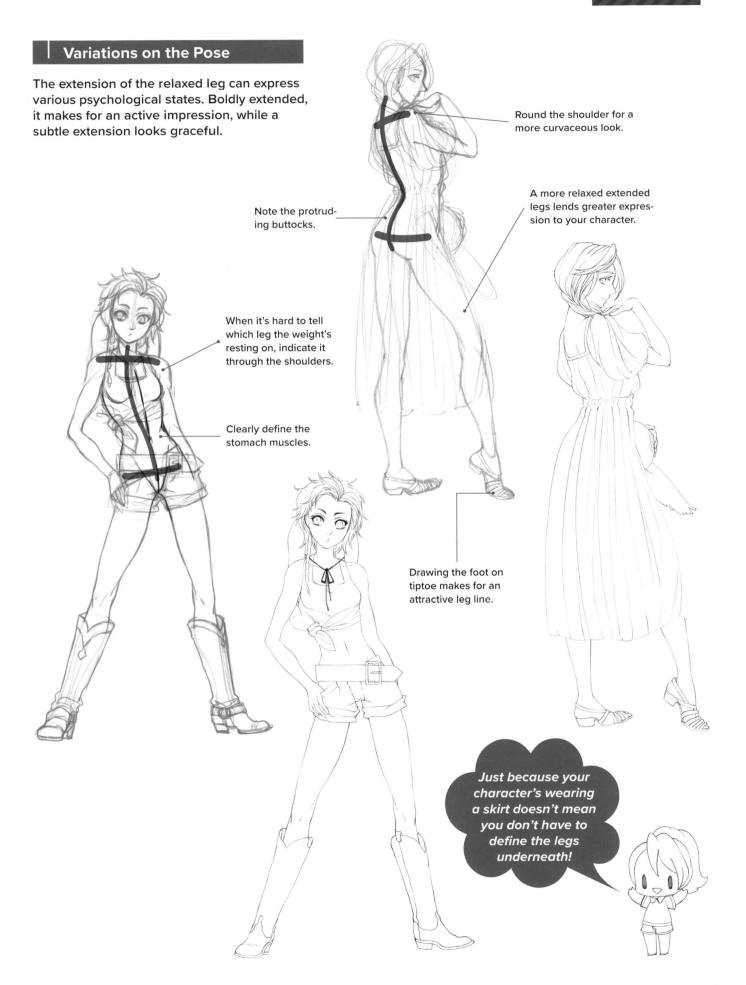

Round the shoulder for a more curvaceous look.

Note the protruding buttocks.

A more relaxed extended legs lends greater expression to your character.

When it's hard to tell which leg the weight's resting on, indicate it through the shoulders.

Clearly define the stomach muscles.

Drawing the foot on tiptoe makes for an attractive leg line.

Just because your character's wearing a skirt doesn't mean you don't have to define the legs underneath!

27

03 | Drawing a Figure with an Arched Back

An arched-back pose is an invaluable way of creating a sense of dynamism.
Make use of the curved line of the spine for maximum effect.

The Arched Back Basics

With the structure of the backbone in mind, create a curve from the back to the hips. In dance scenes, exaggerating the arch heightens the kinetic sense of movement.

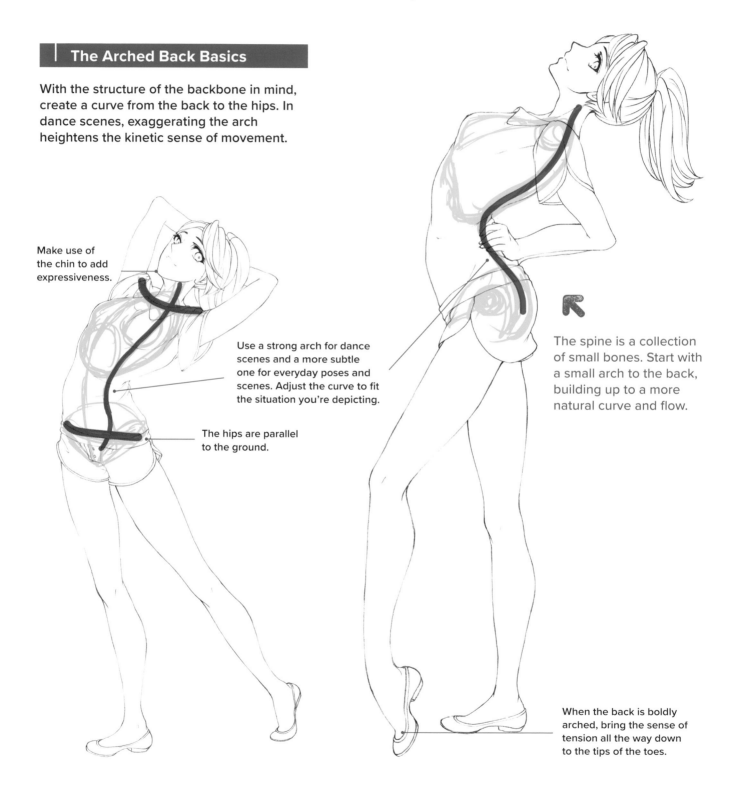

Make use of the chin to add expressiveness.

Use a strong arch for dance scenes and a more subtle one for everyday poses and scenes. Adjust the curve to fit the situation you're depicting.

The hips are parallel to the ground.

The spine is a collection of small bones. Start with a small arch to the back, building up to a more natural curve and flow.

When the back is boldly arched, bring the sense of tension all the way down to the tips of the toes.

Variations on the Pose

Keep the limbs' joints in mind as you draw to create a sharper, more dramatically defined silhouette. For the opposite effect, draw the shoulders and arms in one flowing line to express graceful movement.

The bend and angle of the two joints mirror each other.

Draw the arms and shoulders in one fluid line.

Adding a twist to the arched back yields a passionate pose.

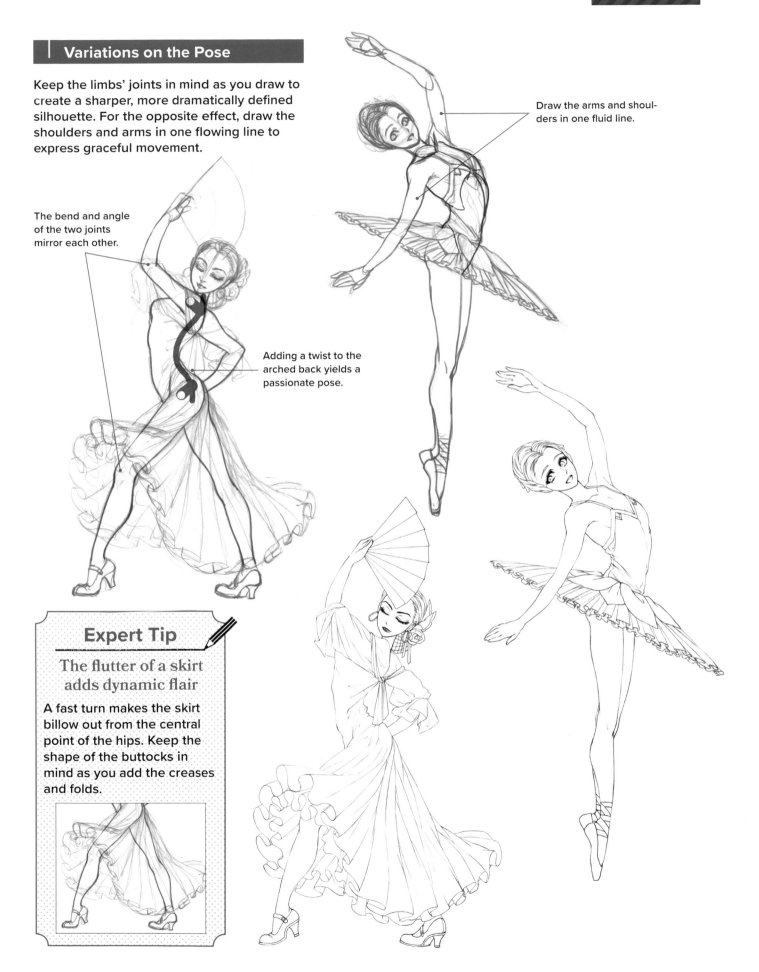

Expert Tip

The flutter of a skirt adds dynamic flair

A fast turn makes the skirt billow out from the central point of the hips. Keep the shape of the buttocks in mind as you add the creases and folds.

04 | Drawing a Bending Figure

Bending over is a common movement, but getting it right can be tricky. The motion of bending is defined by the position of the hips and knees.

The Bent-Over Basics

Keeping the structure of the backbone in mind, draw the upper body slanting diagonally. Raise the hip on the side bearing the weight and direct the knee inward. As you draw, remember the shoulder and the arm on the weight-bearing side angle in toward the knee.

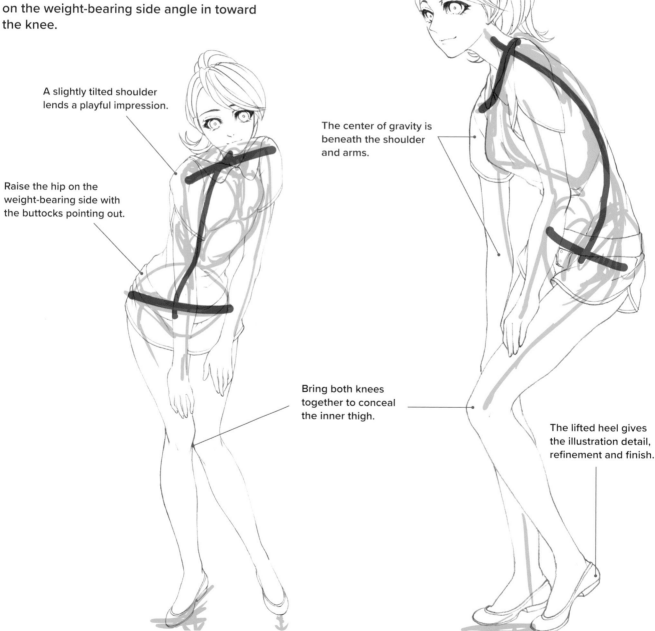

A slightly tilted shoulder lends a playful impression.

Raise the hip on the weight-bearing side with the buttocks pointing out.

The center of gravity is beneath the shoulder and arms.

Bring both knees together to conceal the inner thigh.

The lifted heel gives the illustration detail, refinement and finish.

Variations on the Pose

When drawing a bending pose in which the legs are straight, make the back and arms straight also to bring out a sense of tension. For the opposite effect, drawing the back to have a soft S curve creates a relaxed look.

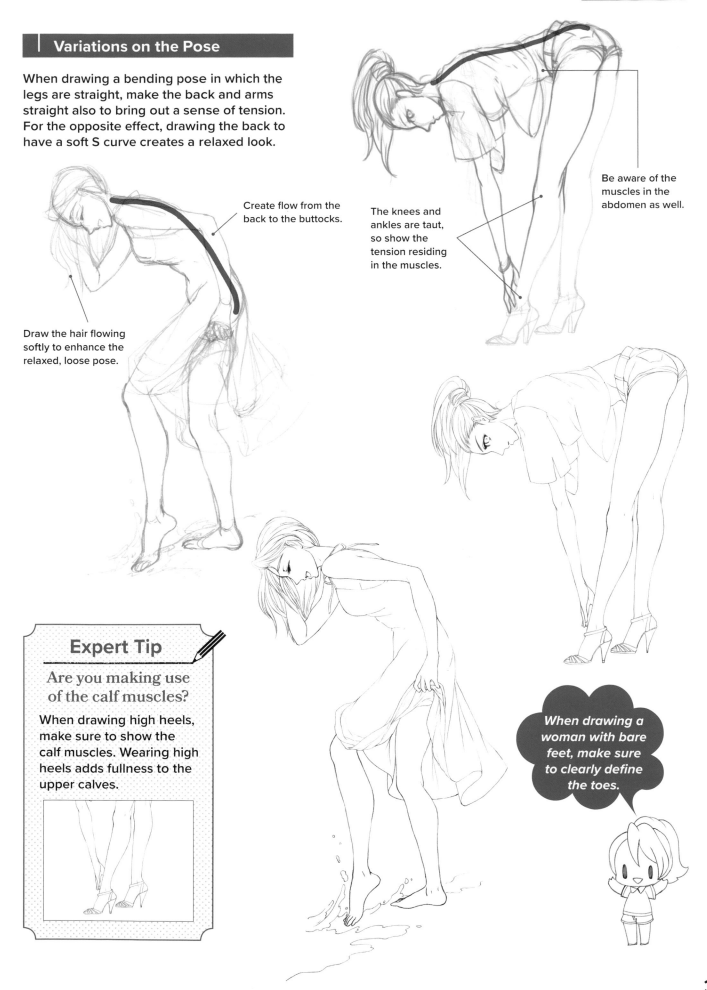

Create flow from the back to the buttocks.

Draw the hair flowing softly to enhance the relaxed, loose pose.

Be aware of the muscles in the abdomen as well.

The knees and ankles are taut, so show the tension residing in the muscles.

Expert Tip

Are you making use of the calf muscles?

When drawing high heels, make sure to show the calf muscles. Wearing high heels adds fullness to the upper calves.

When drawing a woman with bare feet, make sure to clearly define the toes.

05

Drawing a Figure Standing on One Leg

The trick to making the more acrobatic pose of standing on one leg look natural is creating a sense of stability in the character.

The One-Legged Basics

The hip on the side bearing the weight lowers and the shoulder rises. Keep the ankle on the weight-bearing side directly beneath the head to create balance and thus creating a more natural look.

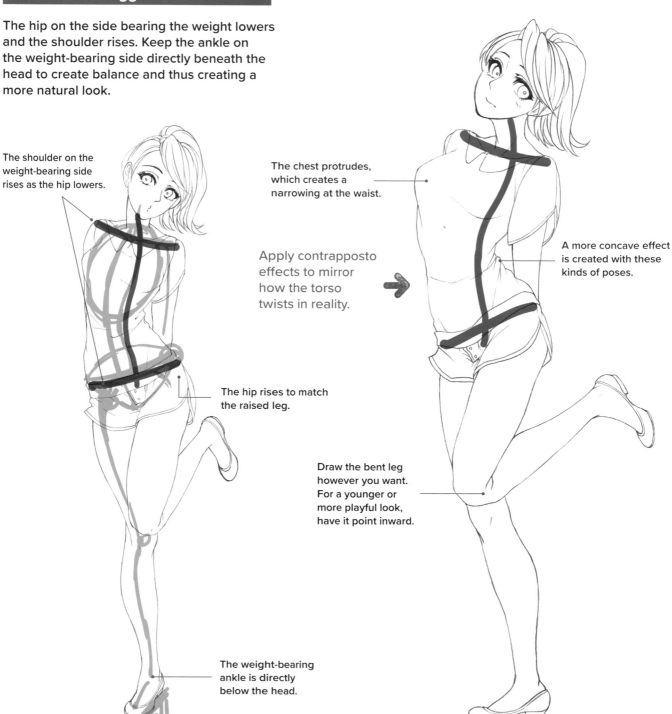

The shoulder on the weight-bearing side rises as the hip lowers.

The chest protrudes, which creates a narrowing at the waist.

Apply contrapposto effects to mirror how the torso twists in reality.

A more concave effect is created with these kinds of poses.

The hip rises to match the raised leg.

Draw the bent leg however you want. For a younger or more playful look, have it point inward.

The weight-bearing ankle is directly below the head.

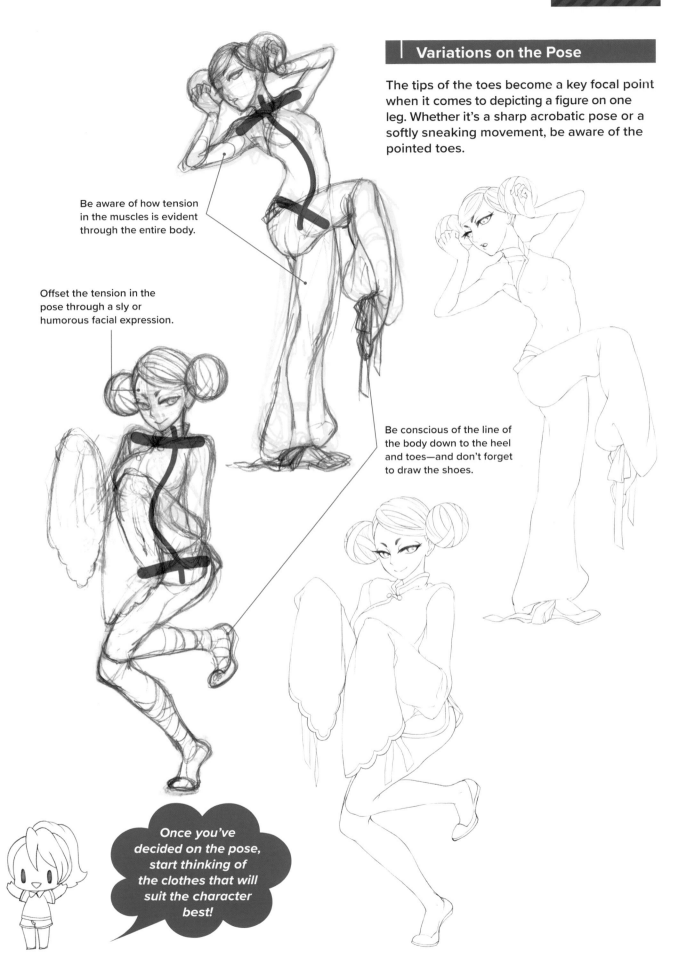

Variations on the Pose

The tips of the toes become a key focal point when it comes to depicting a figure on one leg. Whether it's a sharp acrobatic pose or a softly sneaking movement, be aware of the pointed toes.

Be aware of how tension in the muscles is evident through the entire body.

Offset the tension in the pose through a sly or humorous facial expression.

Be conscious of the line of the body down to the heel and toes—and don't forget to draw the shoes.

Once you've decided on the pose, start thinking of the clothes that will suit the character best!

06 | Drawing a Figure Turning Around

A turning pose lends a gracefully dramatic effect to your characters.

The Turn-Around Basics

When showing a character turning, if the dimension of the chest isn't considered, the result tends to be unnatural. Think of the figure as a piece of clay that's being twisted.

In this pose, the upper body naturally pivots in the opposite direction of the lower body.

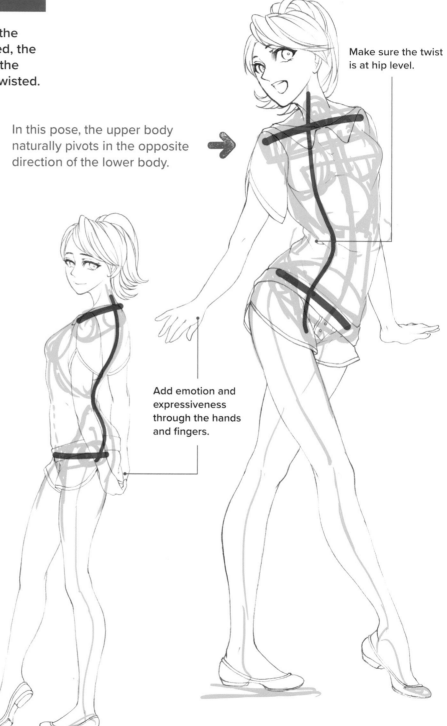

Make sure the twist is at hip level.

Add emotion and expressiveness through the hands and fingers.

Expert Tip

As if it's the moment the shutter clicks.

First think of a character in motion. Then draw her as if you're taking a photograph the moment the figure turns toward the camera.

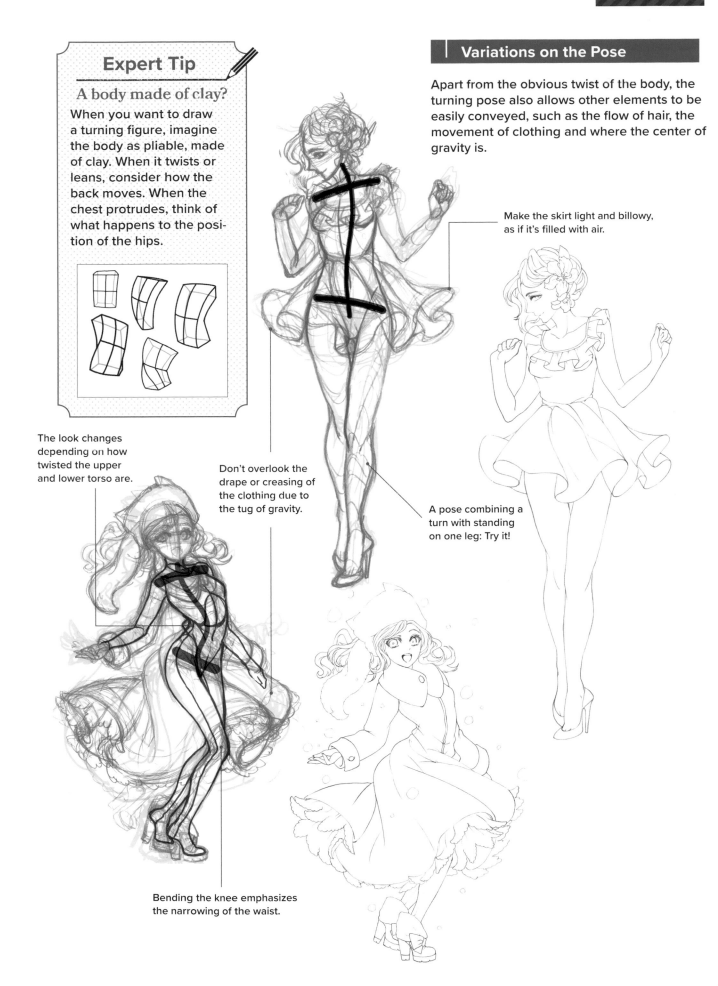

Expert Tip

A body made of clay?

When you want to draw a turning figure, imagine the body as pliable, made of clay. When it twists or leans, consider how the back moves. When the chest protrudes, think of what happens to the position of the hips.

Variations on the Pose

Apart from the obvious twist of the body, the turning pose also allows other elements to be easily conveyed, such as the flow of hair, the movement of clothing and where the center of gravity is.

Make the skirt light and billowy, as if it's filled with air.

The look changes depending on how twisted the upper and lower torso are.

Don't overlook the drape or creasing of the clothing due to the tug of gravity.

A pose combining a turn with standing on one leg: Try it!

Bending the knee emphasizes the narrowing of the waist.

07 | Drawing a Slumping Figure

The spine and shoulders are the key areas to focus on when making a slumping figure look natural.

The Slumping Basics

The shoulders drop, thus making the spine curve. Place the weight-bearing ankle directly below the drooping head, keeping contrapposto in mind as you draw.

Expert Tip

Try this languid pose for yourself.

Observe how the spine and shoulders move when the body slumps. The best way to understand the pose is to try it yourself.

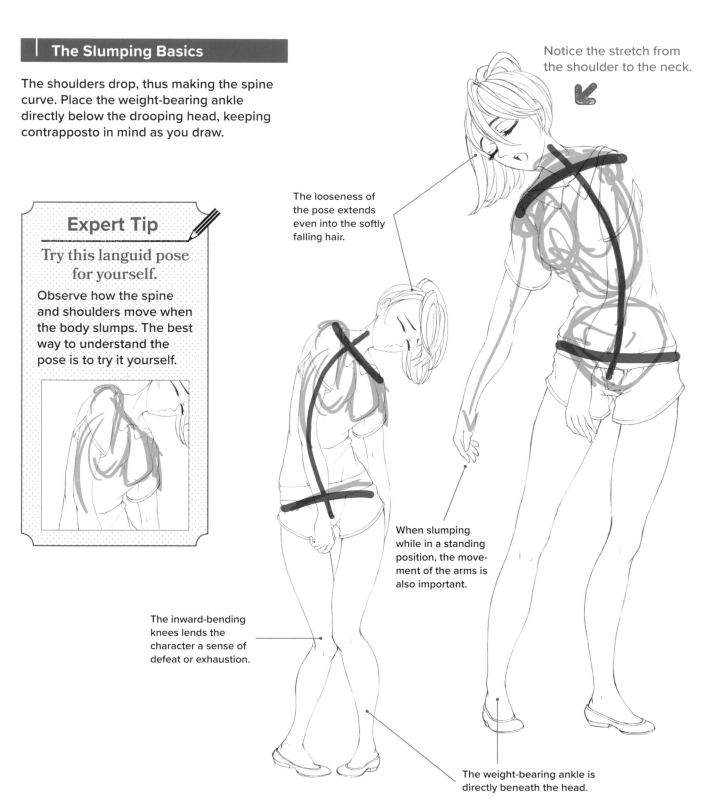

Notice the stretch from the shoulder to the neck.

The looseness of the pose extends even into the softly falling hair.

When slumping while in a standing position, the movement of the arms is also important.

The inward-bending knees lends the character a sense of defeat or exhaustion.

The weight-bearing ankle is directly beneath the head.

Variations on the Pose

Variations on the slumped-over figure can be created depending on how the back is curved. A boldly curved back increases the hunched-over, dramatic effect.

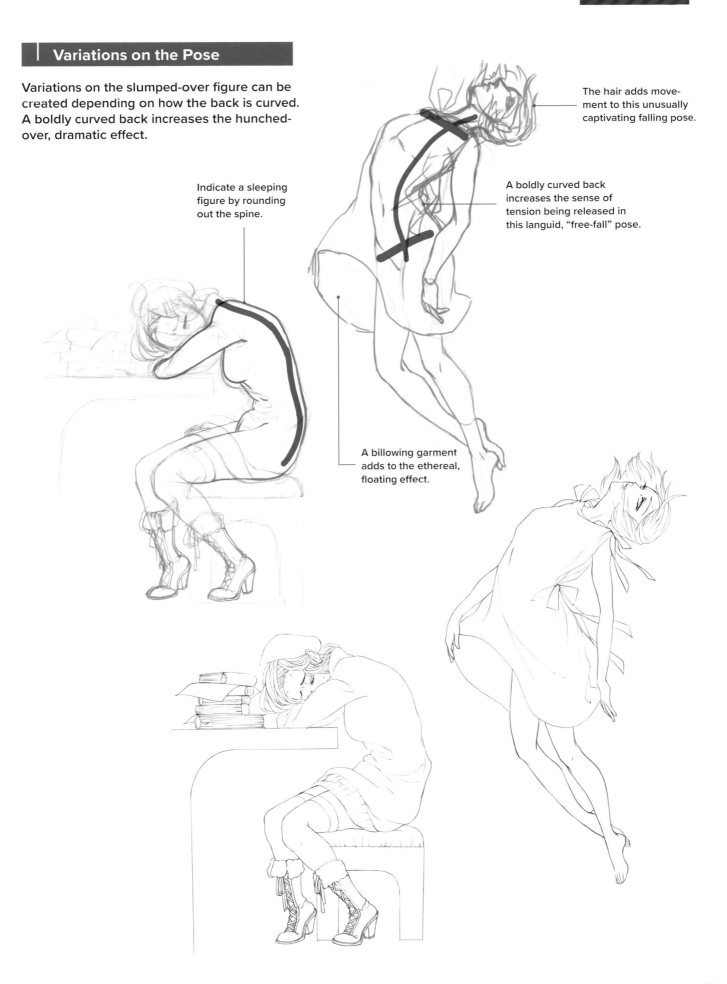

The hair adds movement to this unusually captivating falling pose.

Indicate a sleeping figure by rounding out the spine.

A boldly curved back increases the sense of tension being released in this languid, "free-fall" pose.

A billowing garment adds to the ethereal, floating effect.

08

Drawing a Figure with Arms Folded

The folded arms pose may be a bit difficult for beginners, but once you learn it, there's no limit to its uses.

The Folded Arms Basics

It's important to place the shoulders, chest and elbows parallel to one another. Placing the upper arms out wide creates stability, while positioning them close to the body creates an air of fragility.

Folded arms pair well with a troubled or worried facial expression.

Even the eyes and shoulders help convey the body's S shape, all the way down to the ankle.

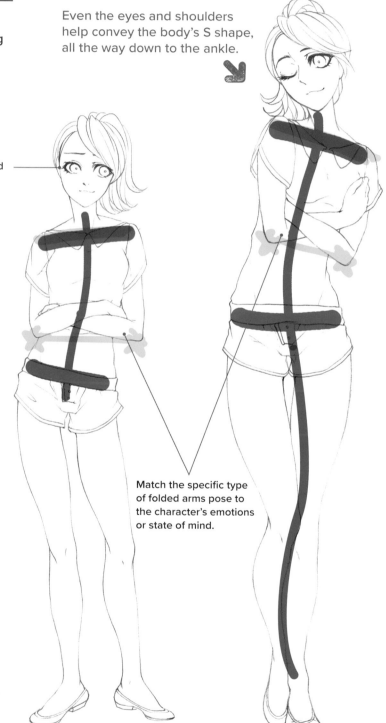

Match the specific type of folded arms pose to the character's emotions or state of mind.

Expert Tip

Convey a character's mood through her fingertips.

Add movement to the hands and fingers to express emotion: have characters grip their upper arms or have the arm taper delicately down to the fingertips.

Variations on the Pose

Is your character lost in thought or striking a provocative pose? Consider the scenario or situation while being aware of the movement in the arms and back too.

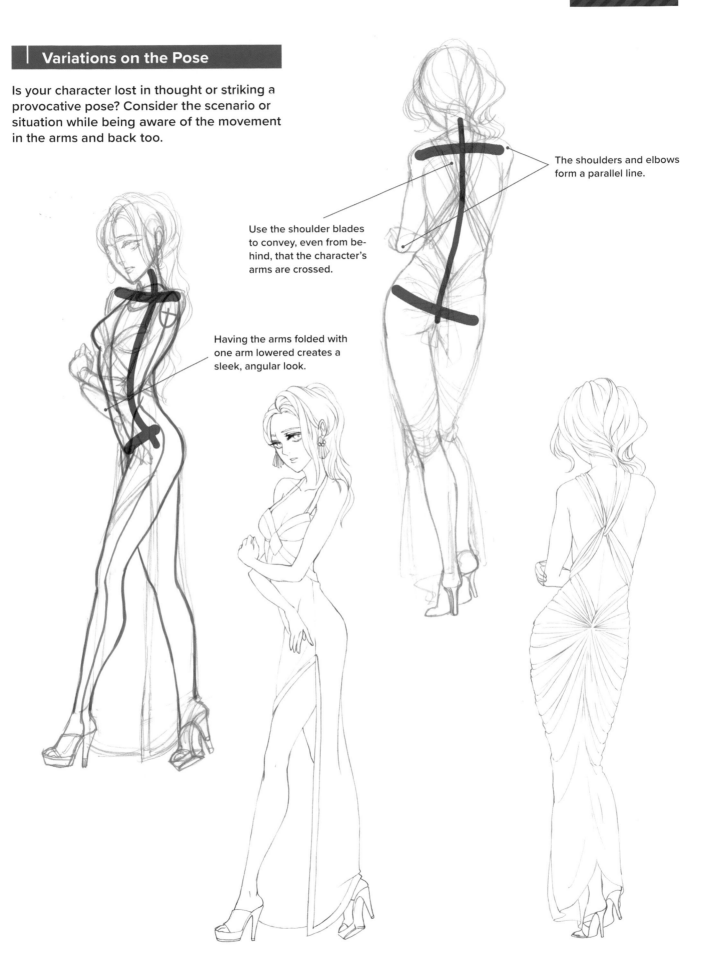

The shoulders and elbows form a parallel line.

Use the shoulder blades to convey, even from behind, that the character's arms are crossed.

Having the arms folded with one arm lowered creates a sleek, angular look.

Hands Folded Behind the Back

Apart from making the shoulder blades and elbow joints parallel, make sure the upper arms jut out and away from the body. The folded hands should be lower than the elbows. Carefully observe this pose in real life to make it easier to replicate on the page or screen.

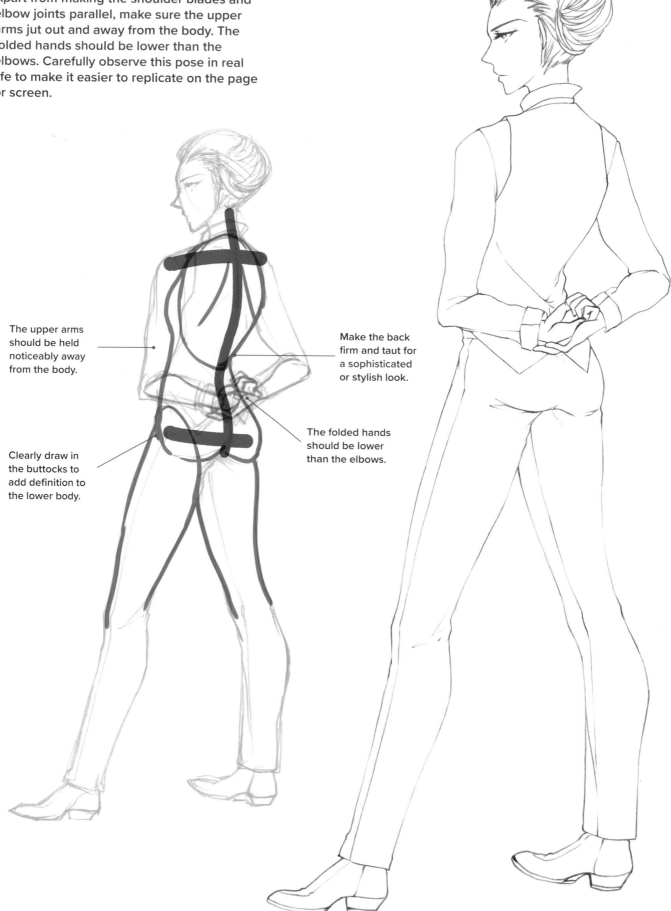

The upper arms should be held noticeably away from the body.

Make the back firm and taut for a sophisticated or stylish look.

The folded hands should be lower than the elbows.

Clearly draw in the buttocks to add definition to the lower body.

Part 2

Standing Poses:
Practical Applications

There are tricks to making a pose appealing when a figure is holding or carrying an object or engaging another character. Take a look!

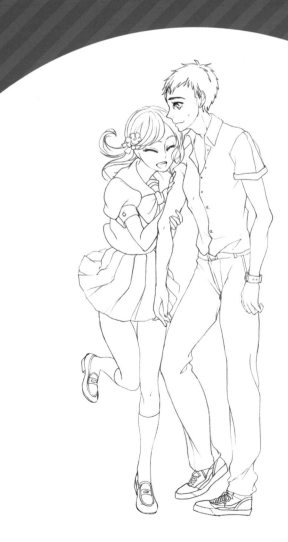

01 | Drawing a Leaning Figure

When attempting this pose, be conscious of the part of the back, buttocks or other areas that are in contact with the wall or vertical surface.

The Leaning Basics

When leaning on a wall, the back takes the weight, shifting the body's axis to the back of the head. Match the position of the head with the back and be conscious of the wall.

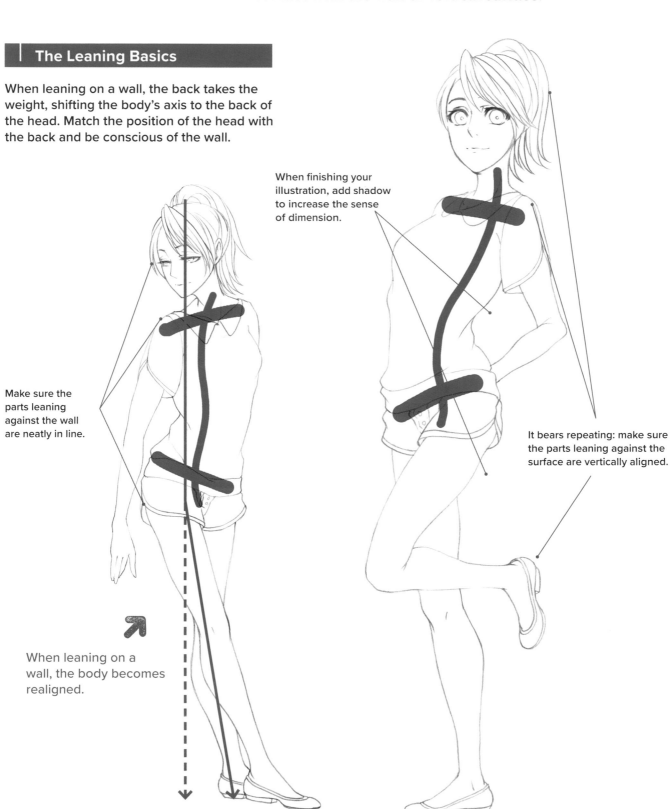

When finishing your illustration, add shadow to increase the sense of dimension.

Make sure the parts leaning against the wall are neatly in line.

It bears repeating: make sure the parts leaning against the surface are vertically aligned.

When leaning on a wall, the body becomes realigned.

Variations on the Pose

The wall is perpendicular to the ground, so the head and back remain in line. If they extend too far behind or in front, the figure will look unnatural.

The arm isn't entirely against the wall but curves slightly away from it.

Creating a space between the wall and the figure makes for a lithe, graceful pose.

The hip on the side of the weight-bearing leg rises.

Align the parts leaning against the vertical surface.

Make sure this foot is the center of gravity.

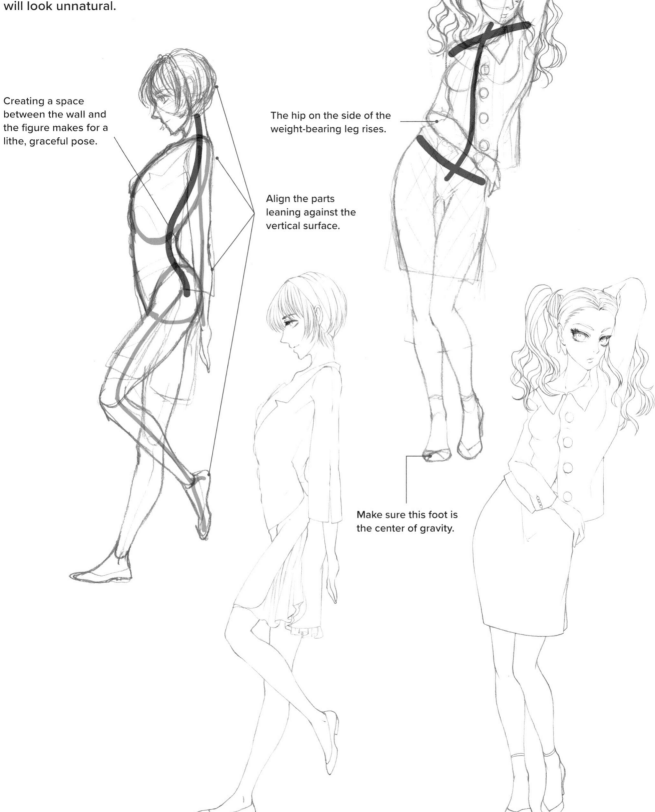

02

Drawing a Figure Holding an Object

The shoulders are key in poses where the figure is hoisting or holding something up. The character's movements change depending on the size of the object.

Carrying a Shoulder Bag

The shoulder on the side carrying the bag rises, with weight resting on the foot on the other side of the body. Be sure to apply contrapposto effects to the hip line also.

The size of the head needs to be in balance with the width of the shoulders.

On the side of the body that's carrying the object or item, the shoulder rises.

Expert Tip

Alter the rise of the shoulder depending on the size and weight of the object.

When carrying a large or heavy item, the shoulder on the side carrying it rises significantly. If the item's small, the change is minor. Make sure to clearly differentiate this in your drawing.

The hip rises on the opposite side of the object.

The foot on the side opposite to the object bears the weight.

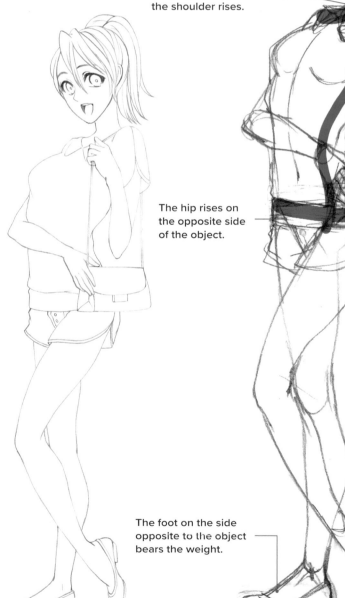

Variations on the Pose

Carrying an object restricts the body's movement. Exaggerated poses tend to look unnatural, so keep the movement of the limbs to a bare minimum.

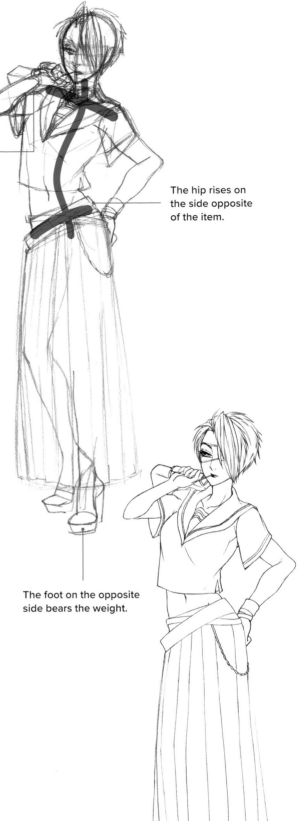

The shoulder rises on the side that's supporting the object.

The hip rises on the side opposite of the item.

Use the upper-arm muscles to indicate the weight and heft of the object.

The hip tilts upward on the opposite side.

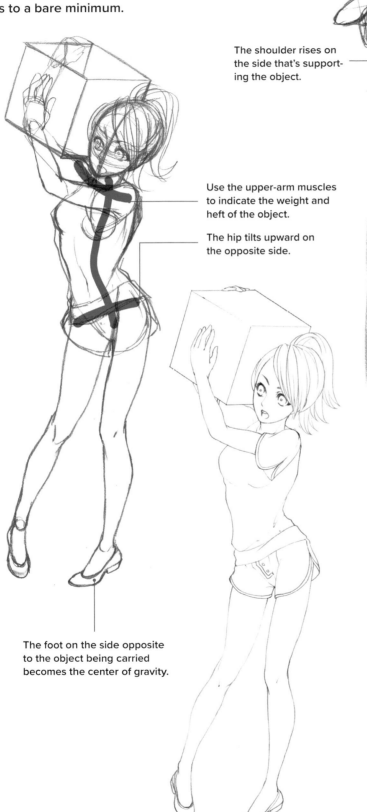

The foot on the opposite side bears the weight.

The foot on the side opposite to the object being carried becomes the center of gravity.

03 | Drawing a Figure Throwing Something

In throwing poses, expressing the movement of the arms, the twist of the chest and the weight-bearing leg is key.

Throwing a Ball

Be aware that the leg stepping forward takes the weight and use contrapposto effects to decide whether to raise or lower the shoulder to create a realistic sense of movement.

Draw the shoulder on the opposite side of the weight-bearing leg as slightly raised.

Create a dynamic movement through the toss of the hair.

The shape of the hands indicates the form and size of the object being thrown.

If the object's thrown slightly to the left, the momentum makes the clothing flow to the right.

The hip rises on the side bearing the weight.

The foot that's stepping or slightly raised becomes the center of gravity.

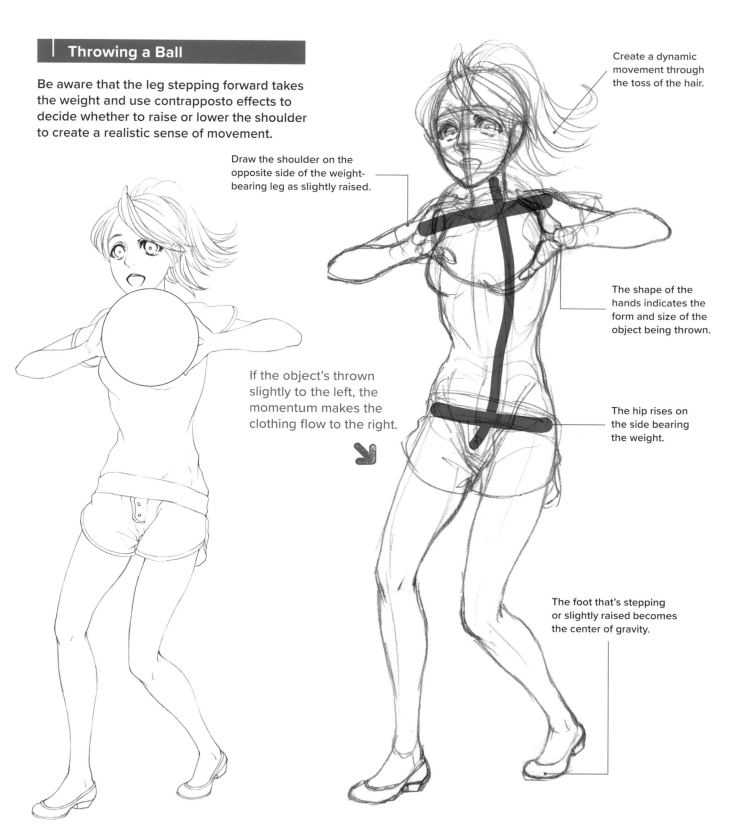

Variations on the Pose

For poses where the hands are raised or about to throw something, an arched back increases momentum. Locate the center of gravity directly has shifted.

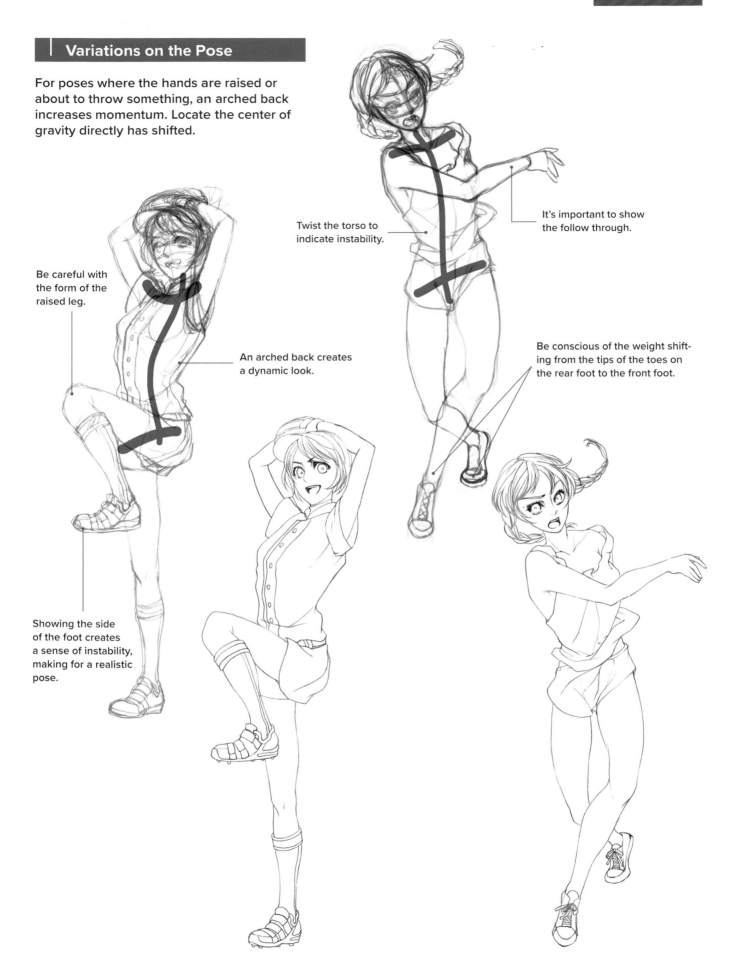

Twist the torso to indicate instability.

It's important to show the follow through.

Be careful with the form of the raised leg.

An arched back creates a dynamic look.

Be conscious of the weight shifting from the tips of the toes on the rear foot to the front foot.

Showing the side of the foot creates a sense of instability, making for a realistic pose.

04 | Drawing Two Standing Figures

When drawing two standing figures, make sure to create an overall sense of balance through the movement and through each figure's center of gravity.

A Woman Leaning on a Man

With this pose, a forward-tilting woman is leaning on a man standing firmly upright. Be aware of the woman's weight resting on the man's right arm.

Don't forget to consider the parts that are concealed as well.

Expert Tip

Tighten each figure's movements for overall balance.

When drawing two figures close together, decide on each figure's center of gravity to create a pose that retains balance for the pair as a unit.

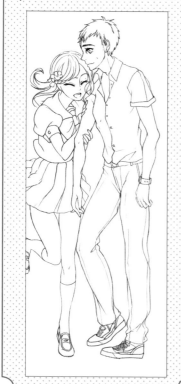

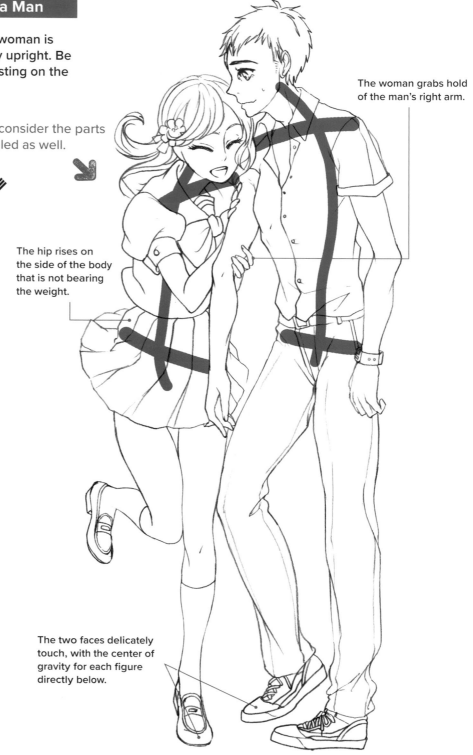

The woman grabs hold of the man's right arm.

The hip rises on the side of the body that is not bearing the weight.

The two faces delicately touch, with the center of gravity for each figure directly below.

Variations on the Pose

Bend the knees of the taller figure so that the figures' faces and eye lines match. Locate the centers of gravity directly beneath where their faces touch to create stability.

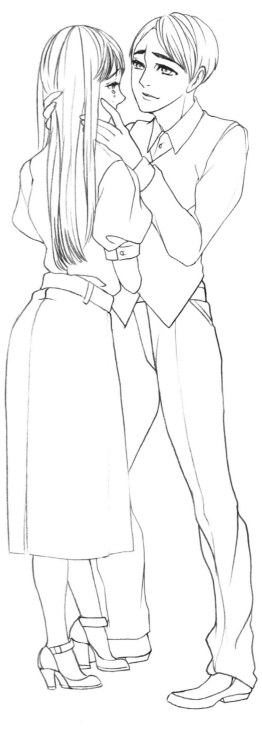

The slight distance between the closely positioned faces adds intensity and emotion to the scene.

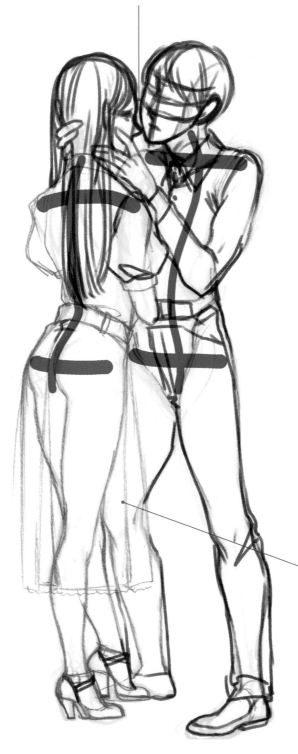

Bend the man's knees and drop his gaze slightly to meet the woman's slightly turned-away face.

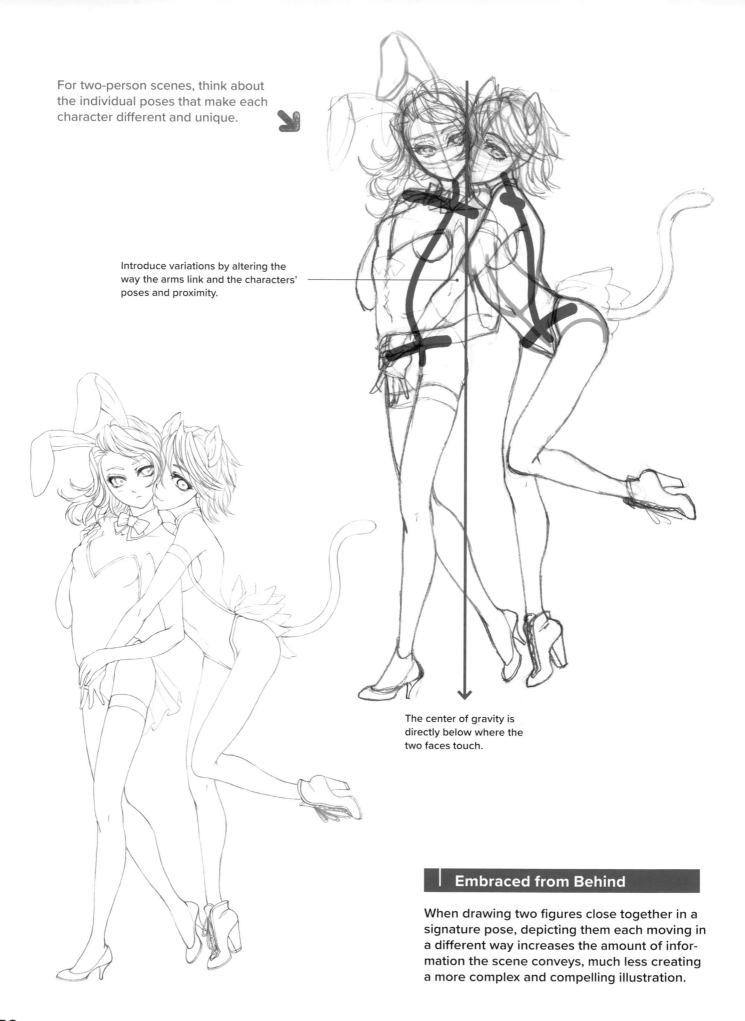

For two-person scenes, think about the individual poses that make each character different and unique.

Introduce variations by altering the way the arms link and the characters' poses and proximity.

The center of gravity is directly below where the two faces touch.

Embraced from Behind

When drawing two figures close together in a signature pose, depicting them each moving in a different way increases the amount of information the scene conveys, much less creating a more complex and compelling illustration.

A Slightly Sinister Embrace

When depicting an aggressive or threatening relationship between two characters, positioning the figure in power behind the other character ratchets up the tension and creates an appropriately edgy atmosphere.

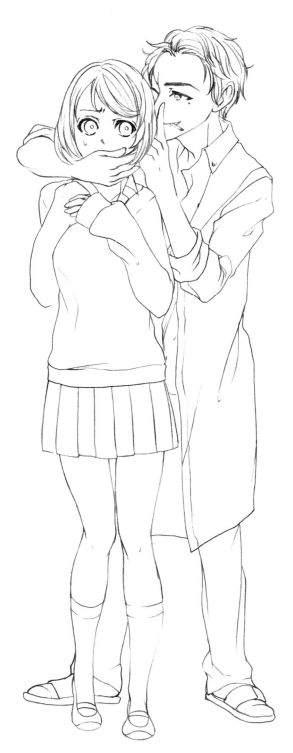

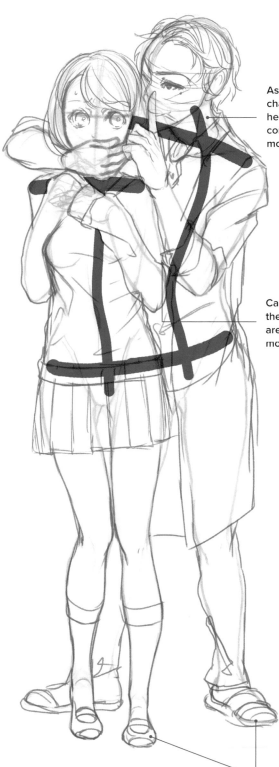

As with poses where characters are carrying heavy objects, limit and control the degree of movement portrayed.

Carefully fill where the two characters are touching for a more cohesive look.

Use perspective to add depth and complexity to the positions the characters are assuming.

Drawing a Supple or Stretched Body

Drawing delicate fingertips adds detail and expression to the movement of a flexible figure engaged in ballet, yoga or any extension-centered activity.

The Flexibility Basics

Depict the limbs as powerfully extended, with the tension running all the way to the tips of the fingers. Make sure to maintain proper ratios between the various body parts to prevent an unnatural look.

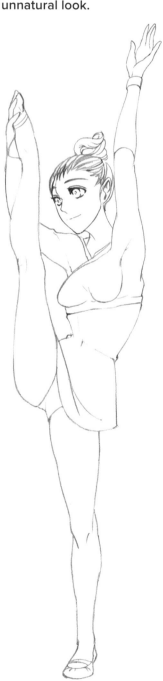

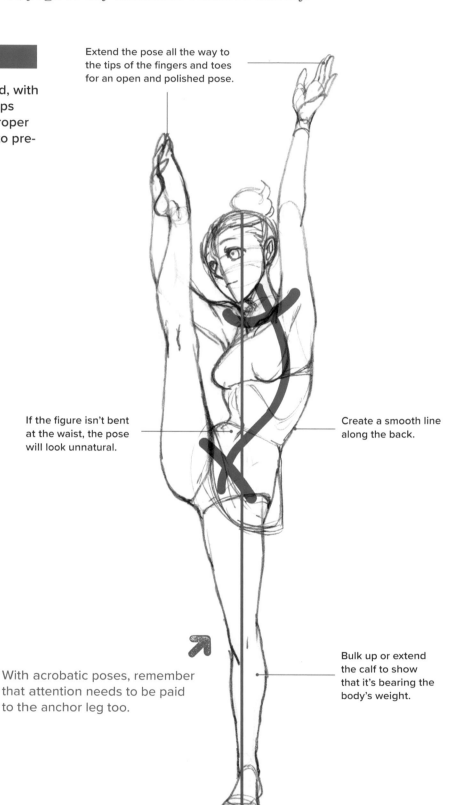

Extend the pose all the way to the tips of the fingers and toes for an open and polished pose.

If the figure isn't bent at the waist, the pose will look unnatural.

Create a smooth line along the back.

With acrobatic poses, remember that attention needs to be paid to the anchor leg too.

Bulk up or extend the calf to show that it's bearing the body's weight.

Variations on the Pose

Some poses seem possible only on the page or screen. Use curved lines to show the flexibility of the stomach and torso.

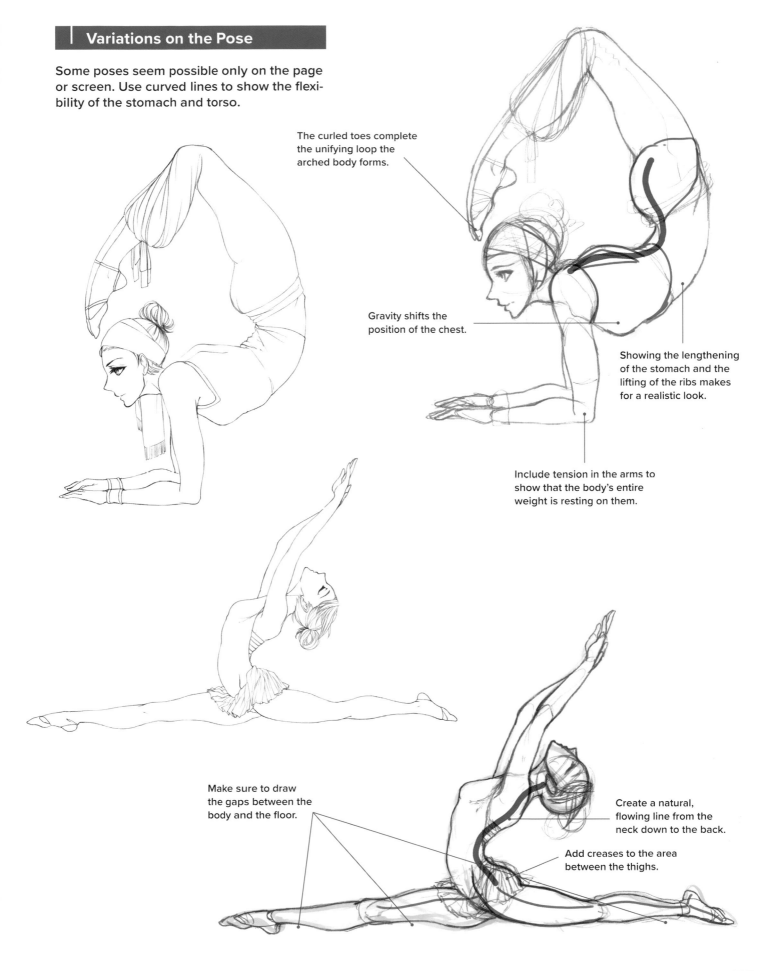

The curled toes complete the unifying loop the arched body forms.

Gravity shifts the position of the chest.

Showing the lengthening of the stomach and the lifting of the ribs makes for a realistic look.

Include tension in the arms to show that the body's entire weight is resting on them.

Make sure to draw the gaps between the body and the floor.

Create a natural, flowing line from the neck down to the back.

Add creases to the area between the thighs.

53

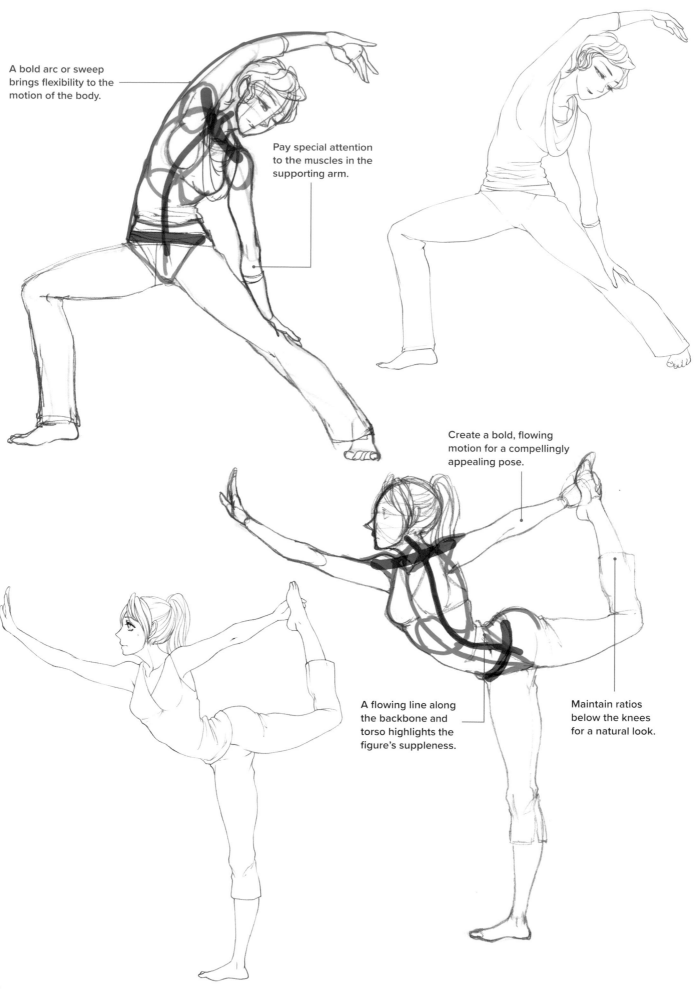

A bold arc or sweep brings flexibility to the motion of the body.

Pay special attention to the muscles in the supporting arm.

Create a bold, flowing motion for a compellingly appealing pose.

A flowing line along the backbone and torso highlights the figure's suppleness.

Maintain ratios below the knees for a natural look.

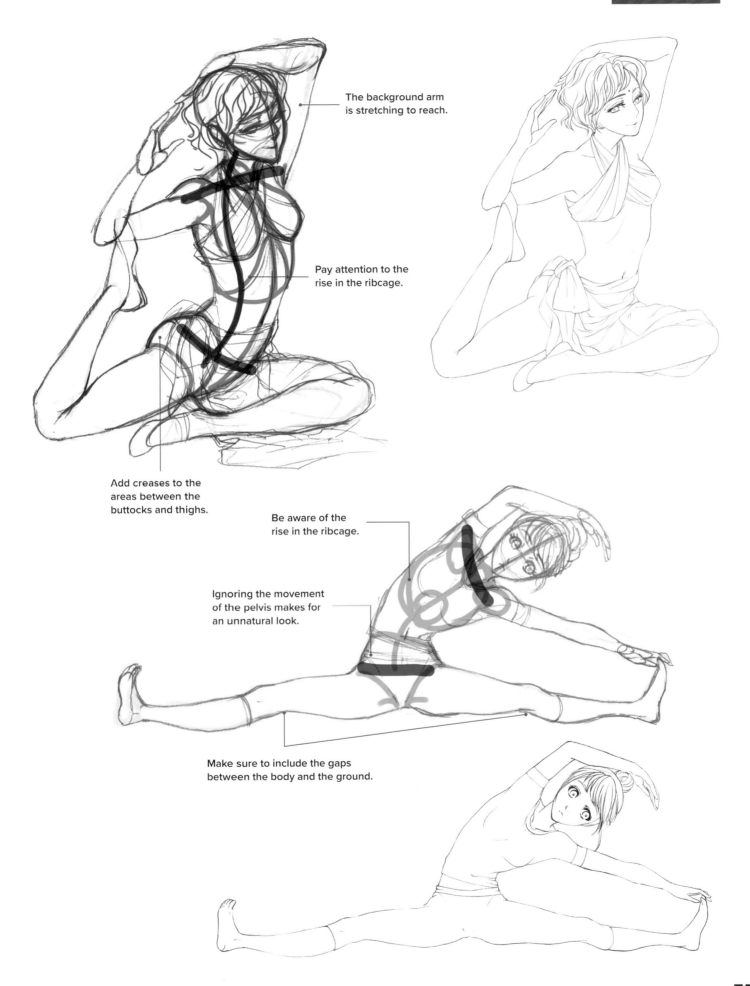

The background arm
is stretching to reach.

Pay attention to the
rise in the ribcage.

Add creases to the
areas between the
buttocks and thighs.

Be aware of the
rise in the ribcage.

Ignoring the movement
of the pelvis makes for
an unnatural look.

Make sure to include the gaps
between the body and the ground.

Extension in Action Poses

Flexibility and suppleness need to be highlighted for realistic action poses involving bold leg movements. Take care positioning the supporting leg (or axis leg) and the kicking leg.

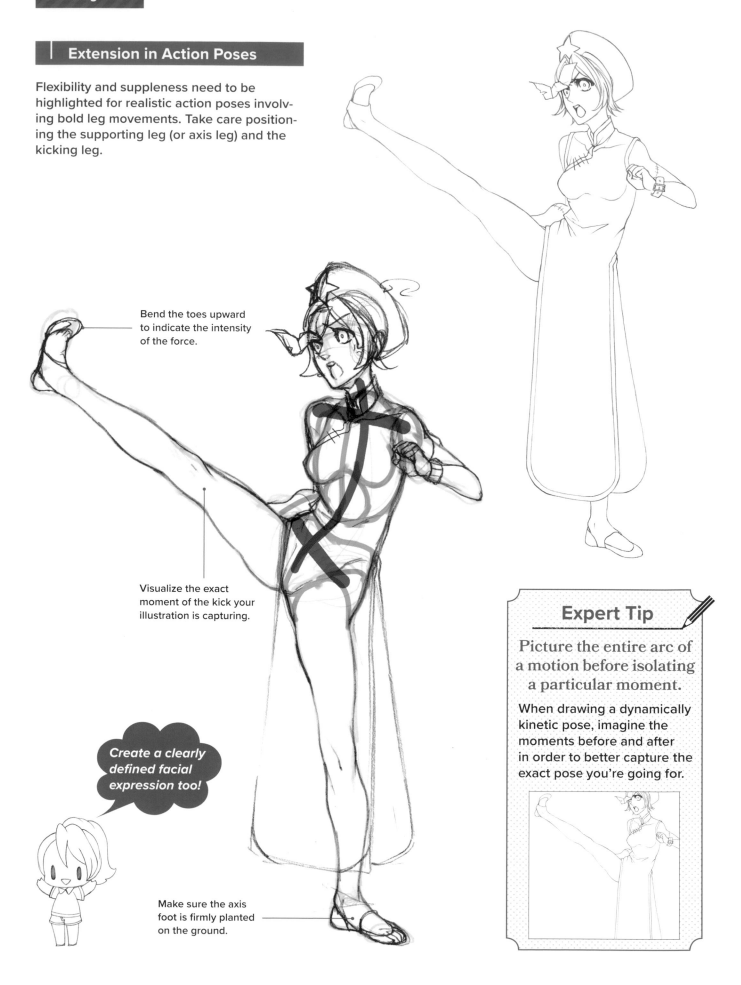

Bend the toes upward to indicate the intensity of the force.

Visualize the exact moment of the kick your illustration is capturing.

Create a clearly defined facial expression too!

Make sure the axis foot is firmly planted on the ground.

Expert Tip

Picture the entire arc of a motion before isolating a particular moment.

When drawing a dynamically kinetic pose, imagine the moments before and after in order to better capture the exact pose you're going for.

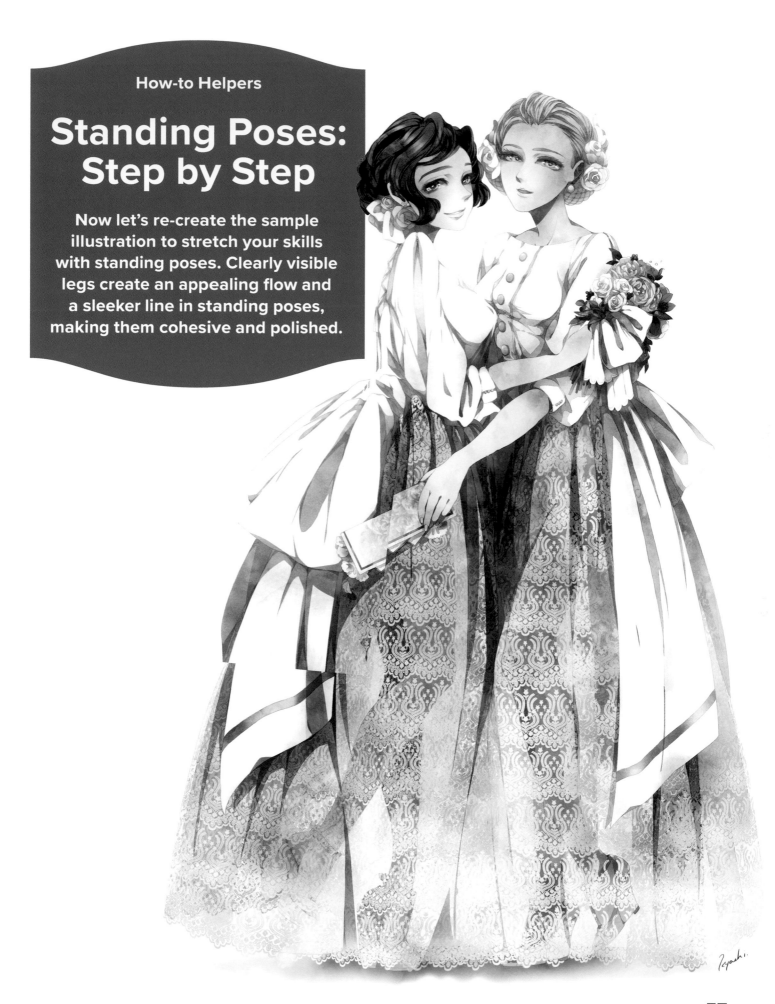

Standing Poses: Step by Step

Now let's re-create the sample illustration to stretch your skills with standing poses. Clearly visible legs create an appealing flow and a sleeker line in standing poses, making them cohesive and polished.

Arm in Arm

This example will stretch your ability to draw closely positioned figures. Start by using a pencil on paper, then shift to a digital format.

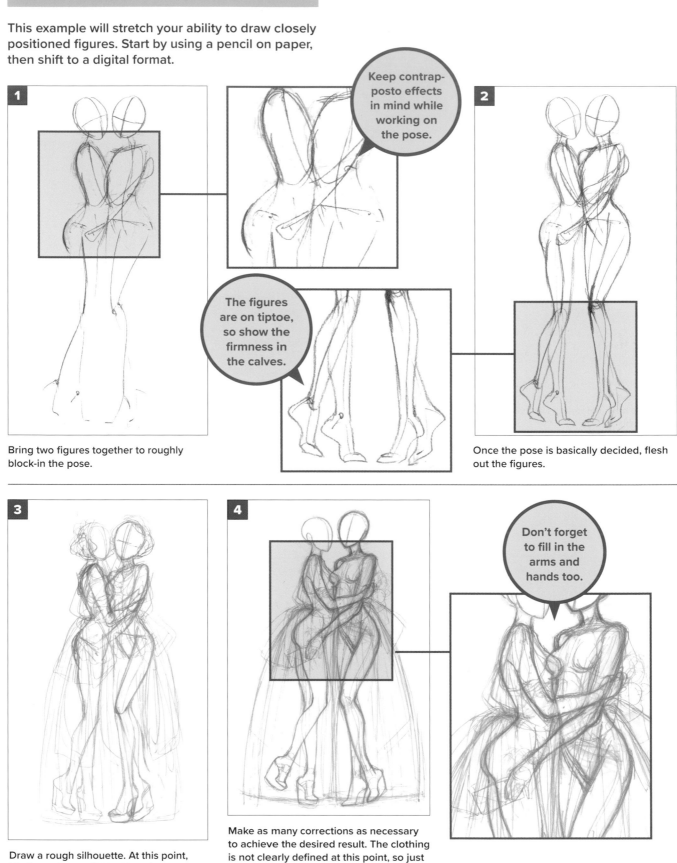

1

Keep contrapposto effects in mind while working on the pose.

The figures are on tiptoe, so show the firmness in the calves.

Bring two figures together to roughly block-in the pose.

2

Once the pose is basically decided, flesh out the figures.

3

Draw a rough silhouette. At this point, it's fine to just scribble things in.

4

Don't forget to fill in the arms and hands too.

Make as many corrections as necessary to achieve the desired result. The clothing is not clearly defined at this point, so just sketch it in.

5

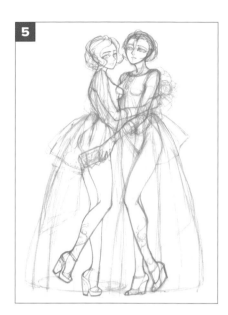

Scan the drawing and check on screen whether the figures are in balance. At the same time, enlarge the drawing and fill in details such as clothing and shoes. Once they have been added, print out the drawing.

Focus on Format

Illustration on Paper	Digital Illustration
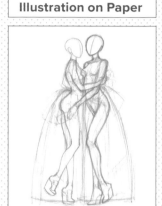	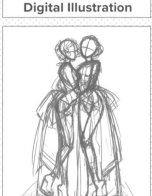

Maximize the advantages of the format you're working in

Using only paper and pencil or only a computer to create an illustration can lead to various problems. If this happens, switch platforms. Block-in and do other rough-sketch work using pencil, then change to a digital format to add in the finer details. Try scanning what you've drawn in pencil and using your preferred illustration software to fine-tune and add balance to the overall presentation.

6

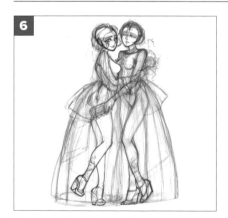

Compare the printout with the screen and check the limb length and body ratios. If there are no problems, draw in the faces.

Draw in facial expressions to further indicate the relationship between the two. Subtle smiles suggest the intimacy of their friendship.

7

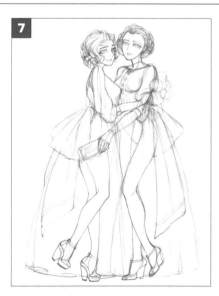

Roughly decide the proportions and clothing to create a silhouette. At this stage, decide on the characters' situation (relationship, ages, personalities and so on) to determine their hairstyles, facial expressions and outfits.

8

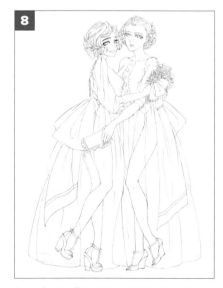

Draw in details such as the sweep and flow of the hair and the creases in the clothing. If you become confused, refer to magazines and specialist publications to check posing, details and textures. Make a clean copy to complete the rough draft.

Arm in Arm

Once the rough sketch is done, use Photoshop, or similar software, to add color. Keep the finished illustration clearly in mind as you start to draw.

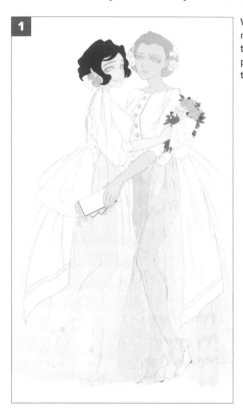

1

With the finished result in mind, start to add color. As the skirt is made from transparent lace, follow its lines to paste on the lacy fabric.

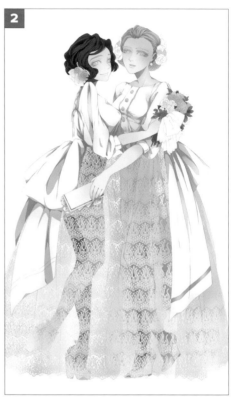

2

Add shadows. Start by applying soft gradation to build a clearer form little by little. Work the hair into bundles and add shading to the dress, feet and so on. Alter the hip area of the figure on the right so it is not too transparent.

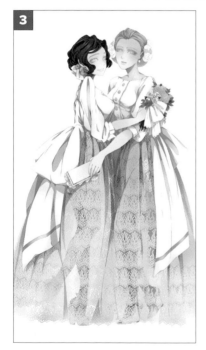

3

Apply pale blue to the areas of shadow as an accent color. Add highlights to the hair.

A Bit of Advice

Without texture	With texture

Add texture to manipulate and strengthen the impression you're creating.

Layering texture over the image allows you to alter the overall look of the illustration. Here texture adds to the old-fashioned or period style. Simply adding texture to the hair lends it a glossy look, and if you feel your illustration lacks punch, try adding textured effects.

4

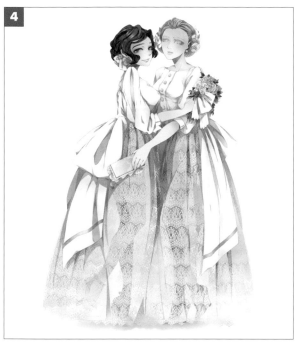

Correct overall color to create a cohesive look. At this stage, add texture to bring out an antique feel. Add small items such as a bouquet or corsage.

5

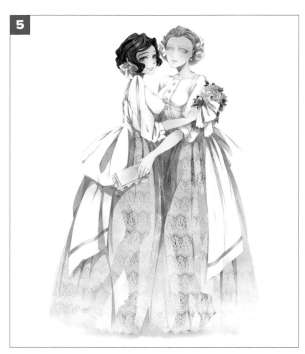

The finished result. Adjust the shadow at the hem of the skirts to be somewhat more defined. At this stage, look at the overall image again to make sure everything is in balance.

A Little More Advice ✏️

Skin texture	Hair texture	Clothing texture

Using appropriate textures

There are various textures to choose from. Even if one seems too bold or garish, once it's applied, texture can blend in. Adding texture creates variety in an illustration, so give it a try. It's also worth changing the texture on different parts of the illustration. Use what suits your work best.

6

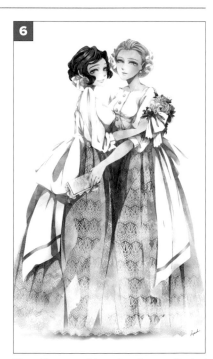

Here, the overall tone has been adjusted. Once the focus and contrast have been adjusted, the image will be complete.

Drawing the Creases in Clothes

Creases in clothing tend to form in the underarms, around joints and in places where there are seams. The thinner the fabric, the more creases there will be.

Front View

Adapting them to the type of material, draw in creases around the chest, underarms and hips.

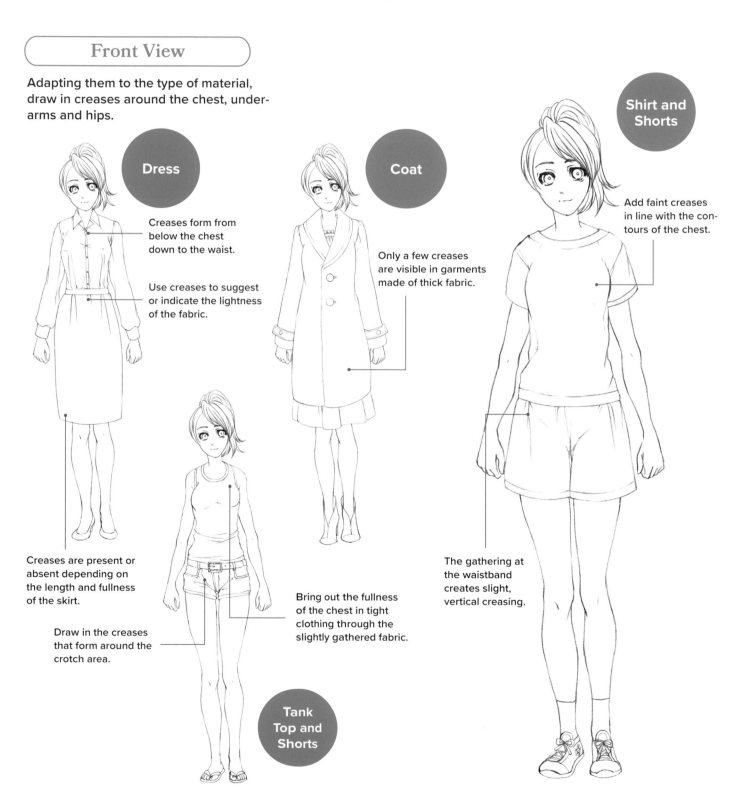

Dress

Creases form from below the chest down to the waist.

Use creases to suggest or indicate the lightness of the fabric.

Creases are present or absent depending on the length and fullness of the skirt.

Draw in the creases that form around the crotch area.

Coat

Only a few creases are visible in garments made of thick fabric.

Tank Top and Shorts

Bring out the fullness of the chest in tight clothing through the slightly gathered fabric.

Shirt and Shorts

Add faint creases in line with the contours of the chest.

The gathering at the waistband creates slight, vertical creasing.

Side View

Show the creases that form around the fuller areas such as the chest and buttocks along with the fall of the fabric.

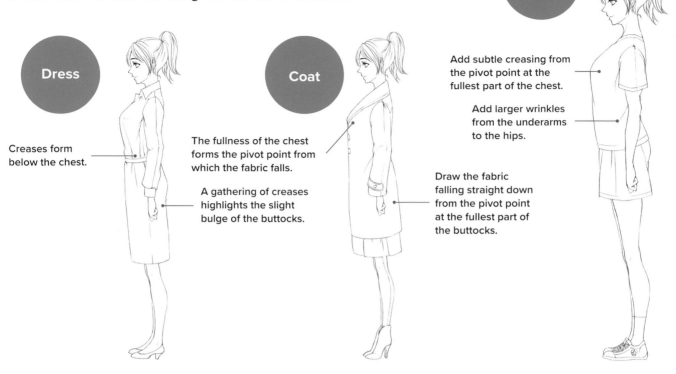

Dress

Creases form below the chest.

A gathering of creases highlights the slight bulge of the buttocks.

Coat

The fullness of the chest forms the pivot point from which the fabric falls.

Draw the fabric falling straight down from the pivot point at the fullest part of the buttocks.

Shirt and Shorts

Add subtle creasing from the pivot point at the fullest part of the chest.

Add larger wrinkles from the underarms to the hips.

Rear View

Including the large creases that form from the shoulder blades, buttocks and from the underarms to the hips is essential.

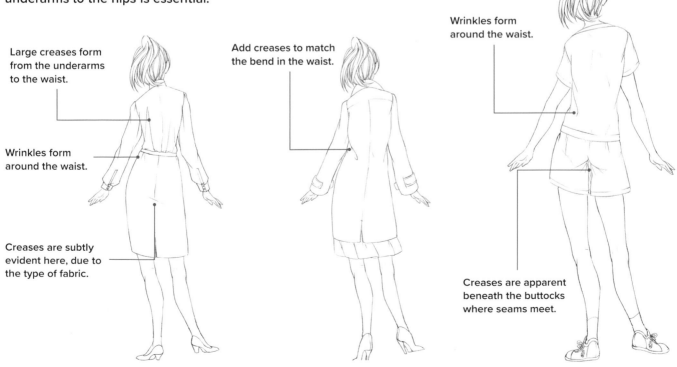

Large creases form from the underarms to the waist.

Wrinkles form around the waist.

Creases are subtly evident here, due to the type of fabric.

Add creases to match the bend in the waist.

Wrinkles form around the waist.

Creases are apparent beneath the buttocks where seams meet.

Drawing the Creases in a Top

Apart from the type of fabric used, arm movements and twists in the upper body also alter how creases form.

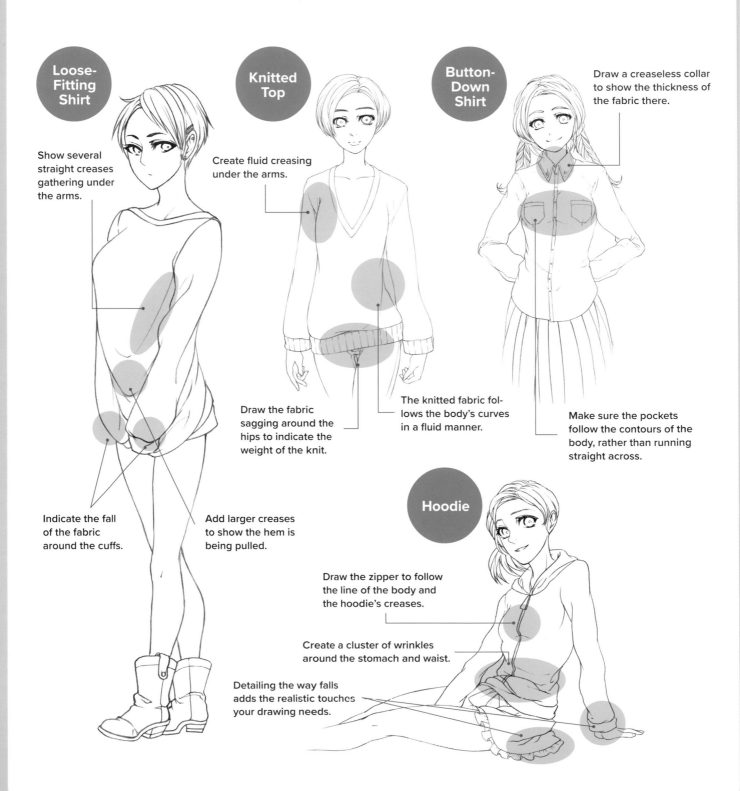

Loose-Fitting Shirt

Show several straight creases gathering under the arms.

Indicate the fall of the fabric around the cuffs.

Knitted Top

Create fluid creasing under the arms.

Draw the fabric sagging around the hips to indicate the weight of the knit.

Add larger creases to show the hem is being pulled.

The knitted fabric follows the body's curves in a fluid manner.

Button-Down Shirt

Draw a creaseless collar to show the thickness of the fabric there.

Make sure the pockets follow the contours of the body, rather than running straight across.

Hoodie

Draw the zipper to follow the line of the body and the hoodie's creases.

Create a cluster of wrinkles around the stomach and waist.

Detailing the way falls adds the realistic touches your drawing needs.

Sitting Poses:
The Basics

The body's position and movements change significantly depending on whether the figure is seated on the ground or in a chair. Consider where the center of gravity is and proceed from there. The positioning of just a single body part can alter the overall impression.

Drawing a Sitting Pose

In a sitting pose, having your character leaning on a seat back
or the armrests helps create a contrapposto pose.

The Basics of Sitting

The shoulder rises on the side of the weight-bearing
arm. Think of the seat or chair as a cube and apply
perspective appropriately. Be conscious of the ground
near the feet to prevent them from floating in the air.

Sitting Poses Check List

- ☐ Movement in the torso is the same as for standing poses.
- ☐ The shoulder rises on the side of the hand touching the chair.
- ☐ Create a sense of depth between the legs and the chair.
- ☐ Be conscious of the ground near the feet.

Have you checked all the boxes?

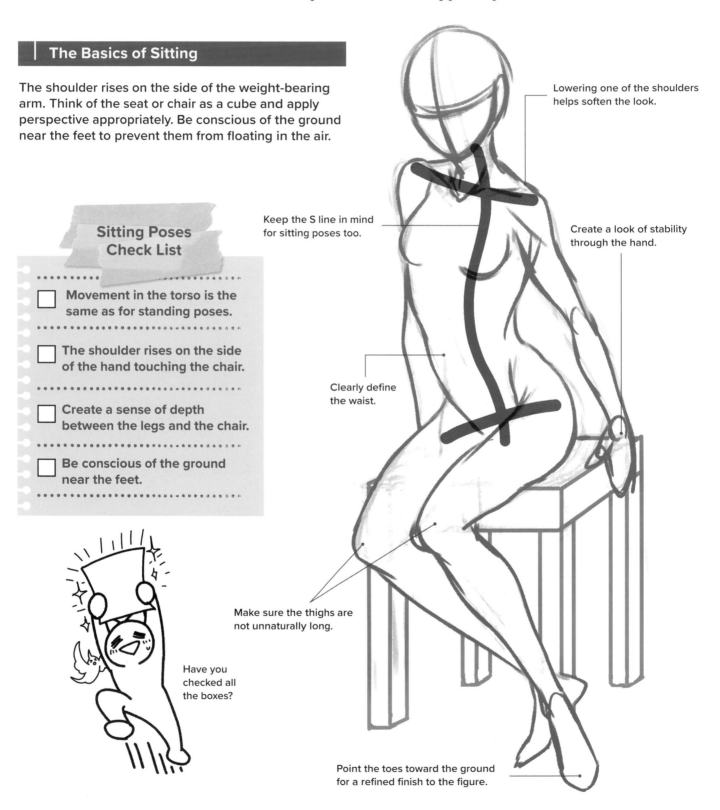

Keep the S line in mind for sitting poses too.

Lowering one of the shoulders helps soften the look.

Create a look of stability through the hand.

Clearly define the waist.

Make sure the thighs are not unnaturally long.

Point the toes toward the ground for a refined finish to the figure.

66

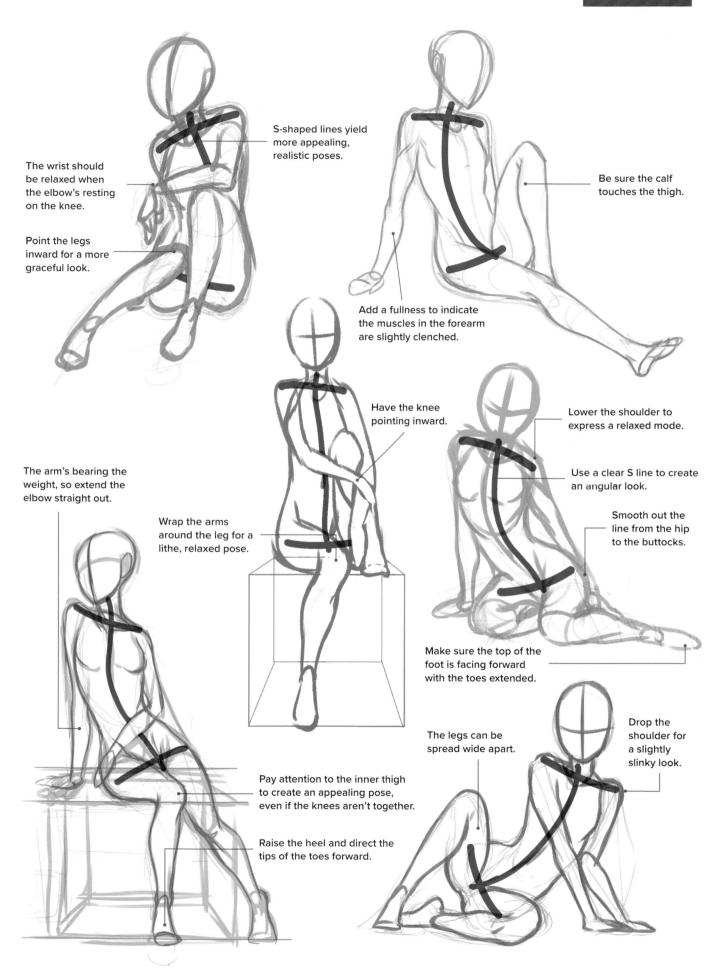

S-shaped lines yield more appealing, realistic poses.

The wrist should be relaxed when the elbow's resting on the knee.

Point the legs inward for a more graceful look.

Be sure the calf touches the thigh.

Add a fullness to indicate the muscles in the forearm are slightly clenched.

Have the knee pointing inward.

Lower the shoulder to express a relaxed mode.

Use a clear S line to create an angular look.

The arm's bearing the weight, so extend the elbow straight out.

Wrap the arms around the leg for a lithe, relaxed pose.

Smooth out the line from the hip to the buttocks.

Make sure the top of the foot is facing forward with the toes extended.

Pay attention to the inner thigh to create an appealing pose, even if the knees aren't together.

The legs can be spread wide apart.

Drop the shoulder for a slightly slinky look.

Raise the heel and direct the tips of the toes forward.

67

Warming Up

Decide the size and height of the chair and position of the lower body
before you start sketching in the figure.

Blocking-In

First, roughly block-in the chair, deciding on the size
and height. Then, draw in the hips, knees and toes in
that order, extending the line from the hips up to the
backbone to create the torso. Finally, add the head.

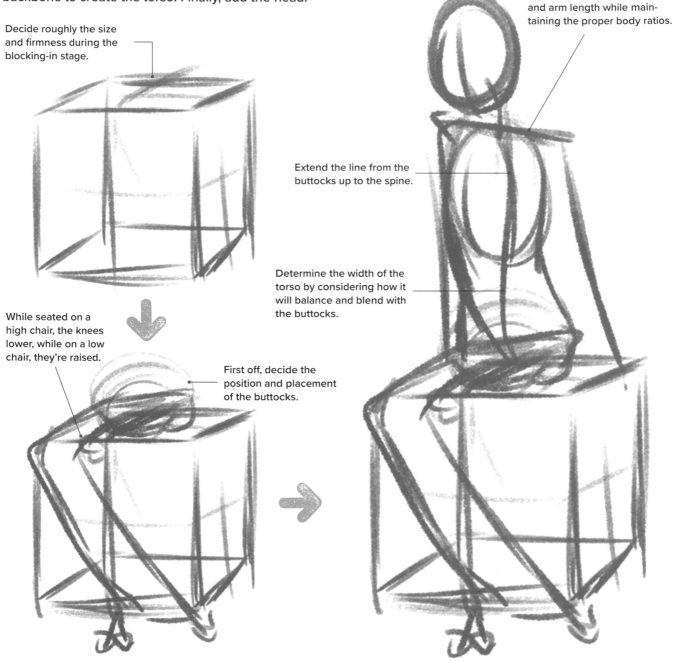

Decide roughly the size
and firmness during the
blocking-in stage.

Decide the shoulder position
and arm length while main-
taining the proper body ratios.

Extend the line from the
buttocks up to the spine.

Determine the width of the
torso by considering how it
will balance and blend with
the buttocks.

While seated on a
high chair, the knees
lower, while on a low
chair, they're raised.

First off, decide the
position and placement
of the buttocks.

68

Flesh Out the Form

The lower body is key, so make sure to depict it clearly. The flesh in the buttocks and thighs changes form depending on the firmness of the chair or object the character's sitting on. The shape of the calves also changes depending on how the ankles are positioned in relation to the floor.

First, draw in the roundness of the buttocks on the surface of the seat and add in the knees, paying attention to the sense of depth. Once the knees are filled in, adjust the shape of the thighs. Consider how the position of the ankles affects the calves as you draw them in.

Clearly indicate the contrast between the seat and the figure, showing the thighs sinking into the seat if it's soft.

Depending on whether the tips of the toes or the sole of the foot is touching the floor, the position of the ankles alters the shape of the calves.

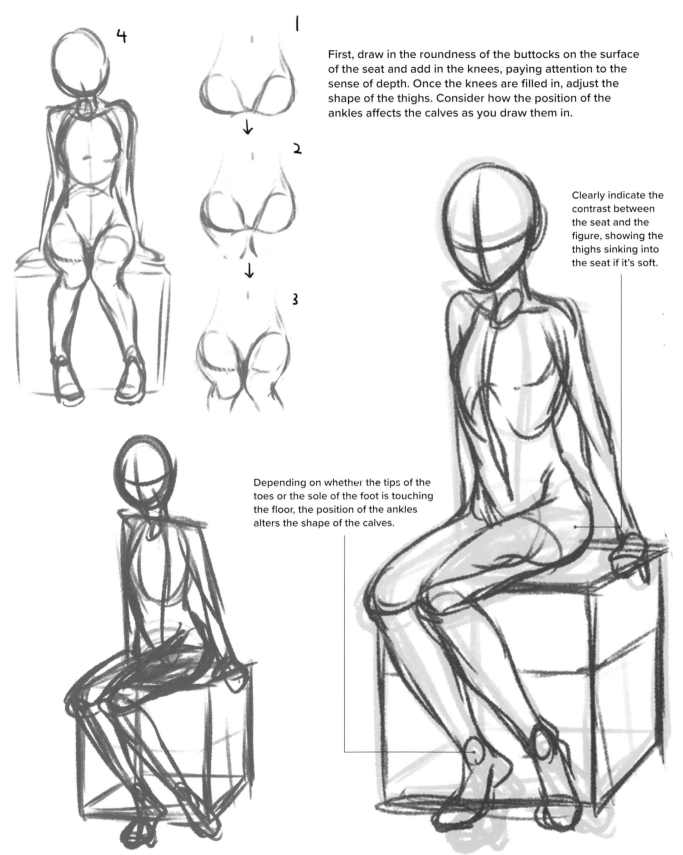

69

Add in Details

Once the flesh has been added, decide the shape of the muscles, the position of the navel and the size of the joints and limbs. Then, add the finer details to the face, hair, fingertips, clothing and shoes.

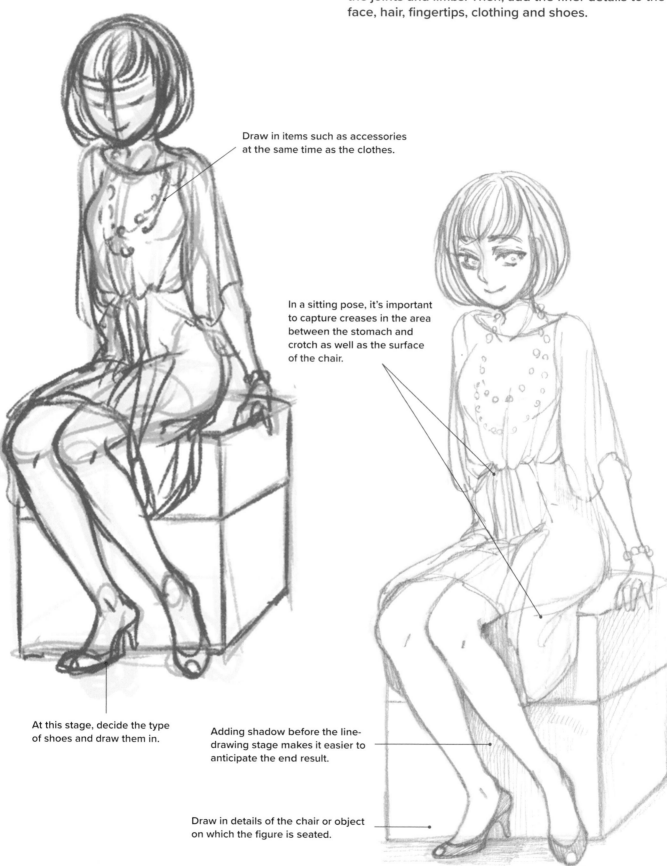

Draw in items such as accessories at the same time as the clothes.

In a sitting pose, it's important to capture creases in the area between the stomach and crotch as well as the surface of the chair.

At this stage, decide the type of shoes and draw them in.

Adding shadow before the line-drawing stage makes it easier to anticipate the end result.

Draw in details of the chair or object on which the figure is seated.

Creating Variation

At the start, you'll have trouble simply drawing the lower half of the body. Don't worry about it: just consult reference material and make copies until you get used to drawing. It's also important to understand the positioning of the seat surface and the body and the movement of the muscles and bones.

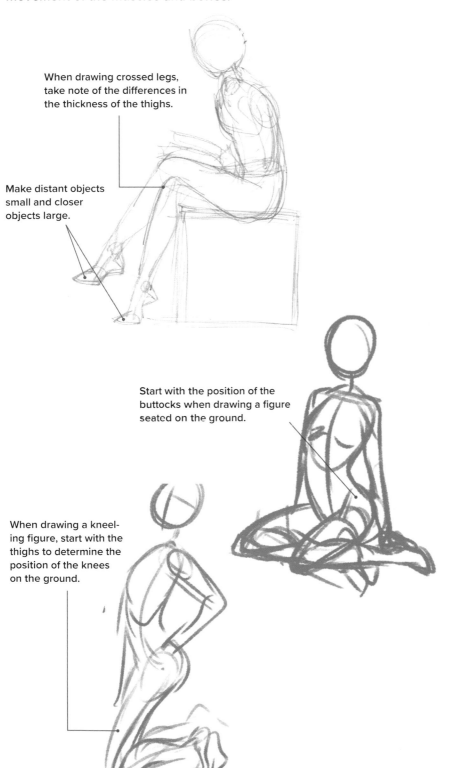

When drawing crossed legs, take note of the differences in the thickness of the thighs.

Make distant objects small and closer objects large.

Start with the position of the buttocks when drawing a figure seated on the ground.

When drawing a kneeling figure, start with the thighs to determine the position of the knees on the ground.

Sitting on a Chair

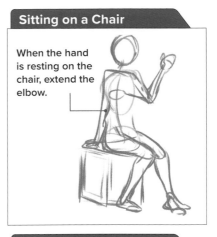

When the hand is resting on the chair, extend the elbow.

Sitting on the Ground

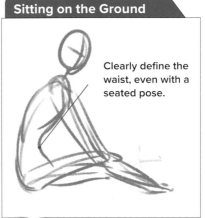

Clearly define the waist, even with a seated pose.

Consider the Character

The way they're sitting and the object they're sitting on can be used to express the character's personality. Keep in mind aspects such as the seat surface and body position and the movement of muscles and bones to try out various poses.

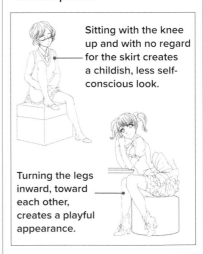

Sitting with the knee up and with no regard for the skirt creates a childish, less self-conscious look.

Turning the legs inward, toward each other, creates a playful appearance.

71

01

Take a Seat

Let's take a look at various poses that involve sitting on the ground, such as formal Japanese such as kneeling or sitting with knees raised.

Knees Bent to One Side

This pose involves shifting from a formal kneeling position so that the knees are skewed to one side. Raising the shoulder on the side where the buttocks touch the floor creates an appealing line.

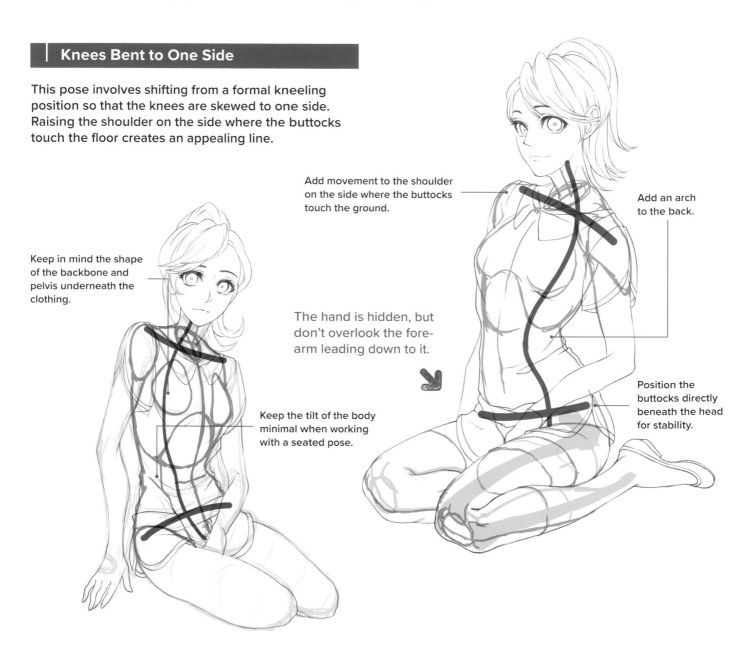

Add movement to the shoulder on the side where the buttocks touch the ground.

Add an arch to the back.

Keep in mind the shape of the backbone and pelvis underneath the clothing.

The hand is hidden, but don't overlook the forearm leading down to it.

Position the buttocks directly beneath the head for stability.

Keep the tilt of the body minimal when working with a seated pose.

Focusing on the Pelvis and Knees

Kneecaps prevent the knees from bending forward. When the figure is seated with the legs flat on the floor, the section below the knees appears twisted due to the pelvis moving. Keeping this body position in mind allows you to capture the shape of the knees in a natural manner.

Seated with the Thighs Open or Closed

Sitting with the legs opened or slightly splayed and the ankles crossed conveys physical cues about your character's personality and defining qualities.

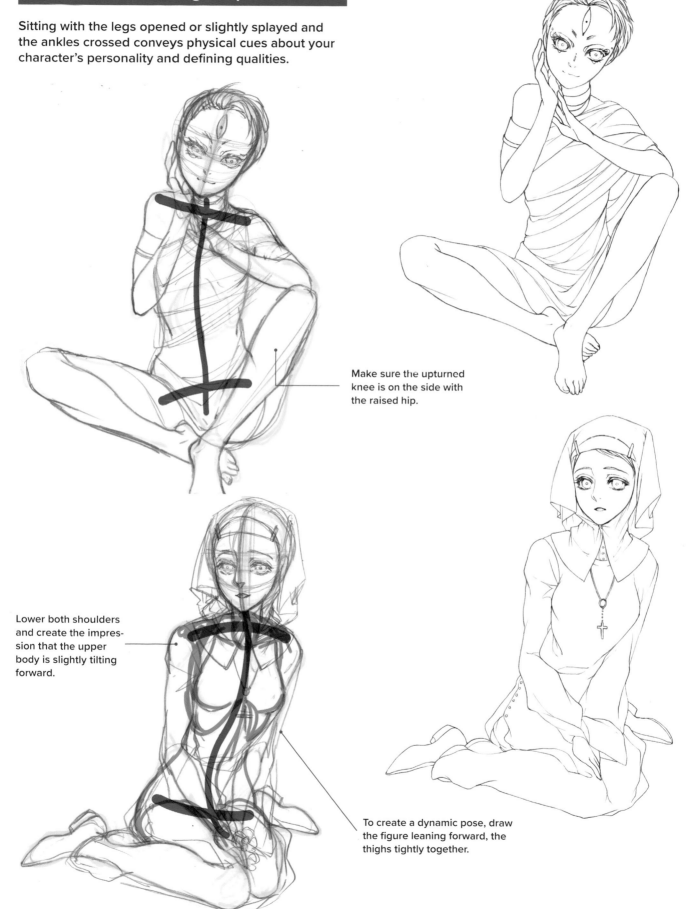

Make sure the upturned knee is on the side with the raised hip.

Lower both shoulders and create the impression that the upper body is slightly tilting forward.

To create a dynamic pose, draw the figure leaning forward, the thighs tightly together.

73

With an Upturned Knee

In this pose, one knee is raised while the other is in a kneeling position or placed to the side. Start with the buttocks and legs to make it easier to create a balanced figure.

The illustration needs to look realistic and natural even with unusual or dramatic poses.

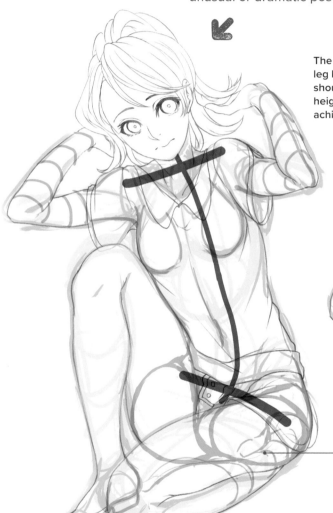

The length of the leg below the knees should be twice the height of the head to achieve balance.

The center of gravity rests on the relaxed leg.

Pay attention to the parts that aren't visible, such as the shape of the buttocks or the intersection of the legs and the lower torso.

Considering Parts That Aren't Visible

As you draw, think of the parts that can't be seen, such as the buttocks, the upper thighs, the shape of the crotch and the leg beneath the buttocks. It's also important to keep in mind when drawing from a model or from a book of poses.

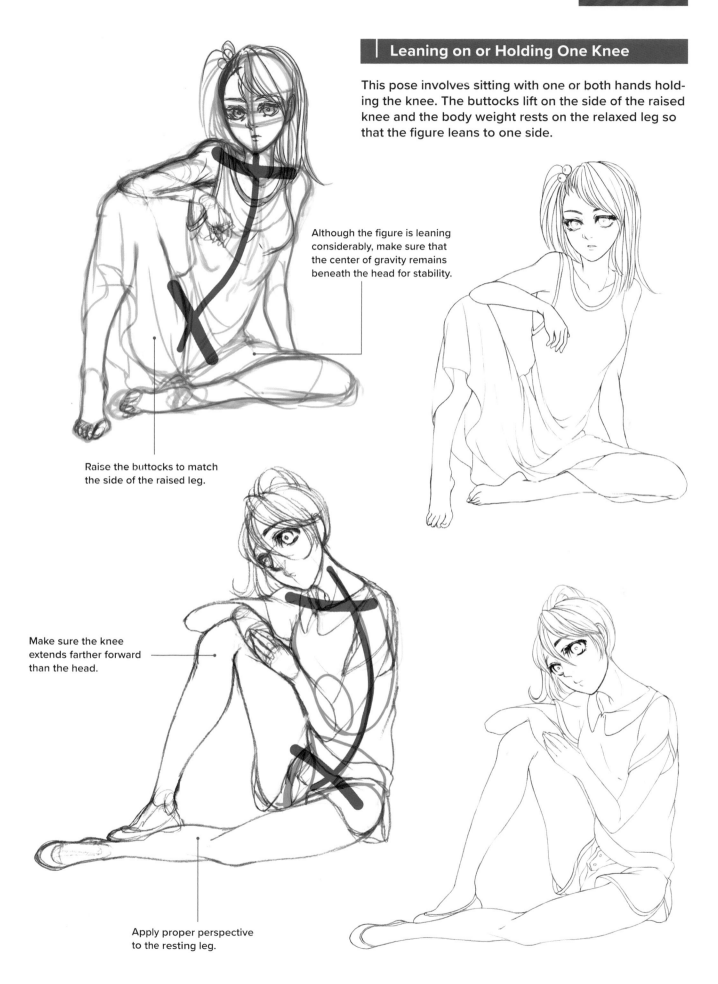

Leaning on or Holding One Knee

This pose involves sitting with one or both hands holding the knee. The buttocks lift on the side of the raised knee and the body weight rests on the relaxed leg so that the figure leans to one side.

Although the figure is leaning considerably, make sure that the center of gravity remains beneath the head for stability.

Raise the buttocks to match the side of the raised leg.

Make sure the knee extends farther forward than the head.

Apply proper perspective to the resting leg.

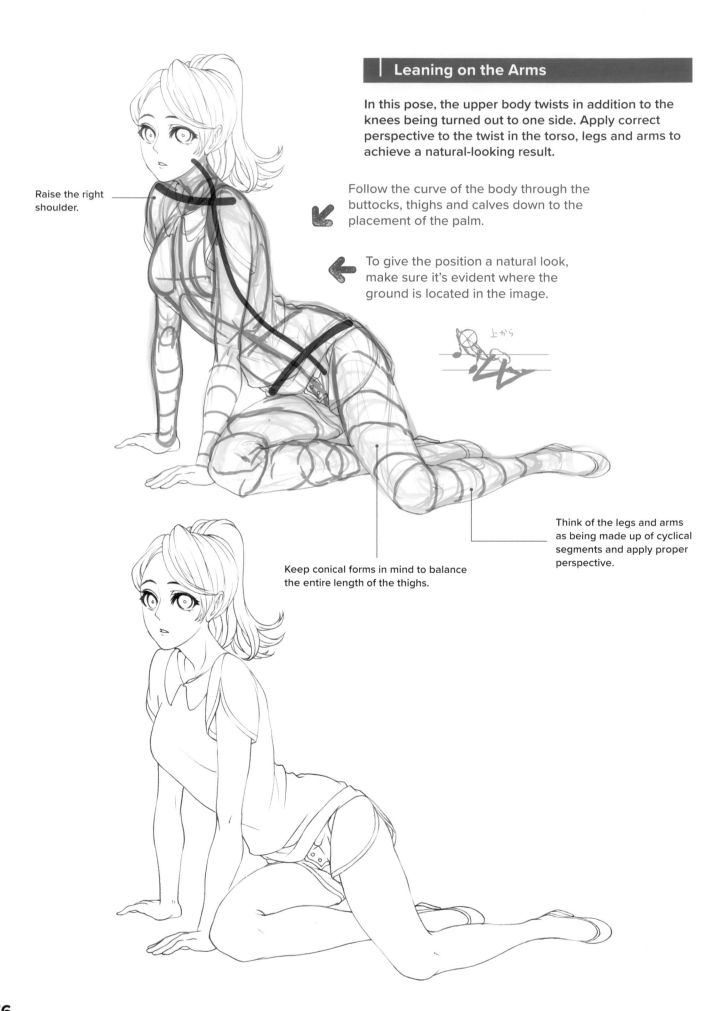

Leaning on the Arms

In this pose, the upper body twists in addition to the knees being turned out to one side. Apply correct perspective to the twist in the torso, legs and arms to achieve a natural-looking result.

Follow the curve of the body through the buttocks, thighs and calves down to the placement of the palm.

To give the position a natural look, make sure it's evident where the ground is located in the image.

Raise the right shoulder.

Keep conical forms in mind to balance the entire length of the thighs.

Think of the legs and arms as being made up of cyclical segments and apply proper perspective.

上から

Variations on Sitting Poses

When drawing figures from the front on or from the back, it's important to show dimension. Familiarize yourself by drawing solid objects such as cylinders and cubes to start with.

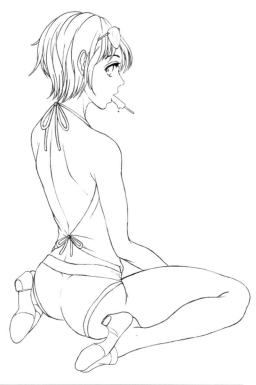

The shape of the buttocks and curve of the back are important.

The center of gravity rests on the buttocks.

Don't ignore the soles and arches of the feet.

Don't forget about the crease formed by bringing the arms together in front.

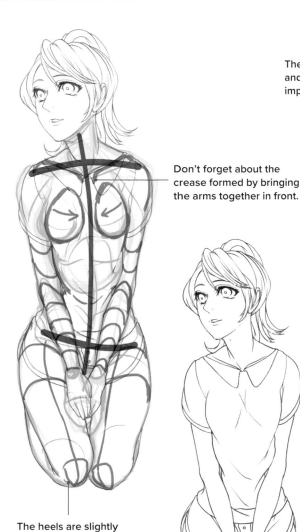

The heels are slightly raised in this casual kneeling position.

Keeping a Sense of Perspective

Think of the limbs as being conical in shape. This helps when applying perspective to the drawing. Holding a cylinder in your hand and observing what it looks like is another method. If you can grasp this sense of perspective, your drawing will improve.

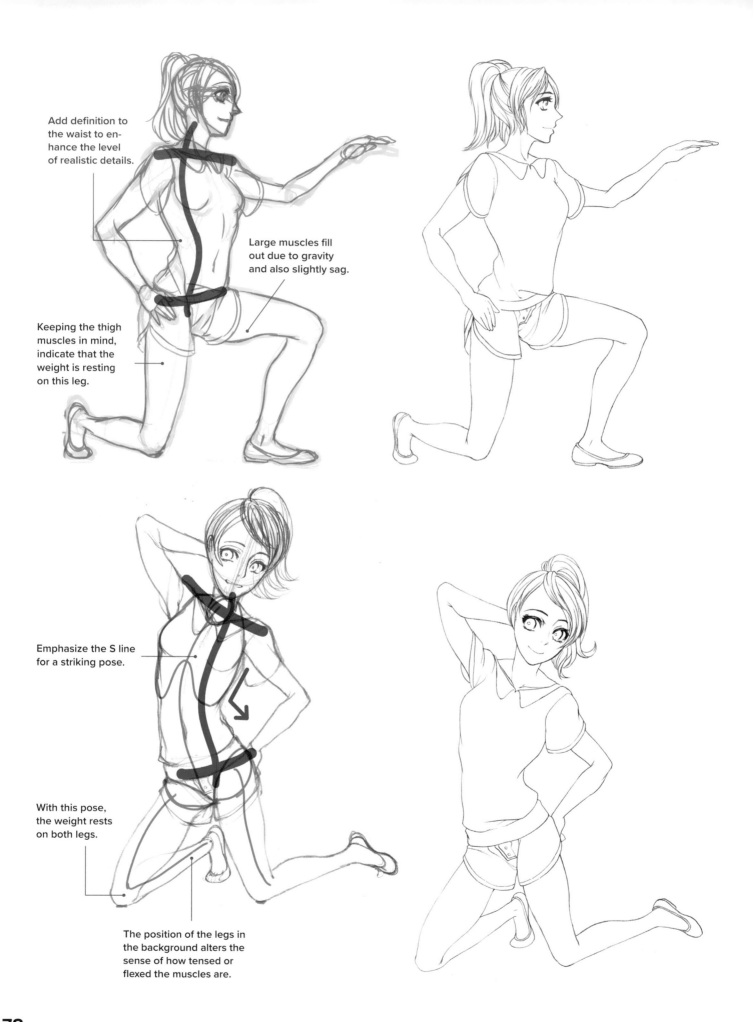

Add definition to the waist to enhance the level of realistic details.

Large muscles fill out due to gravity and also slightly sag.

Keeping the thigh muscles in mind, indicate that the weight is resting on this leg.

Emphasize the S line for a striking pose.

With this pose, the weight rests on both legs.

The position of the legs in the background alters the sense of how tensed or flexed the muscles are.

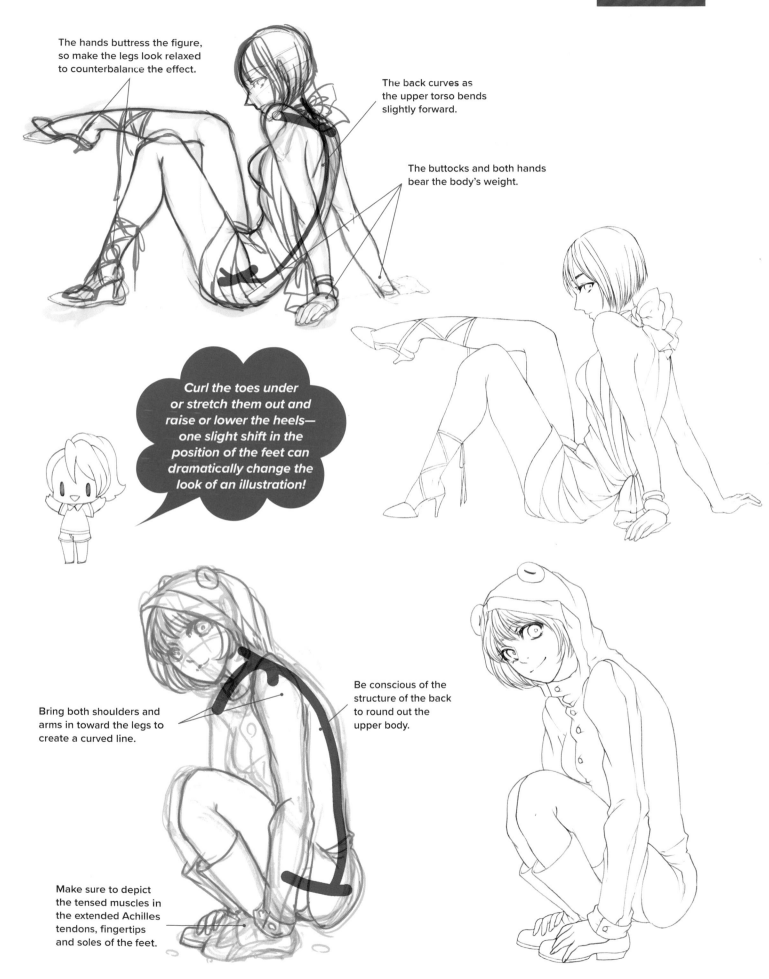

The hands buttress the figure, so make the legs look relaxed to counterbalance the effect.

The back curves as the upper torso bends slightly forward.

The buttocks and both hands bear the body's weight.

Curl the toes under or stretch them out and raise or lower the heels— one slight shift in the position of the feet can dramatically change the look of an illustration!

Bring both shoulders and arms in toward the legs to create a curved line.

Be conscious of the structure of the back to round out the upper body.

Make sure to depict the tensed muscles in the extended Achilles tendons, fingertips and soles of the feet.

02

Drawing a Figure Sitting on a Chair

For figures sitting in chairs, it's important to take note of the body parts that are in contact with the chair.

The Basics of Sitting Upright

Correctly depict the position of the buttocks in contact with the seat and the position of the back, wrists and soles of the feet so as not to lose the center of gravity.

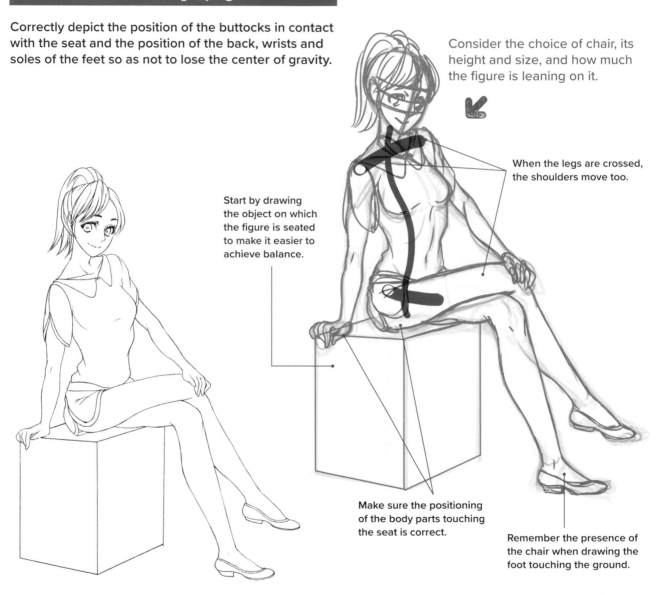

Consider the choice of chair, its height and size, and how much the figure is leaning on it.

When the legs are crossed, the shoulders move too.

Start by drawing the object on which the figure is seated to make it easier to achieve balance.

Make sure the positioning of the body parts touching the seat is correct.

Remember the presence of the chair when drawing the foot touching the ground.

The Chair's Part of the Illustration Too

Feet look completely different depending on whether they're resting on a chair or extended away from it. Be conscious of the muscles. Regardless of how much you distort the figure, if you don't pay attention to the feet, you won't be able to accurately capture a motion-based pose.

Variations on the Pose

When drawing an upright seated pose where the figure is holding one leg, starting with the thighs makes it easier to achieve balance. For a pose in which the figure is leaning on the backrest of a chair, make the back arched with the chest protruding forward.

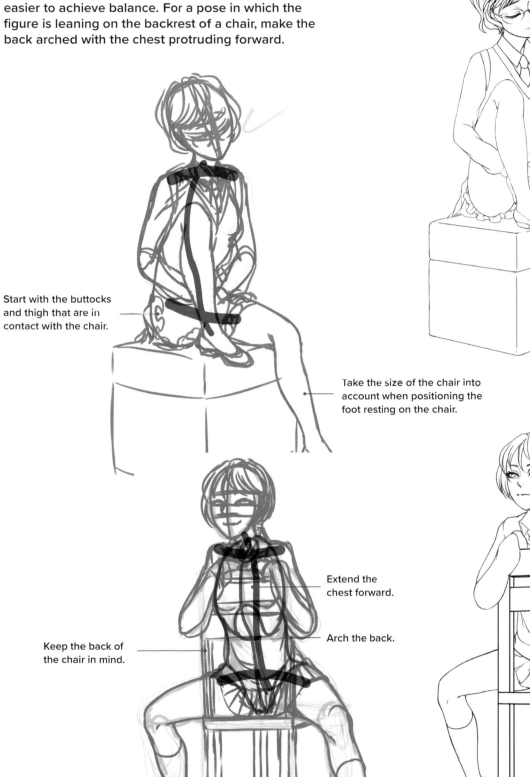

Start with the buttocks and thigh that are in contact with the chair.

Take the size of the chair into account when positioning the foot resting on the chair.

Extend the chest forward.

Arch the back.

Keep the back of the chair in mind.

The position of the chest and the arch of the back determine where the foot will rest on the floor.

When drawing a figure sitting on stairs, the positioning of the knees and hips is important, while the key point to depicting a figure with elbows resting on the knees is the raised shoulders. If the figure is stretching while seated, indicate this by arching the back and showing the underside of the chin.

Follow the curve from the side of the buttocks to the inward turn of the knee.

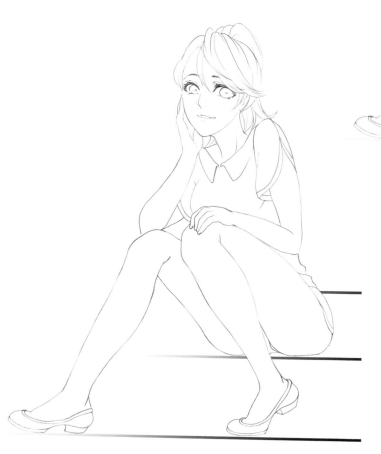

Be aware of the different height levels present.

Also be aware of the buttocks resting on the horizontal surface.

Expert Tip

The bend in the knees

For a pose seated on stairs or a low chair, the knees can nearly touch the chest. Note where the buttocks come in contact with the chair to determine the position of the knees, so the end result doesn't look unnatural.

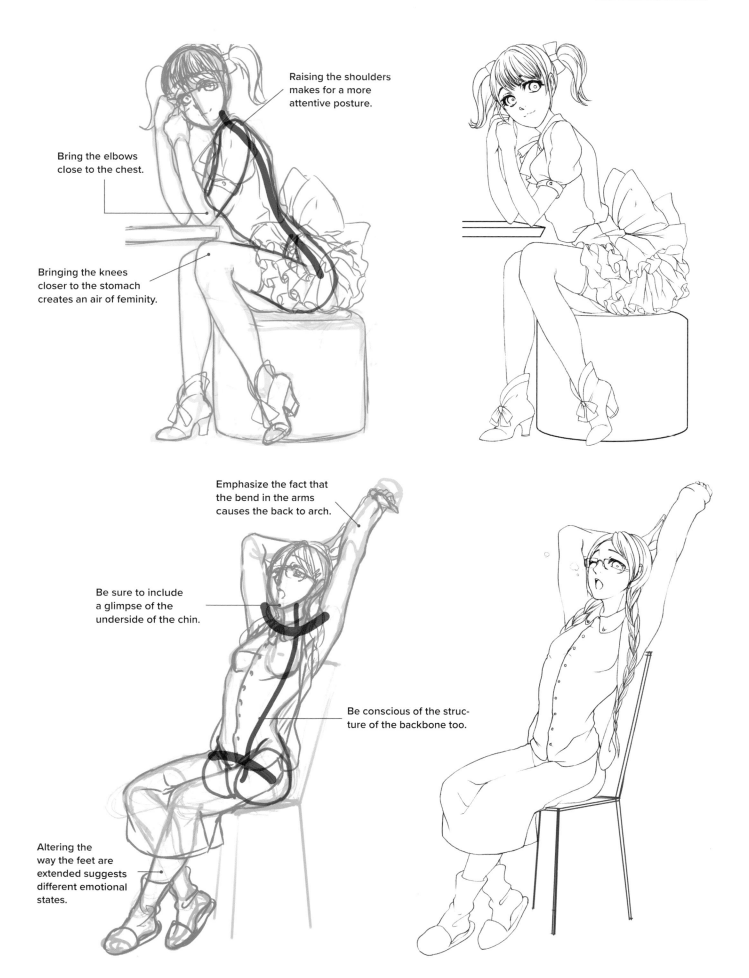

Raising the shoulders makes for a more attentive posture.

Bring the elbows close to the chest.

Bringing the knees closer to the stomach creates an air of feminity.

Emphasize the fact that the bend in the arms causes the back to arch.

Be sure to include a glimpse of the underside of the chin.

Be conscious of the structure of the backbone too.

Altering the way the feet are extended suggests different emotional states.

03 | Drawing a Crouching Figure

As a crouching movement involves the rounding of the entire body, perspective becomes especially important.

Viewed from the Front

The position of the head, shoulders and knees is important. Round the shoulders, bring the upper arms into the front of the body and bring the elbows and knees together to indicate the curving of the back.

Bring the head and shoulders closer to the bend in the knee.

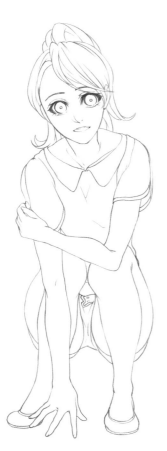

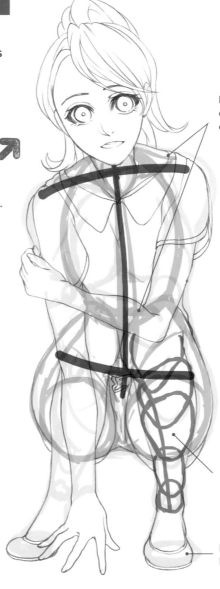

Raising the shoulders creates an attentive, eye-catching pose.

Keep the cylindrical forms of the legs in mind. Start by sketching in a rough sense of perspective to make it easier to proceed.

Don't forget that the heels are off the ground.

Applying Perspective

Think carefully about where to apply perspective before you start to draw. When depicting a crouching figure from the front, the legs require foreshortening, while it's not necessary for a figure viewed from the side. Think of the legs in terms of cylinders, making distant sections narrower and closer sections thicker.

Front

Side

Seen from the Side

For a crouching pose depicted from the side, think of the upper body and the thighs as ovals. When the body is on a diagonal, make sure to apply appropriate perspective to the thighs.

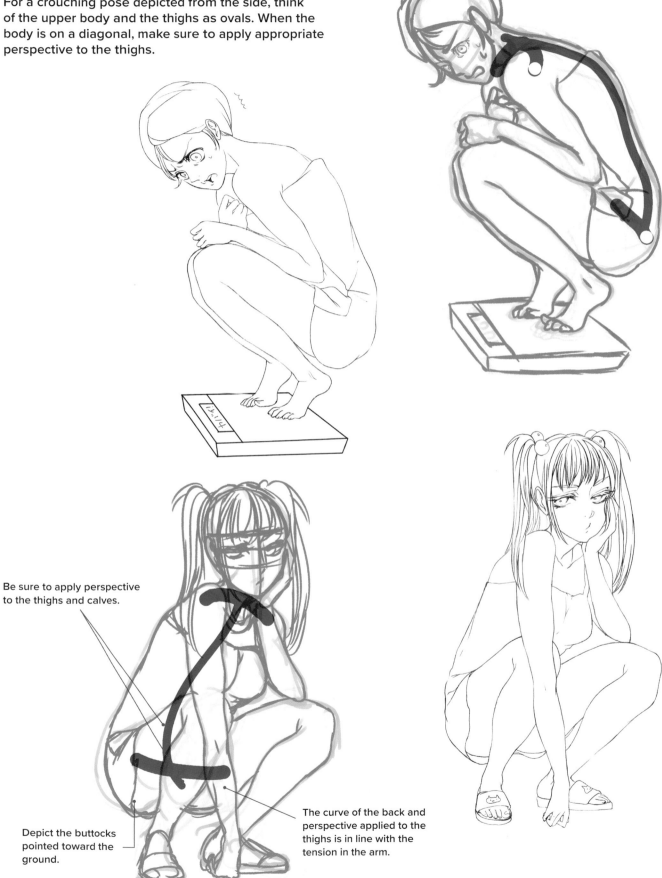

Be sure to apply perspective to the thighs and calves.

Depict the buttocks pointed toward the ground.

The curve of the back and perspective applied to the thighs is in line with the tension in the arm.

04

Drawing Two Seated Figures

Two closely seated figures increases the complexity and sense of balance the illustration requires.

One in Front of the Other

When drawing two figures sitting close, bring the centers of gravity together, while in the case of two figures leaning toward each other with separate centers of gravity, express distance in the way the knees entwine.

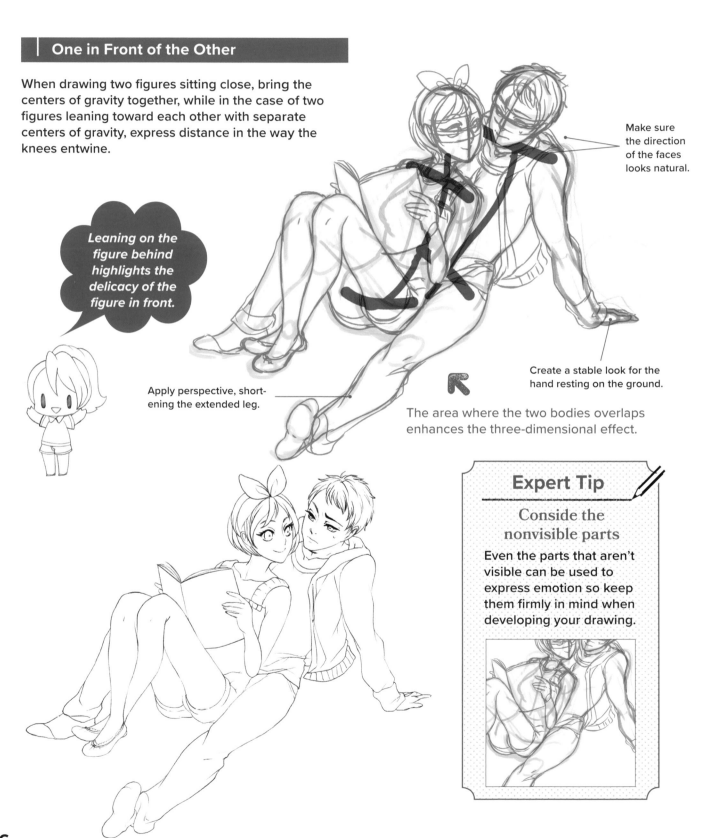

Leaning on the figure behind highlights the delicacy of the figure in front.

Apply perspective, shortening the extended leg.

Make sure the direction of the faces looks natural.

Create a stable look for the hand resting on the ground.

The area where the two bodies overlaps enhances the three-dimensional effect.

Expert Tip

Conside the nonvisible parts

Even the parts that aren't visible can be used to express emotion so keep them firmly in mind when developing your drawing.

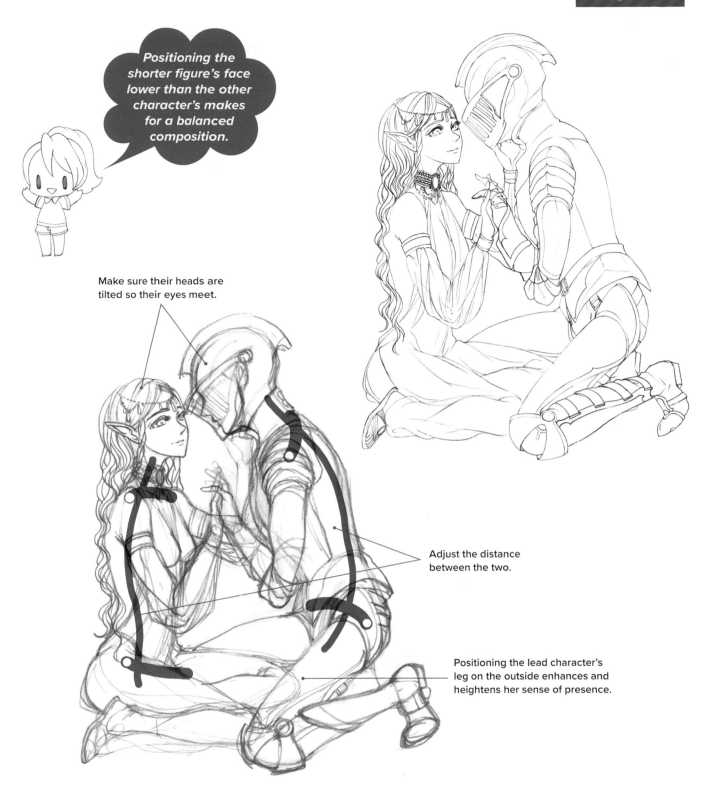

Positioning the shorter figure's face lower than the other character's makes for a balanced composition.

Make sure their heads are tilted so their eyes meet.

Adjust the distance between the two.

Positioning the lead character's leg on the outside enhances and heightens her sense of presence.

Distance Between Facing Figures

Distance is important in a scene in which two characters are interacting. Decide on the position of the torsos depending on the degree of closeness and draw the arms, faces and lower bodies in that order. Entwining the knees increases the degree of intimacy. Position the lead figure's knees on the outside.

Adult Cuddling a Child

When drawing two figures with different physiques, such as an adult and a child, think of the larger character as the chair and draw him or her first to make it easier to achieve a balanced illustration.

> *When drawing two figures close together, indicating areas that aren't visible makes the pose look more natural.*

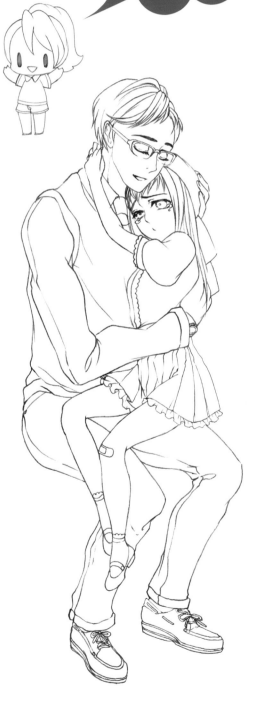

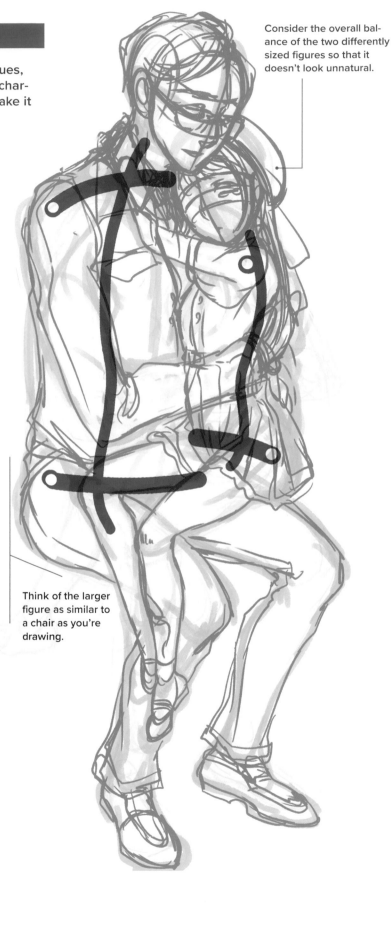

Consider the overall balance of the two differently sized figures so that it doesn't look unnatural.

Think of the larger figure as similar to a chair as you're drawing.

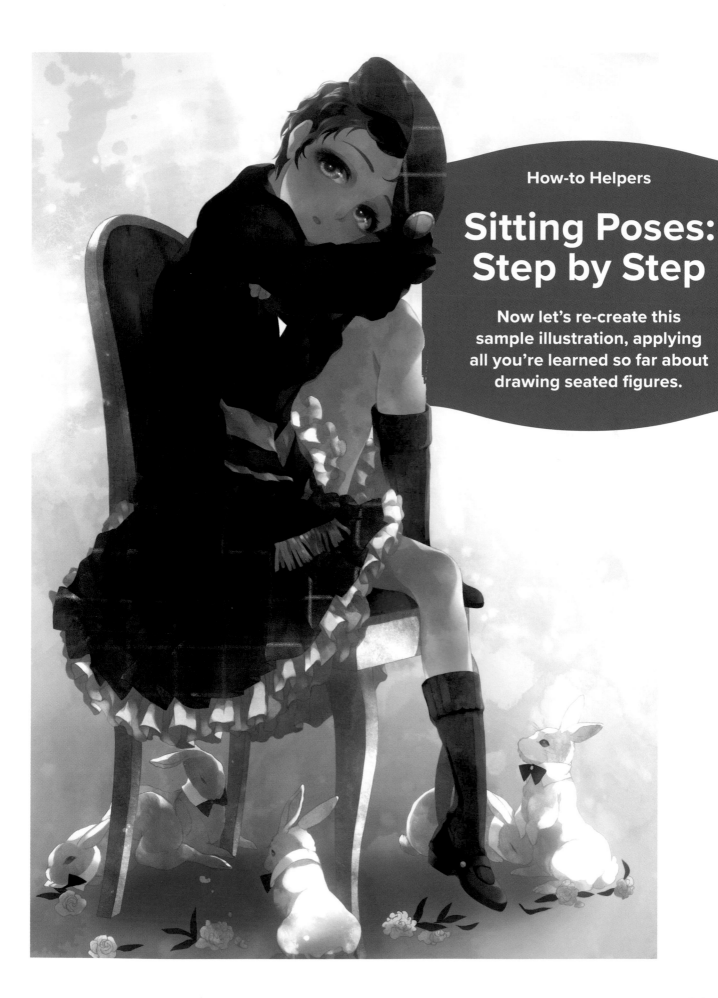

Sitting Poses: Step by Step

Now let's re-create this sample illustration, applying all you're learned so far about drawing seated figures.

Won't You Sit Down?

Perspective is important when depicting a sitting pose. At the rough draft stage, decide where the buttocks are in contrast to the seat surface, the position of the legs and how the clothing hangs.

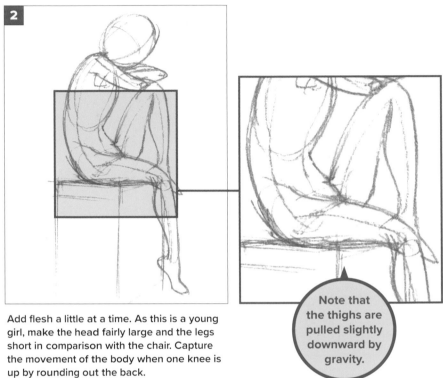

1

Roughly block-in the figure. First, draw the seat, then the buttocks (which are the center of gravity) and thighs. This makes it easier to achieve a balanced look.

2

Add flesh a little at a time. As this is a young girl, make the head fairly large and the legs short in comparison with the chair. Capture the movement of the body when one knee is up by rounding out the back.

> Note that the thighs are pulled slightly downward by gravity.

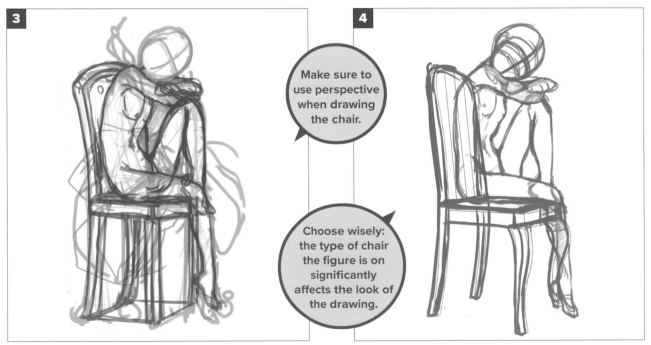

3

Scan the drawing and use your digital illustration program to decide on the overall composition.

> Make sure to use perspective when drawing the chair.

> Choose wisely: the type of chair the figure is on significantly affects the look of the drawing.

4

Correct the perspective as you refine your decision about the woman's clothing and the type of chair. Add antique details to the chair and block-in the ears and the jaw on the woman's face.

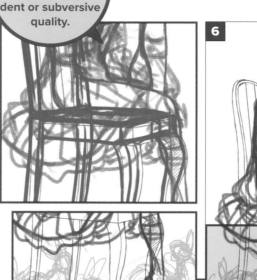

Sitting with her foot on her skirt gives the character an impudent or subversive quality.

5

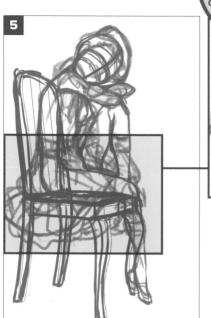

Consider how the how the outfit—a classic skirt with layers of petticoats complemented with a stole—will hang when the figure is seated on a chair.

6

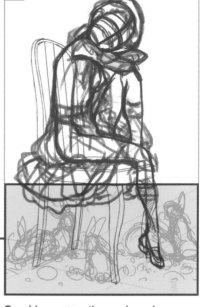

Consider perspective again and complete the form of the chair. Add rabbits around the base to add detail and depth to the image and play up the figure's appealing qualities.

7

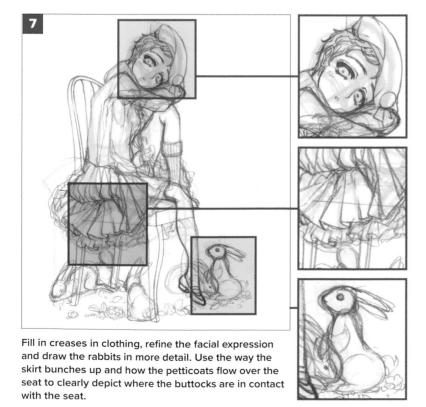

Fill in creases in clothing, refine the facial expression and draw the rabbits in more detail. Use the way the skirt bunches up and how the petticoats flow over the seat to clearly depict where the buttocks are in contact with the seat.

8

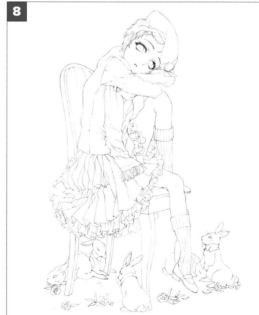

Adding fine details such as the creases in clothing is a chore, but do it as you make a clean copy to complete the draft.

Won't You Sit Down?

As the image is meant to show the figure with the sun behind her, keep this in mind as you apply color: consider the position of the light source and halation (when a fog forms on objects hit by strong light).

1

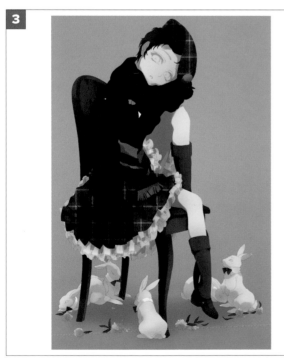

Roughly apply color. Applying color to the background as well makes it easier to visualize the entire image.

2

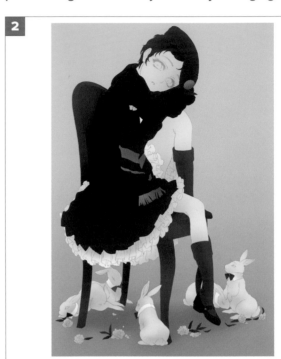

Keep the form of objects in mind, apply gradation to the entire drawing. Add shadow to the ground to make the position of the floor clearer.

3

Add a tartan check pattern to the skirt and hat. Think carefully of how the light is hitting the various objects in order to apply shadow.

A Little Advice

Defining Shadow

To bring depth and body to the drawing, one approach is using the outline search filter in Photoshop. This makes the edges of the shadows sharper, so the figure and clothing are more defined.

4

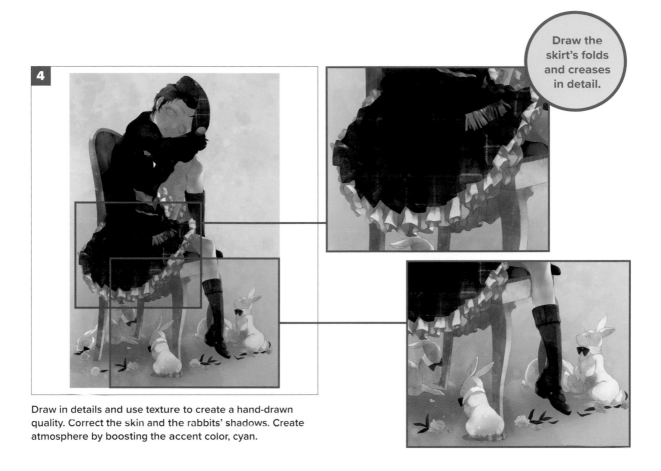

Draw the skirt's folds and creases in detail.

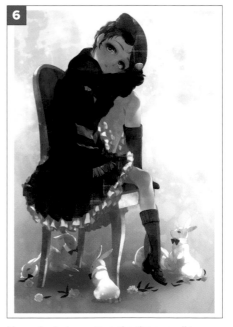

Draw in details and use texture to create a hand-drawn quality. Correct the skin and the rabbits' shadows. Create atmosphere by boosting the accent color, cyan.

5

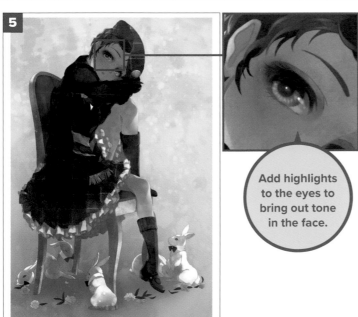

Add highlights to the eyes to bring out tone in the face.

Add brightness with a strong soft-focus brush. The shadows and the way light falls have been captured as envisioned, so once effects are added the image is complete.

6

Use color balance to make the overall tone more yellow. Add more details and adjust shadows and the shapes formed by light. The eyes are in shadow, so keep highlights to a minimum.

Drawing Creases in a Skirt

When drawing creases on a skirt, it helps to picture an upturned bowl.

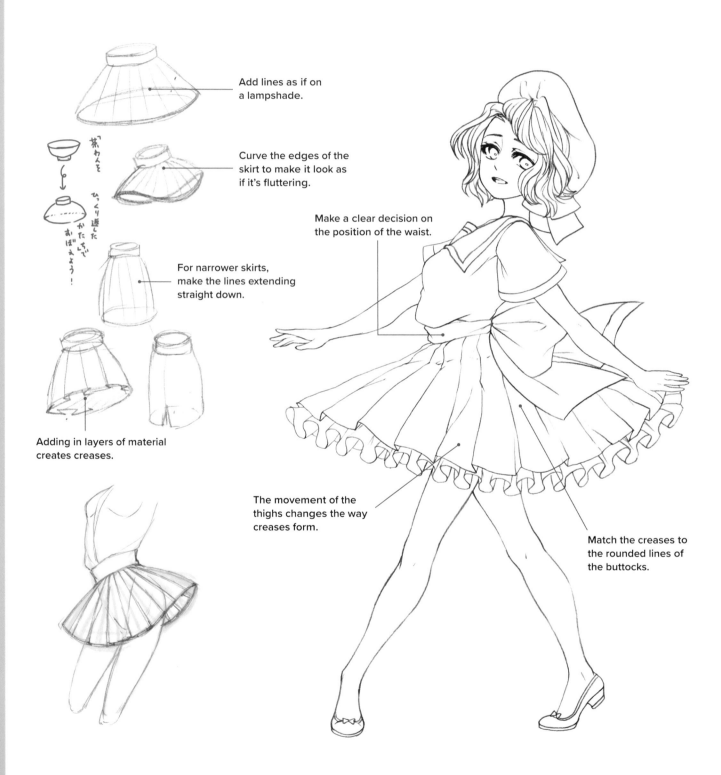

Add lines as if on a lampshade.

Curve the edges of the skirt to make it look as if it's fluttering.

Make a clear decision on the position of the waist.

For narrower skirts, make the lines extending straight down.

Adding in layers of material creates creases.

The movement of the thighs changes the way creases form.

Match the creases to the rounded lines of the buttocks.

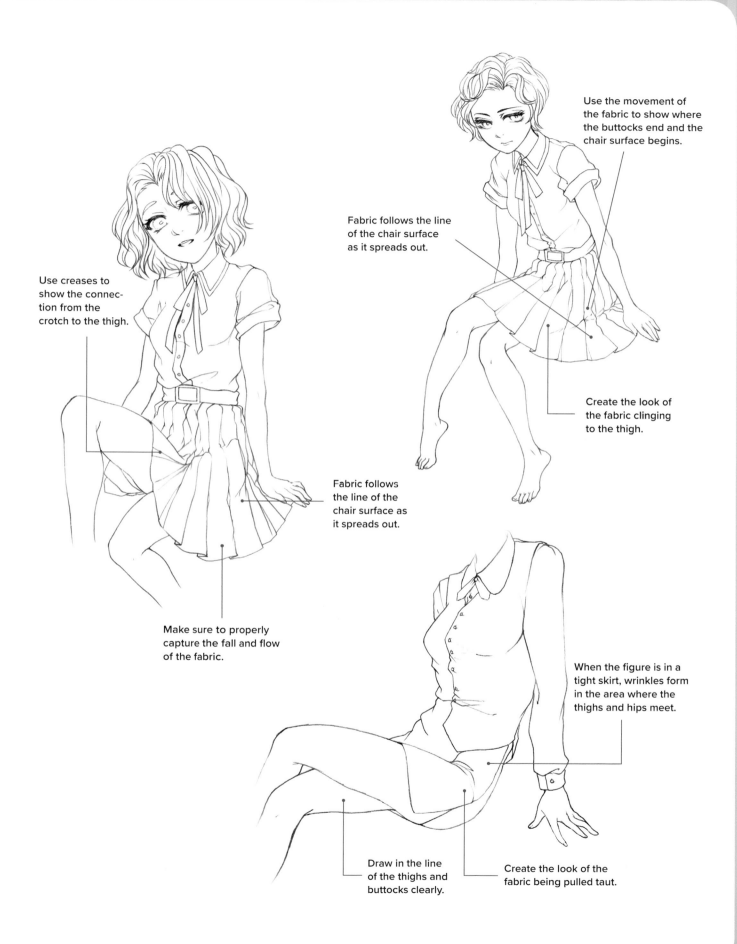

Use creases to
show the connec-
tion from the
crotch to the thigh.

Use the movement of
the fabric to show where
the buttocks end and the
chair surface begins.

Fabric follows the line
of the chair surface
as it spreads out.

Create the look of
the fabric clinging
to the thigh.

Fabric follows
the line of the
chair surface as
it spreads out.

Make sure to properly
capture the fall and flow
of the fabric.

When the figure is in a
tight skirt, wrinkles form
in the area where the
thighs and hips meet.

Draw in the line
of the thighs and
buttocks clearly.

Create the look of the
fabric being pulled taut.

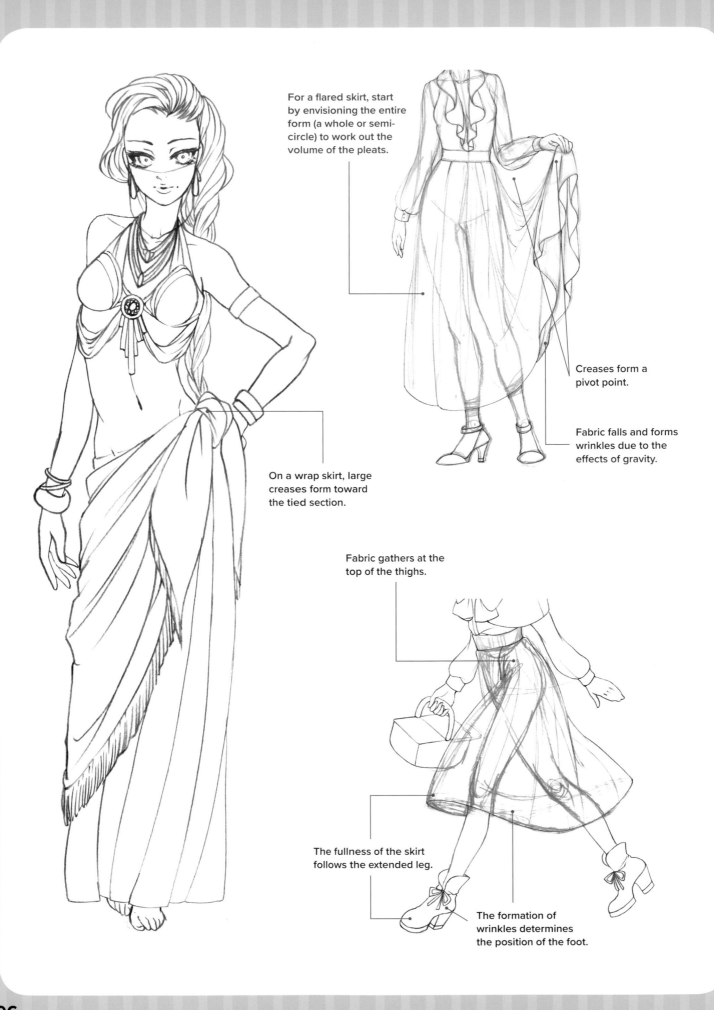

For a flared skirt, start by envisioning the entire form (a whole or semi-circle) to work out the volume of the pleats.

Creases form a pivot point.

Fabric falls and forms wrinkles due to the effects of gravity.

On a wrap skirt, large creases form toward the tied section.

Fabric gathers at the top of the thighs.

The fullness of the skirt follows the extended leg.

The formation of wrinkles determines the position of the foot.

Part

4

Reclining Poses:
The Basics

It's easy to capture a sense of playfulness or charm with a reclining or recumbent pose. Pay special attention to the flowing body line, creating clear definition all the way to the tips of the toes.

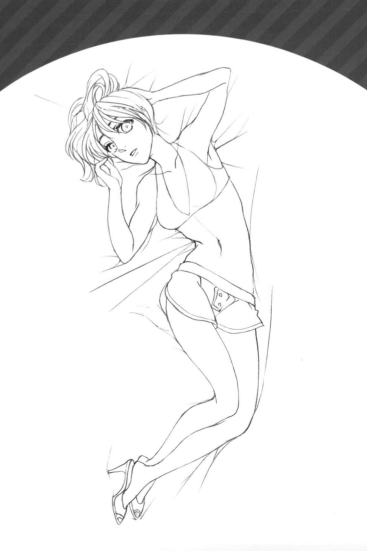

Drawing a Reclining Pose

Limbs are stretched out, the body relaxed and often twisted,
a great opportunity to practice contrapposto effects.

The Basics of Reclining Poses

When lying facing up, the back and buttocks touch the ground, while when lying face down, the arms and hips touch the ground to form the center of gravity. In either pose, large movements are not possible, and the only parts of the body that can be freely posed are the legs.

Mapping out simple perspective on the floor makes it easier to draw the body.

Reclining Check List

- ☐ Map out simple perspective before starting to draw.
- ☐ Create an attractive line along the side of the body (especially the shoulders and hips).
- ☐ Keep in mind the thickness of the torso and arms.
- ☐ Decide which parts of the body will touch the ground.

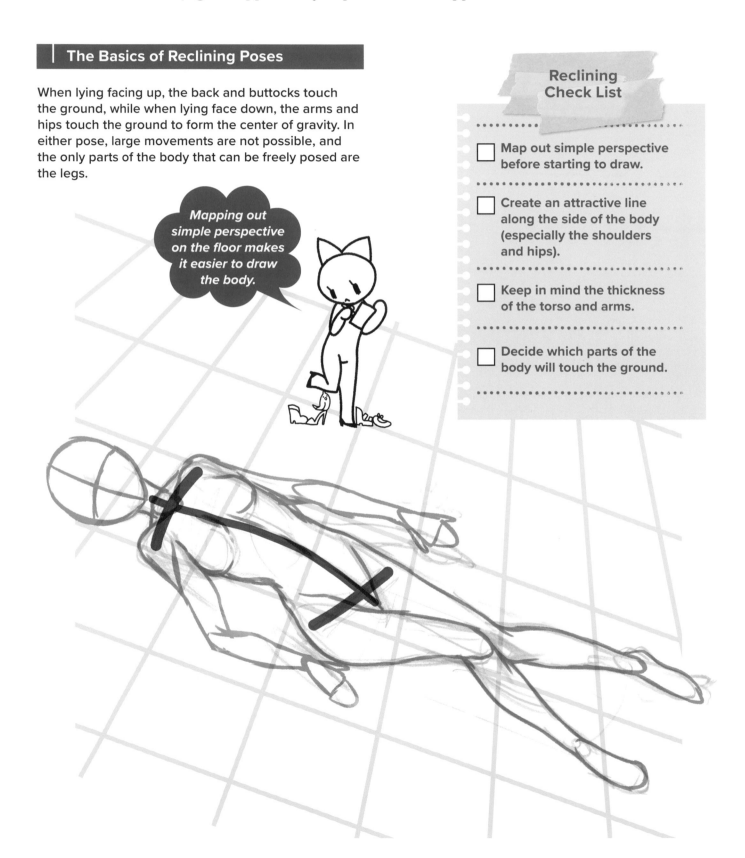

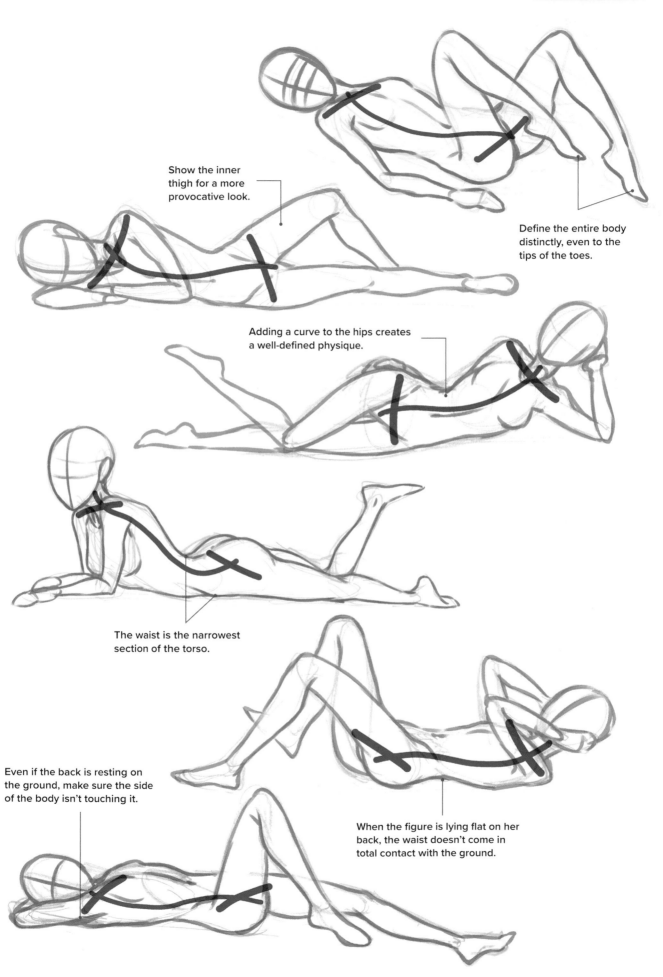

Show the inner thigh for a more provocative look.

Define the entire body distinctly, even to the tips of the toes.

Adding a curve to the hips creates a well-defined physique.

The waist is the narrowest section of the torso.

Even if the back is resting on the ground, make sure the side of the body isn't touching it.

When the figure is lying flat on her back, the waist doesn't come in total contact with the ground.

99

Warming Up

As you draw, consider the positions of the shoulders and arms are and how extended the legs should be.

Block-In the Figure

Once you've decided on the position of the ground, map out simple perspective. Then draw in the torso, being conscious of the back, buttocks and other parts that touch the floor and also deciding on the direction of the limbs. Finally, draw in the neck and head.

Think of the torso as an oval form to create the pose.

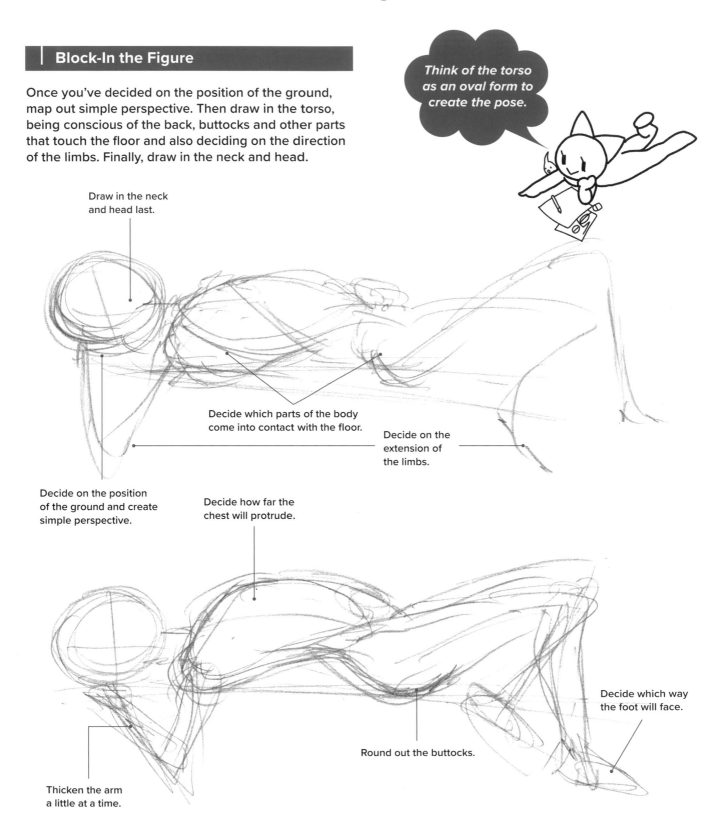

Draw in the neck and head last.

Decide which parts of the body come into contact with the floor.

Decide on the extension of the limbs.

Decide on the position of the ground and create simple perspective.

Decide how far the chest will protrude.

Decide which way the foot will face.

Round out the buttocks.

Thicken the arm a little at a time.

100

Flesh Out the Body

In a reclining pose, the depiction of the flesh determines the standard of the finished drawing, so understanding the form of the muscles and how they are structured will make it easier to draw. Make it a habit to check out the curve of the chest and body in photographs and advertisements.

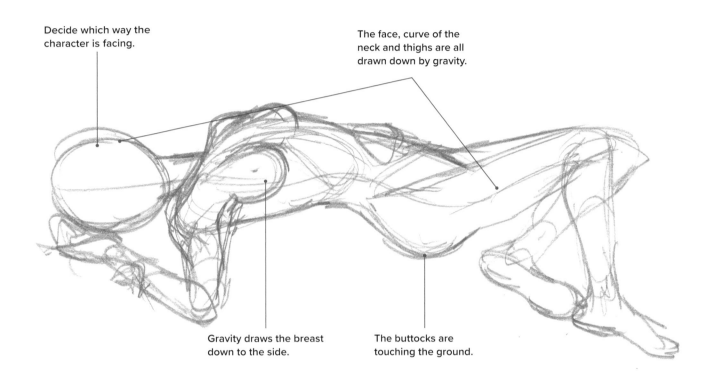

Decide which way the character is facing.

The face, curve of the neck and thighs are all drawn down by gravity.

Gravity draws the breast down to the side.

The buttocks are touching the ground.

Think of the Legs as Ovals

Once the torso has been formed from ovals, start drawing the legs. Here, too, the key is to think of the legs as being composed of a series of ovals. It's difficult to draw the silhouette of the legs from scratch, so start by blocking them in. Join the ovals of the thighs to those that form the calves to create well-balanced legs.

Add in Details

Once flesh has been added, decide on the form of the muscles, the position of the navel and the size of the joints and limbs and add them in. Then sketch in the finer details such as the face, hair, fingertips, clothing and shoes.

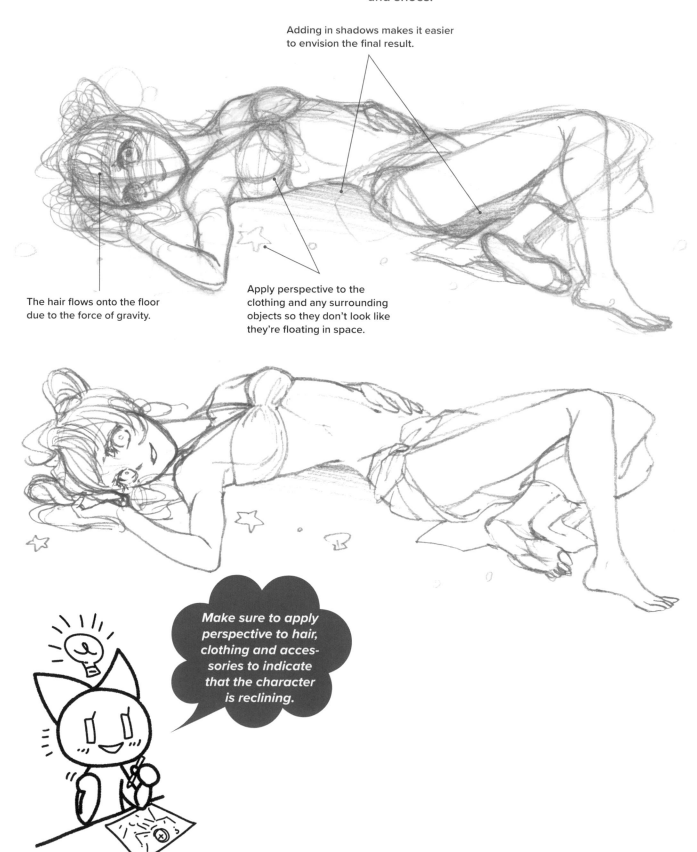

Adding in shadows makes it easier to envision the final result.

The hair flows onto the floor due to the force of gravity.

Apply perspective to the clothing and any surrounding objects so they don't look like they're floating in space.

Make sure to apply perspective to hair, clothing and accessories to indicate that the character is reclining.

Creating Variation

Reclining poses can be hard, even for professional artists. The shortcut to improving is to draw them over and over until you become accustomed to the perspective used. If you become confused while drawing, get into the pose yourself to check on the various movements of the body.

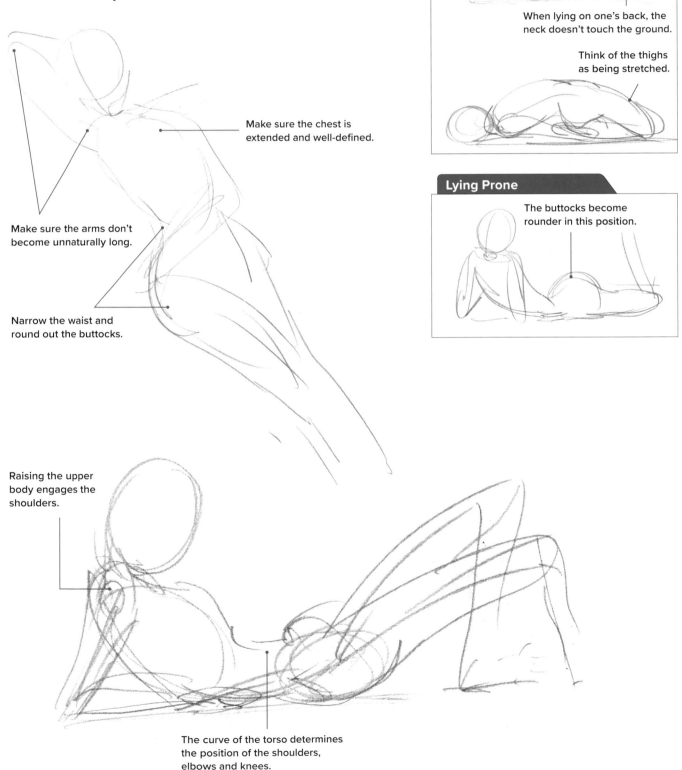

Make sure the chest is extended and well-defined.

Make sure the arms don't become unnaturally long.

Narrow the waist and round out the buttocks.

Raising the upper body engages the shoulders.

The curve of the torso determines the position of the shoulders, elbows and knees.

Lying Supine

When lying on one's back, the neck doesn't touch the ground.

Think of the thighs as being stretched.

Lying Prone

The buttocks become rounder in this position.

Drawing a Figure Lying Face Down

Creating dimension in the back and buttocks is essential to making a figure in a face-down pose look natural and appealing.

The Face-Down Basics

Think of the torso as a conical form, imagining the hidden areas (the sides, the tops of the hips) as you draw. Applying perspective so that parts toward the front are larger and those in the rear are smaller is key.

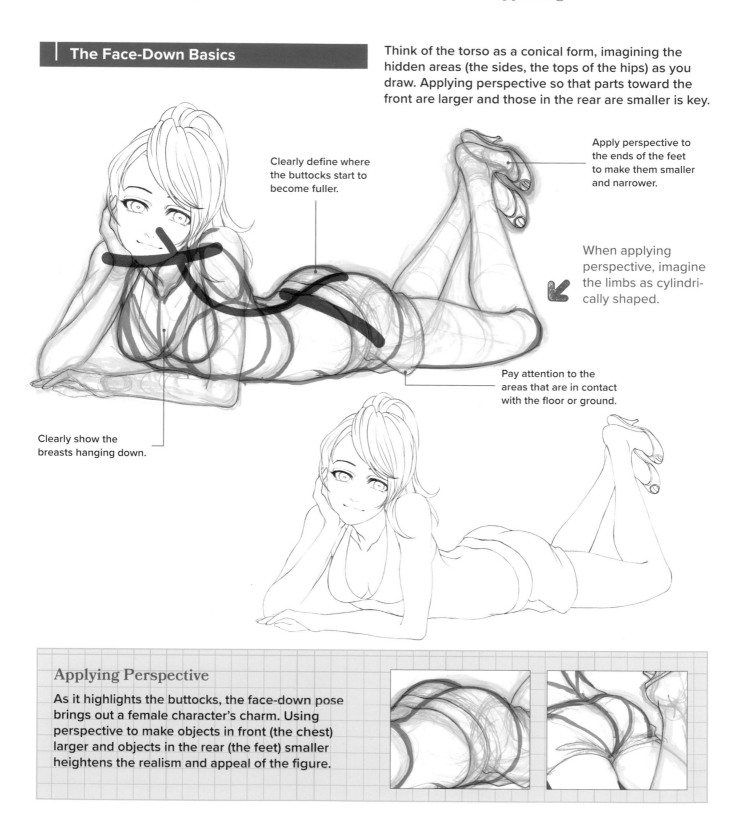

Clearly define where the buttocks start to become fuller.

Apply perspective to the ends of the feet to make them smaller and narrower.

When applying perspective, imagine the limbs as cylindrically shaped.

Pay attention to the areas that are in contact with the floor or ground.

Clearly show the breasts hanging down.

Applying Perspective

As it highlights the buttocks, the face-down pose brings out a female character's charm. Using perspective to make objects in front (the chest) larger and objects in the rear (the feet) smaller heightens the realism and appeal of the figure.

Variations on the Pose

Using a diagonal overhead angle requires the use of perspective, so for a realistic look, think of the figure fitting into a box. When showing the figure directly from the side, keep in mind the parts of the body that are in direct contact with the ground.

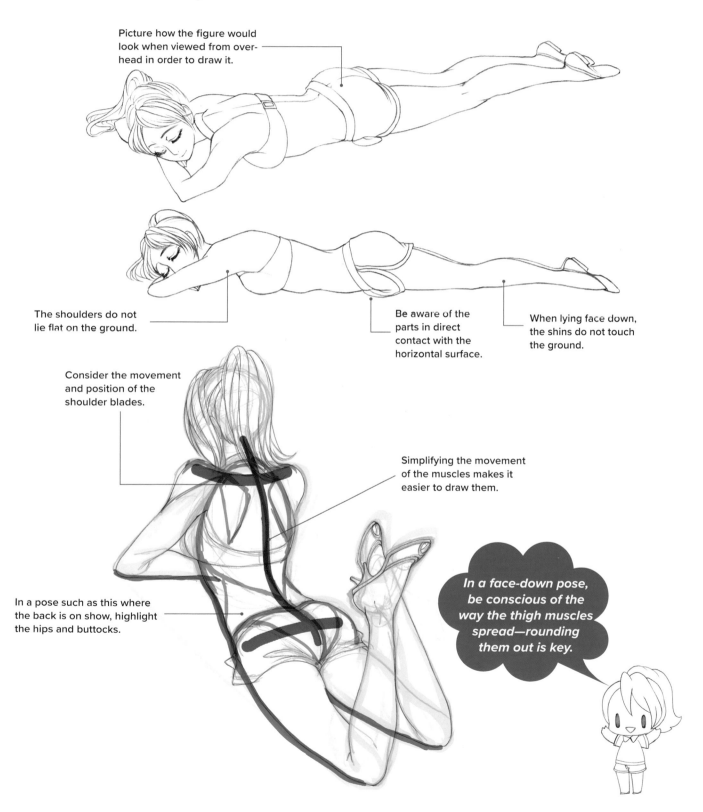

Picture how the figure would look when viewed from over-head in order to draw it.

The shoulders do not lie flat on the ground.

Be aware of the parts in direct contact with the horizontal surface.

When lying face down, the shins do not touch the ground.

Consider the movement and position of the shoulder blades.

Simplifying the movement of the muscles makes it easier to draw them.

In a pose such as this where the back is on show, highlight the hips and buttocks.

In a face-down pose, be conscious of the way the thigh muscles spread—rounding them out is key.

When drawing a pose with the buttocks raised, there's a tendency for the line of the back and the balance of the limbs to appear unnatural. In a pose where the upper torso is twisted, the position of the shoulders and elbows is important. Be aware of the structure of the back when creating the slightly rounded posture.

When the head touches the ground, the back is rounded.

Take care positioning the elbows and knees in relation to each other.

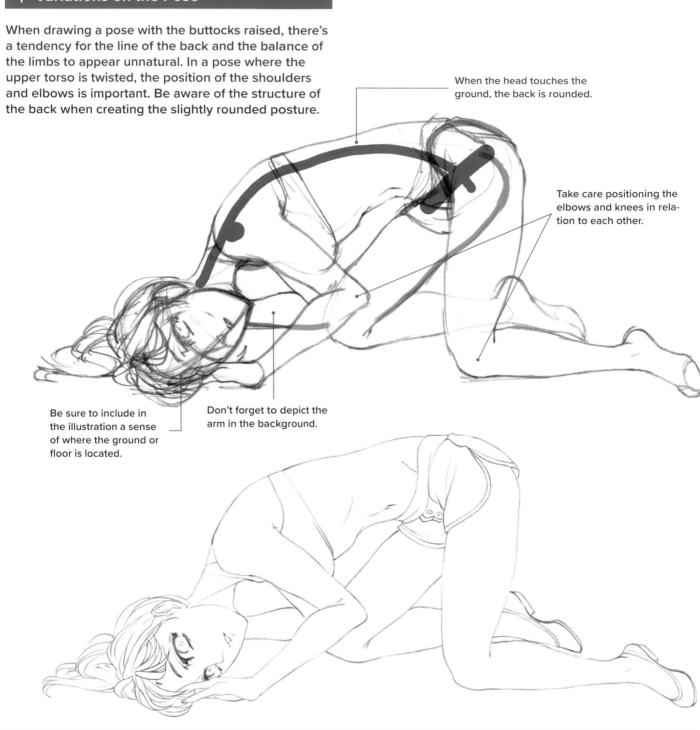

Be sure to include in the illustration a sense of where the ground or floor is located.

Don't forget to depict the arm in the background.

A Gourd-Like or Kidney Bean Shape

The sloping shoulders, narrow waist and round buttocks that characterize some women's bodies (well, in manga world anyway) can be likened to a gourd or a kidney bean. When drawing a pose where the back comes into play, such as a face-down pose, think of a gourd- or bean-shaped piece of clay as you draw.

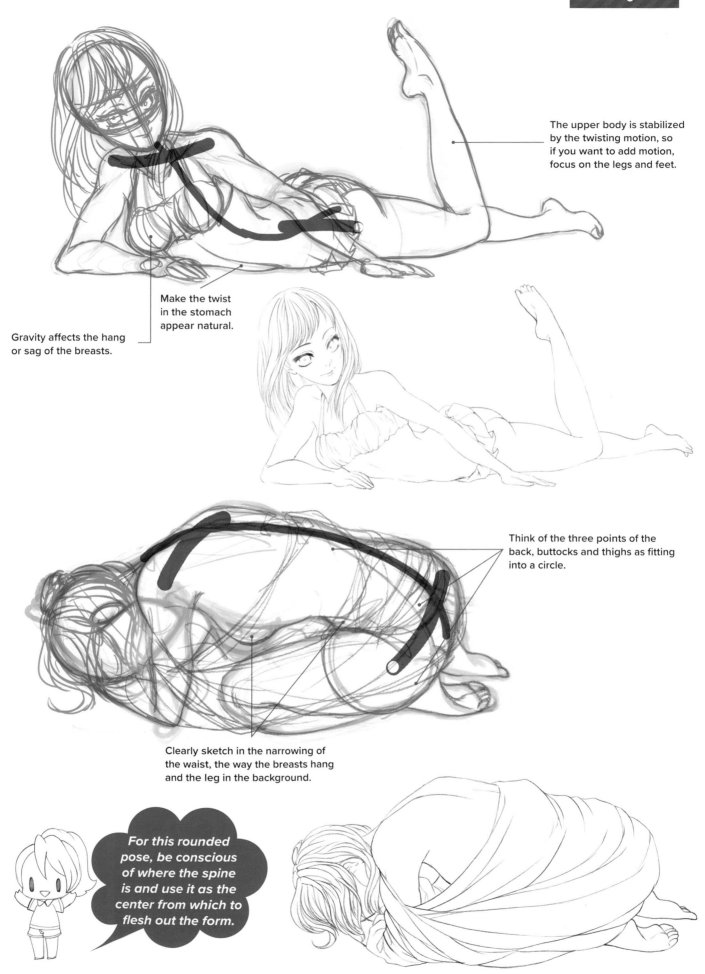

The upper body is stabilized by the twisting motion, so if you want to add motion, focus on the legs and feet.

Make the twist in the stomach appear natural.

Gravity affects the hang or sag of the breasts.

Think of the three points of the back, buttocks and thighs as fitting into a circle.

Clearly sketch in the narrowing of the waist, the way the breasts hang and the leg in the background.

For this rounded pose, be conscious of where the spine is and use it as the center from which to flesh out the form.

Drawing a Figure Lying on Her Back

Create a natural look for the parts touching the ground to to add an angular flow to a figure lying face up.

The depiction of the back in these poses can considerably alter the overall impression created by the drawing. If emphasizing the gracefulness of the pose, arch the back and push the chest out.

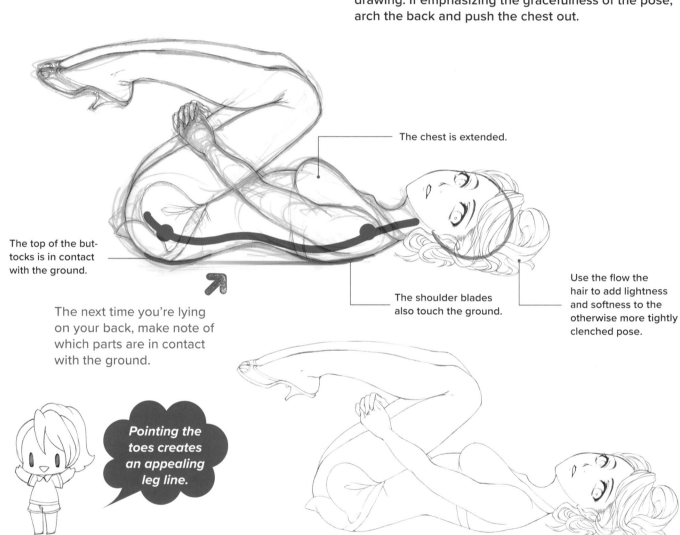

The chest is extended.

The top of the buttocks is in contact with the ground.

The shoulder blades also touch the ground.

Use the flow the hair to add lightness and softness to the otherwise more tightly clenched pose.

The next time you're lying on your back, make note of which parts are in contact with the ground.

Pointing the toes creates an appealing leg line.

Extend the Chest

To create a successful reclining pose, create a gap between the hips and ground. In reality, this is a difficult posture, but it is effective for creating a balanced pose that engages the muscles. Conversely, when drawing a relaxed pose, have the hips directly touching the ground to show tension has been released.

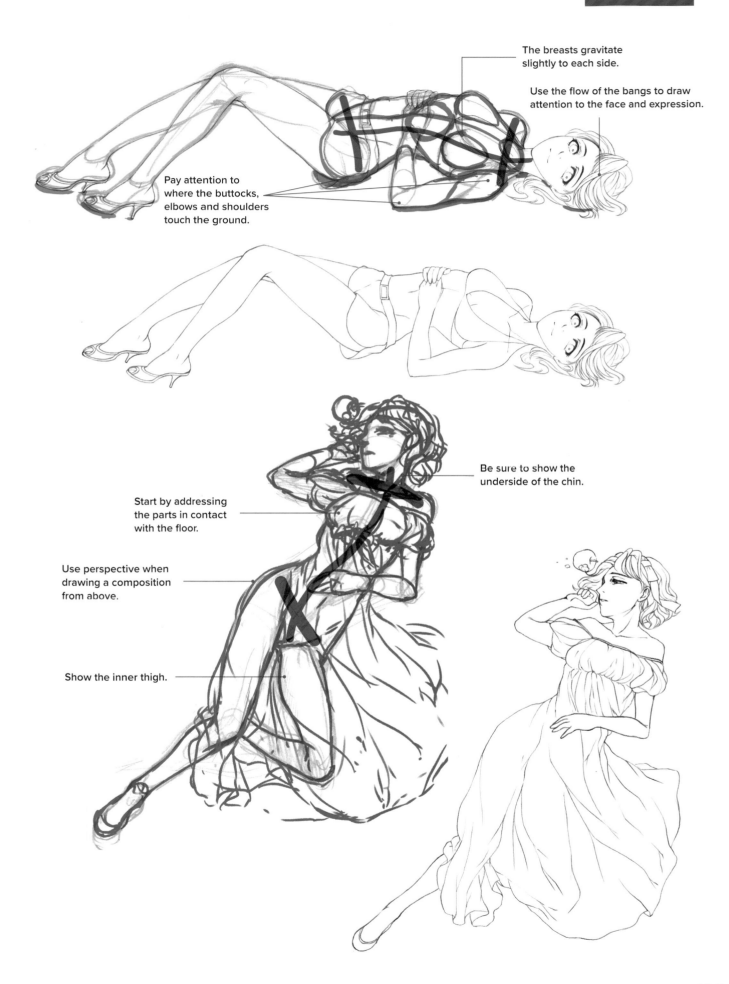

The breasts gravitate slightly to each side.

Use the flow of the bangs to draw attention to the face and expression.

Pay attention to where the buttocks, elbows and shoulders touch the ground.

Be sure to show the underside of the chin.

Start by addressing the parts in contact with the floor.

Use perspective when drawing a composition from above.

Show the inner thigh.

109

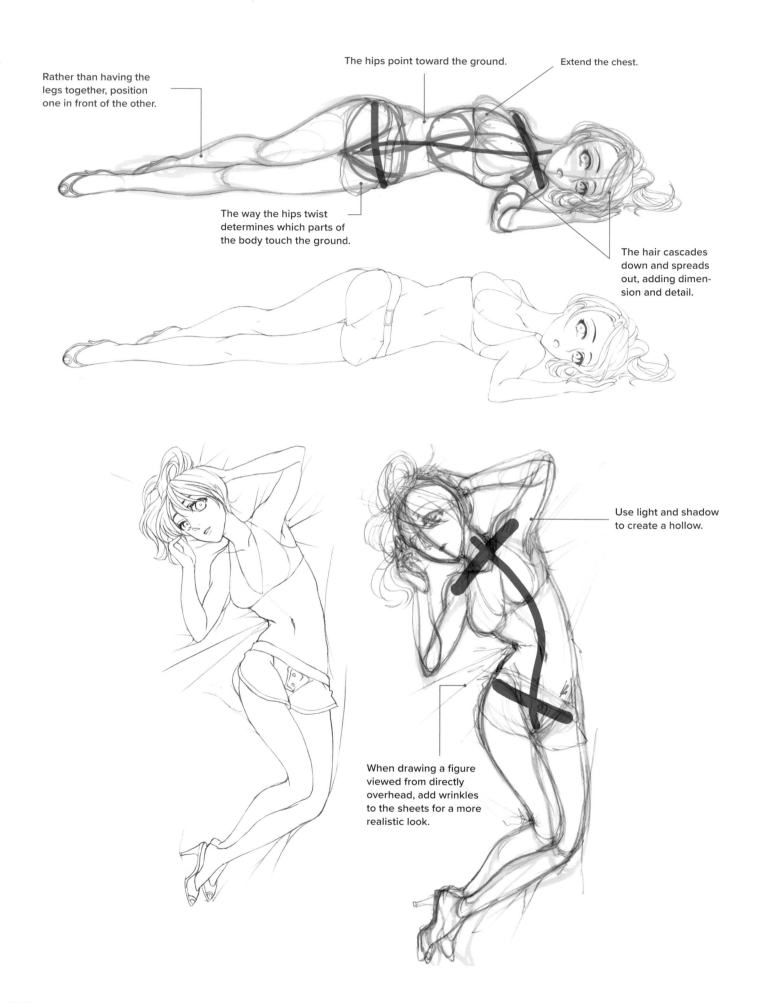

Rather than having the legs together, position one in front of the other.

The hips point toward the ground.

Extend the chest.

The way the hips twist determines which parts of the body touch the ground.

The hair cascades down and spreads out, adding dimension and detail.

Use light and shadow to create a hollow.

When drawing a figure viewed from directly overhead, add wrinkles to the sheets for a more realistic look.

110

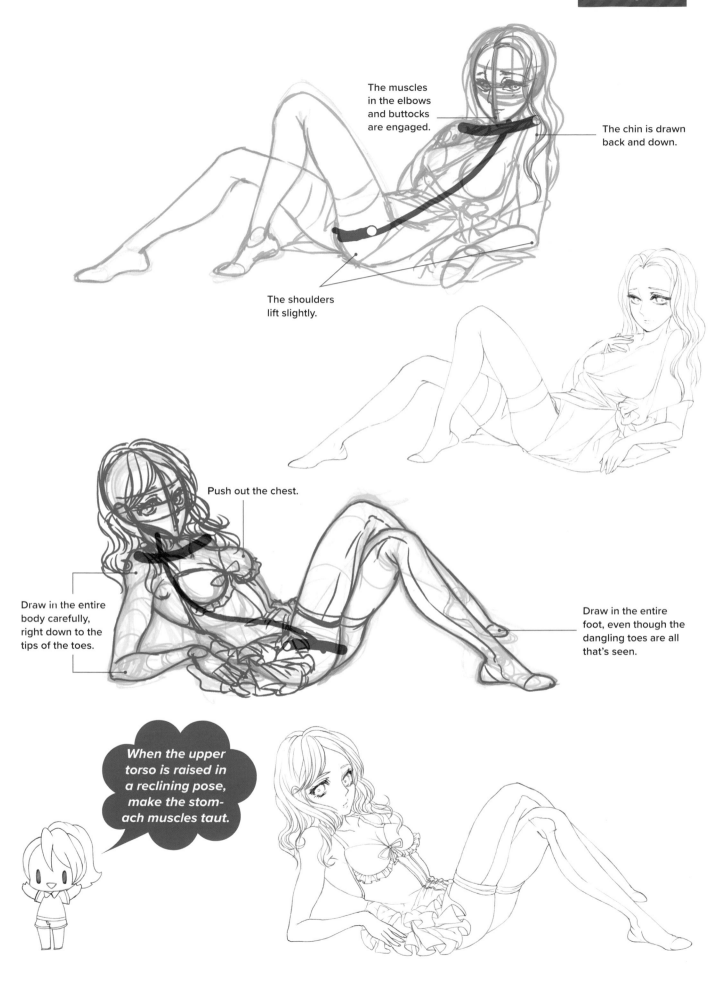

The muscles in the elbows and buttocks are engaged.

The chin is drawn back and down.

The shoulders lift slightly.

Push out the chest.

Draw in the entire body carefully, right down to the tips of the toes.

Draw in the entire foot, even though the dangling toes are all that's seen.

When the upper torso is raised in a reclining pose, make the stomach muscles taut.

Semi-Reclining, Facing Right

When the face is looking to the right in a semi-reclining pose, the left elbow and left hip are engaged. Raising the upper body naturally causes the hip to lift, creating a leisurely air.

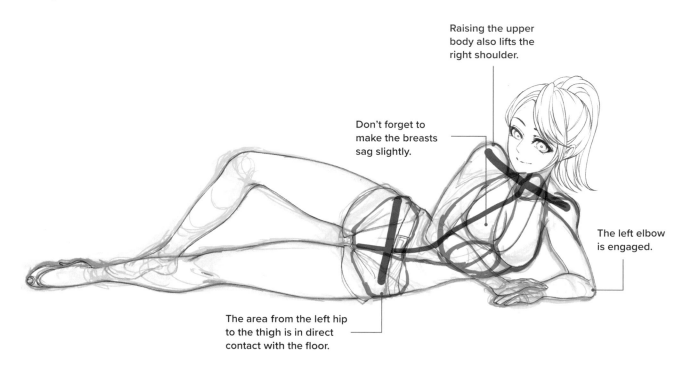

Raising the upper body also lifts the right shoulder.

Don't forget to make the breasts sag slightly.

The left elbow is engaged.

The area from the left hip to the thigh is in direct contact with the floor.

Remember that the tilt of the pelvis changes the look of the legs.

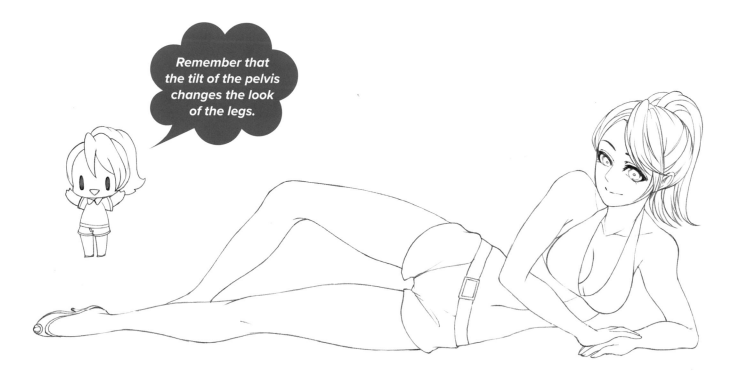

Semi-Reclining, Facing Left

When the face is looking to the left in a semi-reclining pose, the right elbow and right hip are engaged. Resting the head on one hand and having both legs together suggests that the character is taking a nap.

When drawing both thighs drawn together, extend or direct the upper leg slightly forward.

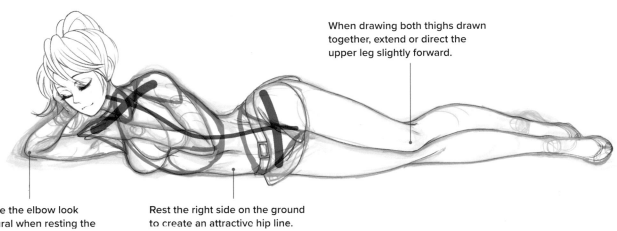

Make the elbow look natural when resting the head on the hand.

Rest the right side on the ground to create an attractive hip line.

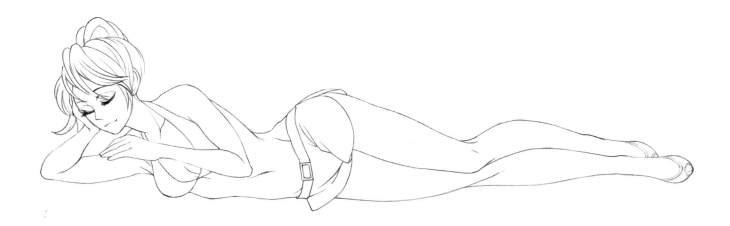

Imagine the Silhouette

In this pose, the arm is supporting the upper body, so take care when drawing the shape of the shoulder. Additionally, be aware of the silhouette when drawing the section from shoulder to hip in order to create the rounding and curves of a female form. The more contrast, the more attractive the physique.

03

Drawing a Glamour Pose

Fashion-influenced illustrations call for pronounced, not-so-everyday poses meant to grab a viewer's attention.

The Glamour-Shot Basics

To bring out the beauty of the form, be bold when drawing the chest, narrow waist and the rounding of the buttocks. In an illustration, overexaggeration can sometimes create just the right look.

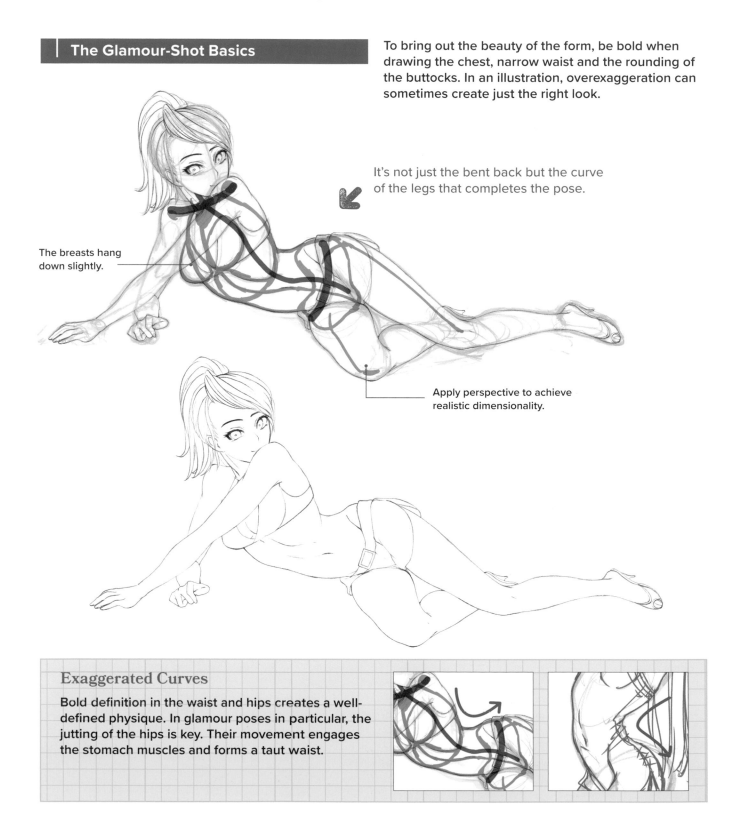

It's not just the bent back but the curve of the legs that completes the pose.

The breasts hang down slightly.

Apply perspective to achieve realistic dimensionality.

Exaggerated Curves

Bold definition in the waist and hips creates a well-defined physique. In glamour poses in particular, the jutting of the hips is key. Their movement engages the stomach muscles and forms a taut waist.

Variations on the Pose 1

When drawing a figure on all fours, take care that the length of the arms and thighs is balanced. For a pose involving bent arms, make sure that the back and buttocks create a fluid line.

Expert Tip

A narrow waist

For a figure on all fours, arch the back to emphasize the fullness of the buttocks and to create a narrowing at the waist if it's a slim-figured look you're after.

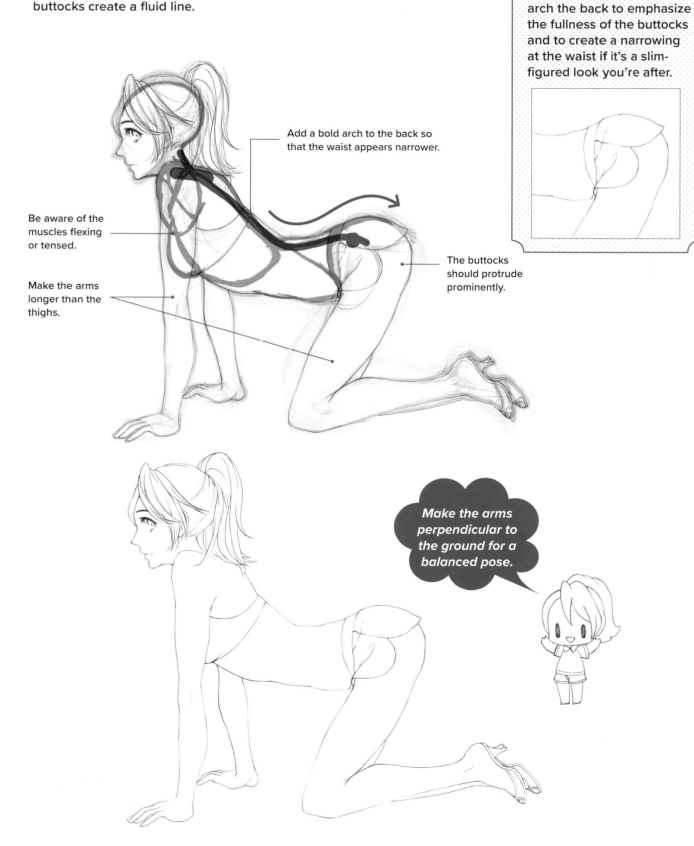

Add a bold arch to the back so that the waist appears narrower.

Be aware of the muscles flexing or tensed.

Make the arms longer than the thighs.

The buttocks should protrude prominently.

Make the arms perpendicular to the ground for a balanced pose.

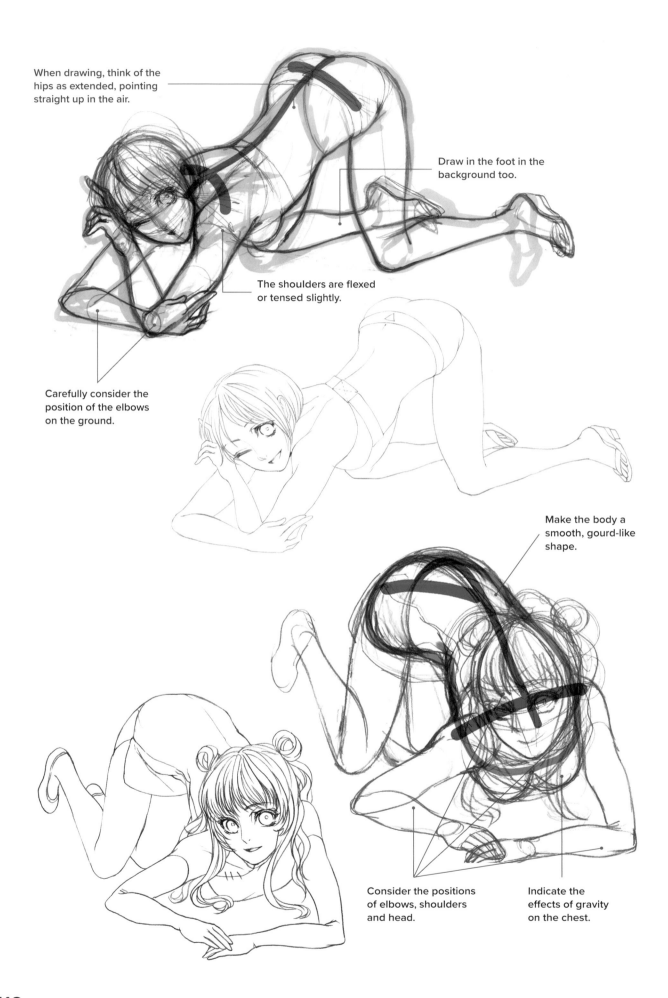

When drawing, think of the hips as extended, pointing straight up in the air.

Draw in the foot in the background too.

The shoulders are flexed or tensed slightly.

Carefully consider the position of the elbows on the ground.

Make the body a smooth, gourd-like shape.

Consider the positions of elbows, shoulders and head.

Indicate the effects of gravity on the chest.

Variations on the Pose 2

For a standing pose, raise the heels to show off the legs. Think of the body as forming an S line with the upper thighs close together and the hips and knees bent to create an appealing look.

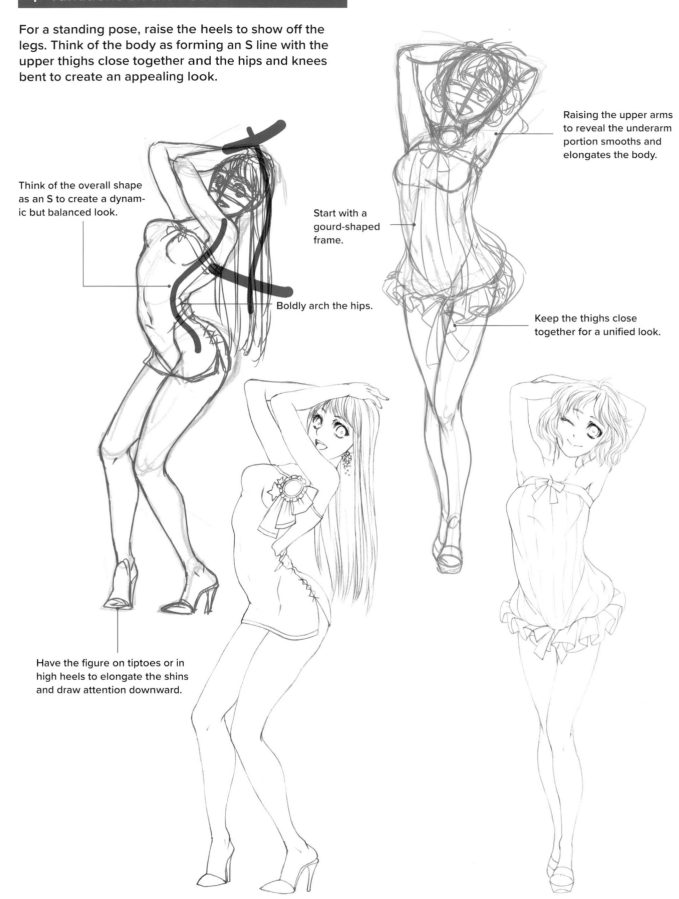

Think of the overall shape as an S to create a dynamic but balanced look.

Raising the upper arms to reveal the underarm portion smooths and elongates the body.

Start with a gourd-shaped frame.

Boldly arch the hips.

Keep the thighs close together for a unified look.

Have the figure on tiptoes or in high heels to elongate the shins and draw attention downward.

04 | Drawing Two Reclining Figures

In scenes where two reclining figures are interacting, the positioning of the limbs can significantly alter the impression created.

The Double Reclining Basics

This pose combines a figure on all fours with one lying on her back. Take care to balance the arms and thighs of the figure on top and to arch the back and push out the chest of the figure below.

When drawing two sets of interlocking legs, it's easiest to start with the feet and work your way up.

Expert Tip

Layered legs

Take note of the legs of the figure on top. If they're placed on the outside, they'll dominate the illustration and block the figure on bottom. Having the lower character's legs on the outside adds a framing and balancing effect.

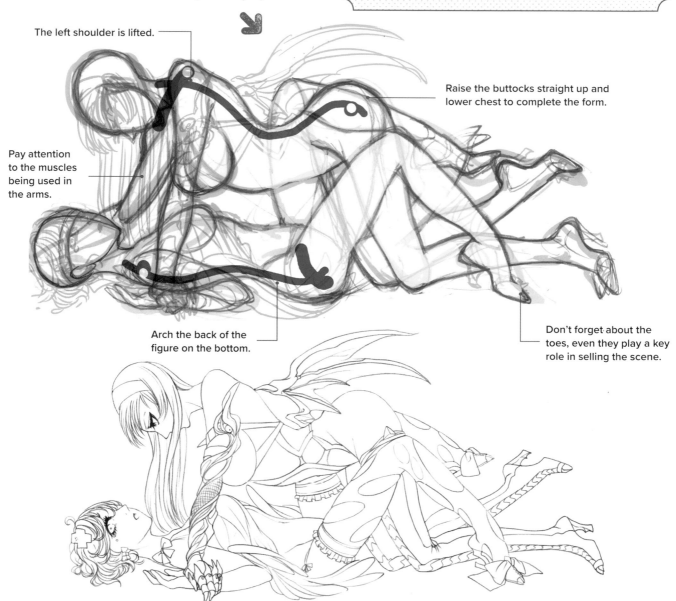

The left shoulder is lifted.

Pay attention to the muscles being used in the arms.

Raise the buttocks straight up and lower chest to complete the form.

Arch the back of the figure on the bottom.

Don't forget about the toes, even they play a key role in selling the scene.

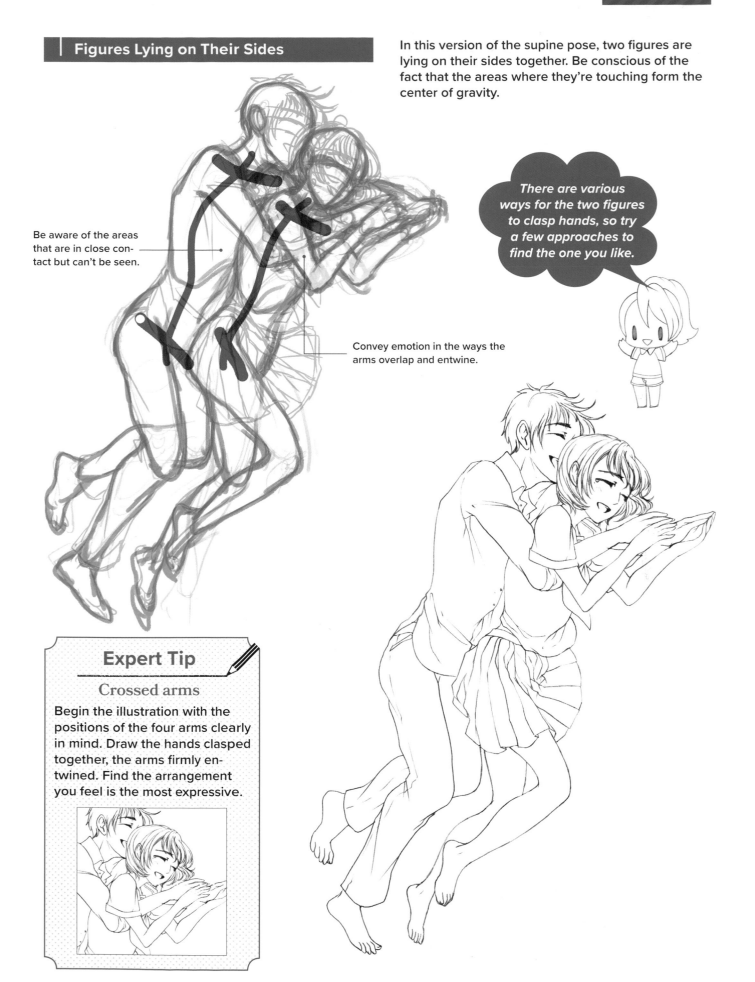

Figures Lying on Their Sides

In this version of the supine pose, two figures are lying on their sides together. Be conscious of the fact that the areas where they're touching form the center of gravity.

Be aware of the areas that are in close contact but can't be seen.

Convey emotion in the ways the arms overlap and entwine.

There are various ways for the two figures to clasp hands, so try a few approaches to find the one you like.

Expert Tip

Crossed arms

Begin the illustration with the positions of the four arms clearly in mind. Draw the hands clasped together, the arms firmly entwined. Find the arrangement you feel is the most expressive.

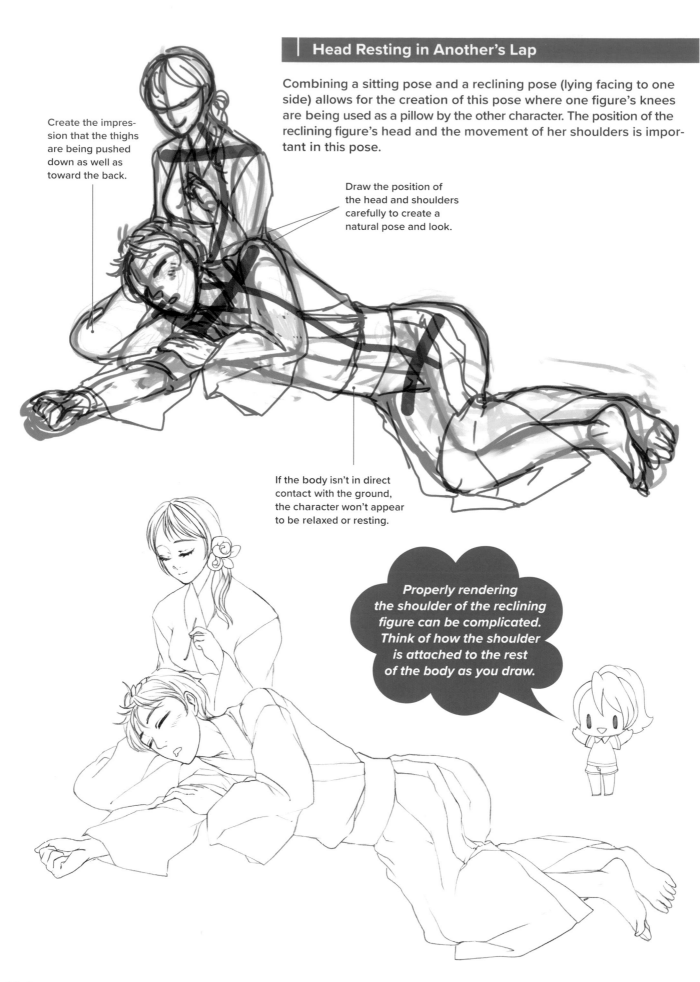

Head Resting in Another's Lap

Combining a sitting pose and a reclining pose (lying facing to one side) allows for the creation of this pose where one figure's knees are being used as a pillow by the other character. The position of the reclining figure's head and the movement of her shoulders is important in this pose.

Create the impression that the thighs are being pushed down as well as toward the back.

Draw the position of the head and shoulders carefully to create a natural pose and look.

If the body isn't in direct contact with the ground, the character won't appear to be relaxed or resting.

Properly rendering the shoulder of the reclining figure can be complicated. Think of how the shoulder is attached to the rest of the body as you draw.

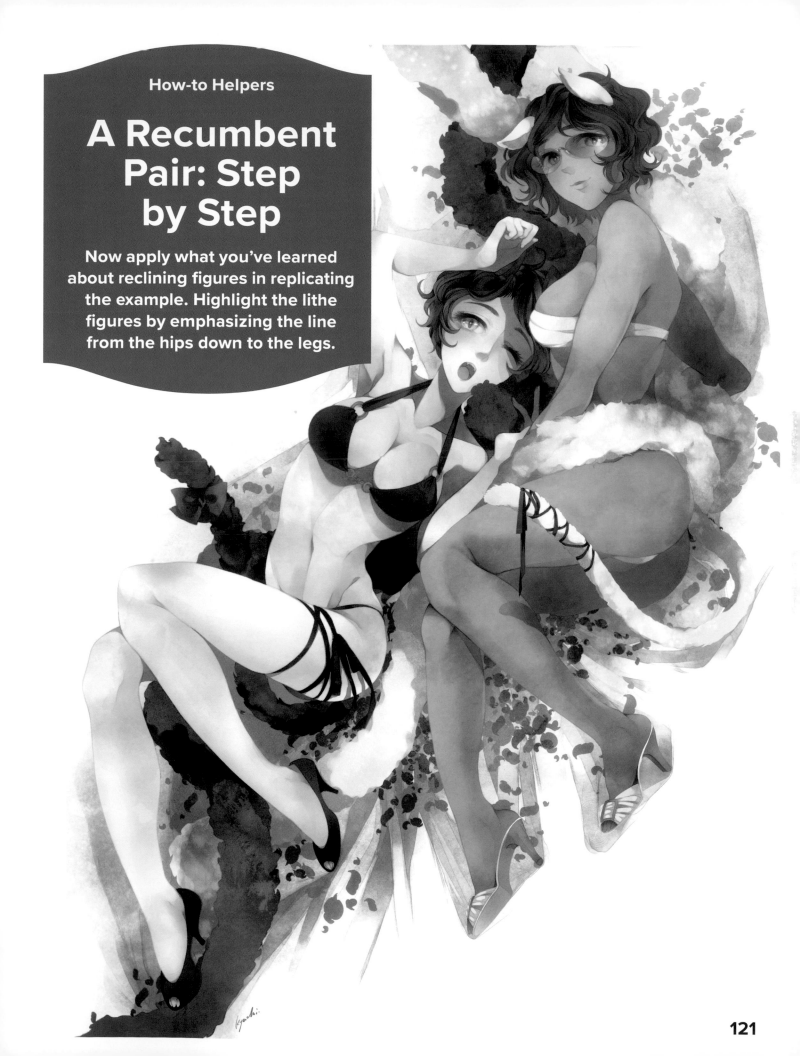

A Recumbent Pair: Step by Step

Now apply what you've learned about reclining figures in replicating the example. Highlight the lithe figures by emphasizing the line from the hips down to the legs.

Figures at Rest

The perspective being applied must be the same for both figures in this illustration. Refer to fashion photography to make elements such as the curve of the back and the position of the limbs appear natural.

1

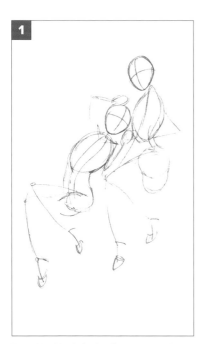

Roughly block-in the figures. Don't focus on the finer points at this stage. As long as you capture the main points, simply draw them as you like.

2

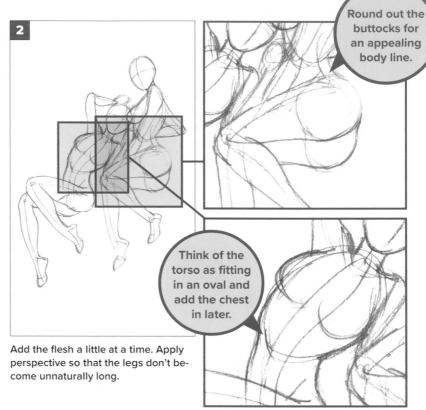

Round out the buttocks for an appealing body line.

Think of the torso as fitting in an oval and add the chest in later.

Add the flesh a little at a time. Apply perspective so that the legs don't become unnaturally long.

Here's a composition that's been abandoned halfway through as the pose wasn't working. Aborted attempts happen all the time.

3

4

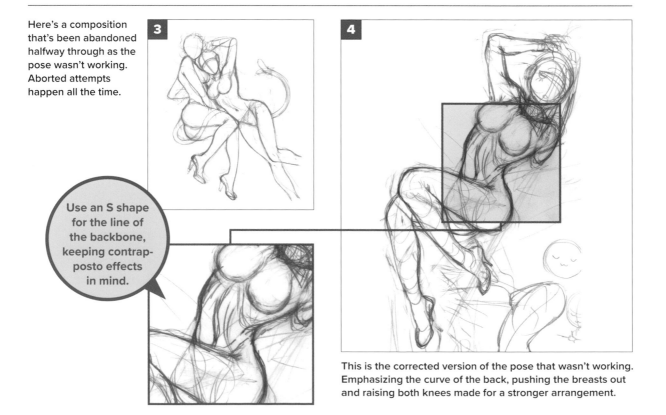

Use an S shape for the line of the backbone, keeping contrapposto effects in mind.

This is the corrected version of the pose that wasn't working. Emphasizing the curve of the back, pushing the breasts out and raising both knees made for a stronger arrangement.

5

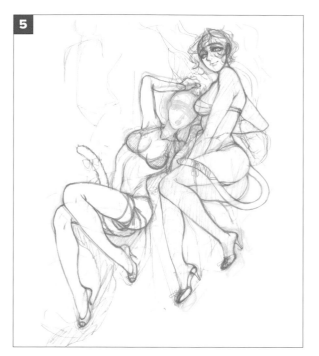

Here, the figure on the left in Step 3 has been reversed and combined with the figure drawn later. Draw in the facial expression of the character whose role you have decided on first.

6

If you can't decide on the facial expression for a character, draw several versions on a separate piece of paper until you're satisfied, then add it to the figure.

7

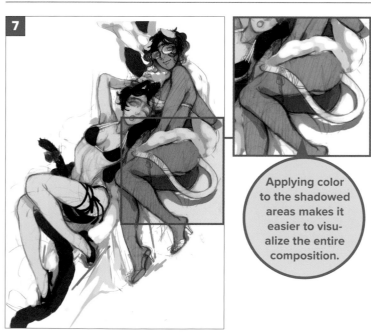

Applying color to the shadowed areas makes it easier to visualize the entire composition.

Scan the pencil drawing and start work on a computer. If you're not confident about drawing in the facial expression, make a rough colored version to clear up the characters' relationship and backstory in your mind.

8

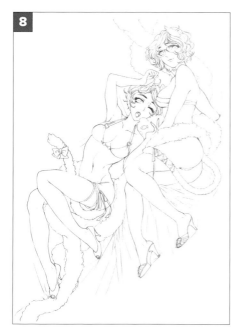

Adjust the facial expressions to complete the rough drawing.

Figures at Rest

When drawing a reclining pose, lack of proper perspective results in the figures appearing to float in the air. Be conscious of depth and overlap when adding color.

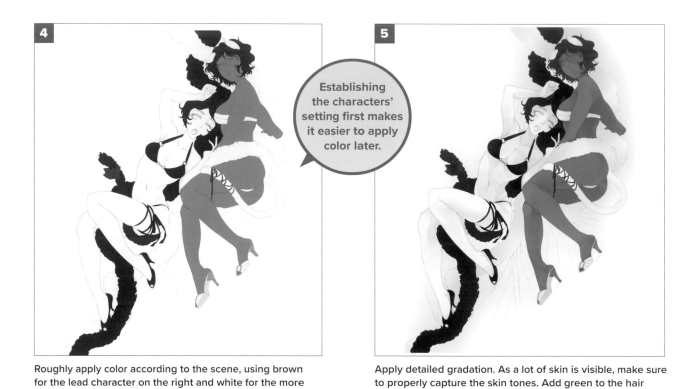

4

Establishing the characters' setting first makes it easier to apply color later.

5

Roughly apply color according to the scene, using brown for the lead character on the right and white for the more passive character on the left. Make the clothing a color that contrasts with each character's skin tone.

Apply detailed gradation. As a lot of skin is visible, make sure to properly capture the skin tones. Add green to the hair color to create gloss and bring out a mohair feel in the tail.

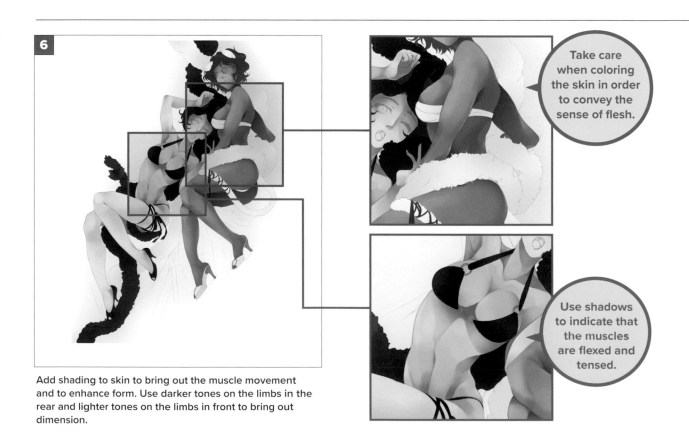

6

Take care when coloring the skin in order to convey the sense of flesh.

Use shadows to indicate that the muscles are flexed and tensed.

Add shading to skin to bring out the muscle movement and to enhance form. Use darker tones on the limbs in the rear and lighter tones on the limbs in front to bring out dimension.

7

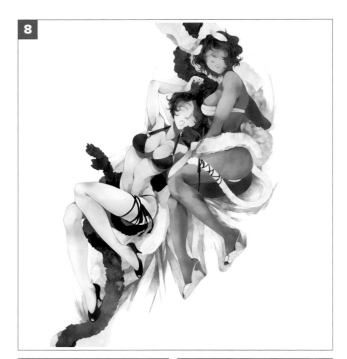

Add detail to the sheets by using a dark color to create a sense of texture where they're in contact with the figure. At this stage, apply texture overall to achieve a hand-drawn look.

8

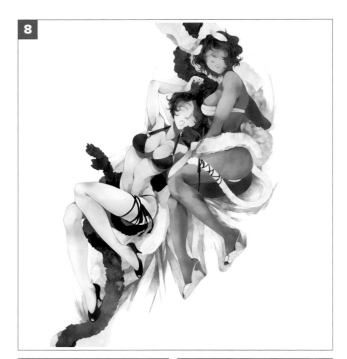

Add further shading detail to the sheets to boost texture. If you're not sure how they should be arranged, take a look at actual sheets to see how wrinkles and shadows form in them.

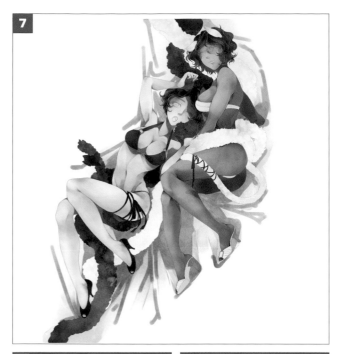

9

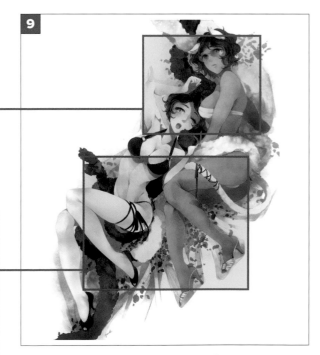

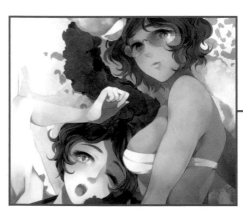

Don't worry about drawing the flowers in too much detail—creating a soft atmosphere is most important.

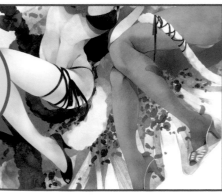

Draw in the eyes and mouth and scatter flowers over the illustration to complete it.

To the Soles of Her Shoes

Weight distribution, the center of gravity and the length of the stride and gait all change significantly depending on the type of shoe being worn and the height of the heel.

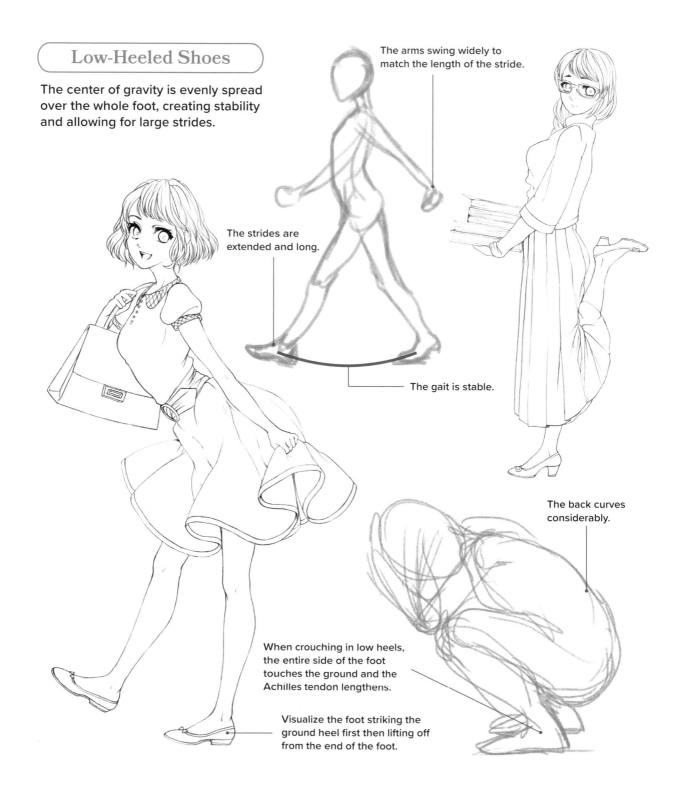

Low-Heeled Shoes

The center of gravity is evenly spread over the whole foot, creating stability and allowing for large strides.

The arms swing widely to match the length of the stride.

The strides are extended and long.

The gait is stable.

The back curves considerably.

When crouching in low heels, the entire side of the foot touches the ground and the Achilles tendon lengthens.

Visualize the foot striking the ground heel first then lifting off from the end of the foot.

High-Heeled Shoes

The center of gravity shifts to the front of the foot, creating a sense of instability and shortening the length of the stride.

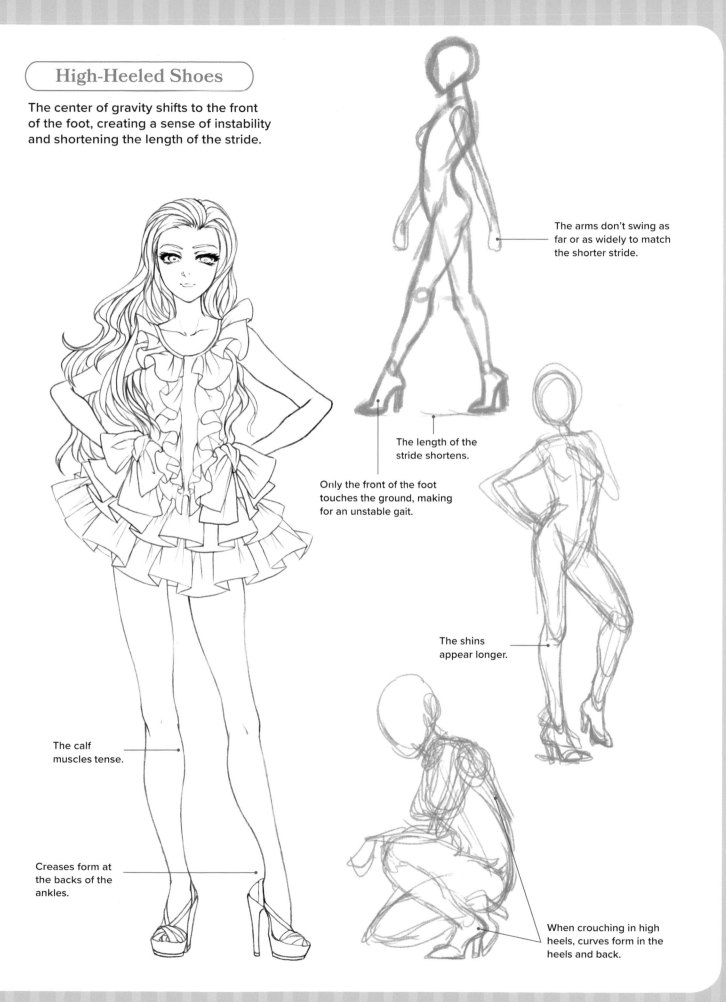

The arms don't swing as far or as widely to match the shorter stride.

The length of the stride shortens.

Only the front of the foot touches the ground, making for an unstable gait.

The shins appear longer.

The calf muscles tense.

Creases form at the backs of the ankles.

When crouching in high heels, curves form in the heels and back.

In order to locate the center of gravity, it's crucial to have an understanding of what exact kind of footwear your character's wearing.

Ballet Pumps
A footwear basic. There is only a slight heel and the heel of the foot is not emphasized. It can be drawn differently depending on whether it is for outdoor or indoor wear.

Flip Flops
Depending on the thickness of the sole, these can be flip flops, traditional Japanese geta or lacquered wooden clogs. The position of the thong section is also important.

Rain Boots
Rather than loose-fitting, go for a more tapered look, finished off by the thin heel for crossing slippery surfaces.

Leather Shoes
Conveying the sturdy texture is key. Make sure to capture the form and width of each section such as the toe sections, uppers and heels.

Sneakers
The soles are surprisingly thick, making the feet look big. There are lots of different types such as low-cut or high-top sneakers.

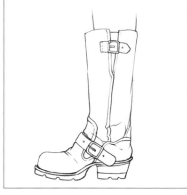

Boots
These are made from firm leather so use the wrinkles to convey this. Try tweaking the attached parts such as the belt and buckle.

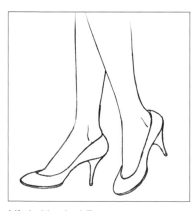

High-Heeled Pumps
The type of heel alters the look, with thick heels appearing stable and thin heels giving the impression of fragility. Rounding the toe section helps finish off the look.

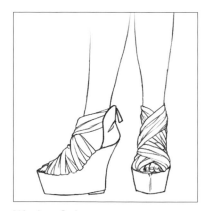

Wedge Soles
As the arch section of the shoe is filled in, these are more stable than high heels and are suitable for casual situations.

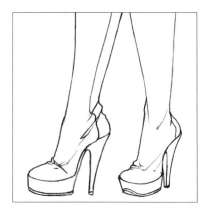

High Heels
Variation can be created via the shape of the heel. The higher the heel of the shoe, the more creases form at the back of the ankle.

5

Poses in Motion

Give a jumping or running figure a sense of vibrancy and dynamism. Let's attempt some more extreme or extended poses, while keeping them realistic and natural looking.

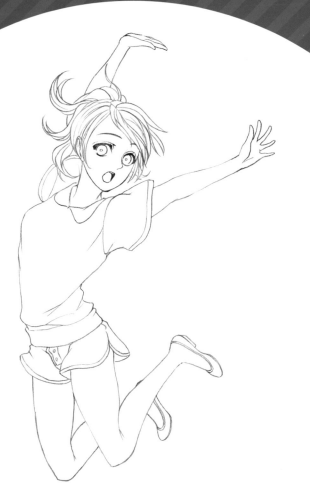

01 | Drawing a Jumping Figure

For a jumping pose, picture the moment after springing off the ground, when your character's preparing to land, as you draw.

The Jumping Basics

Boldly extend the chest and arch the back. The arms extend into the air with the muscles engaged all the way to the fingertips. Use the bend in the legs to indicate the height of the jump and the character's personality.

With this motion, the clothes float up and appear to be suspended in air.

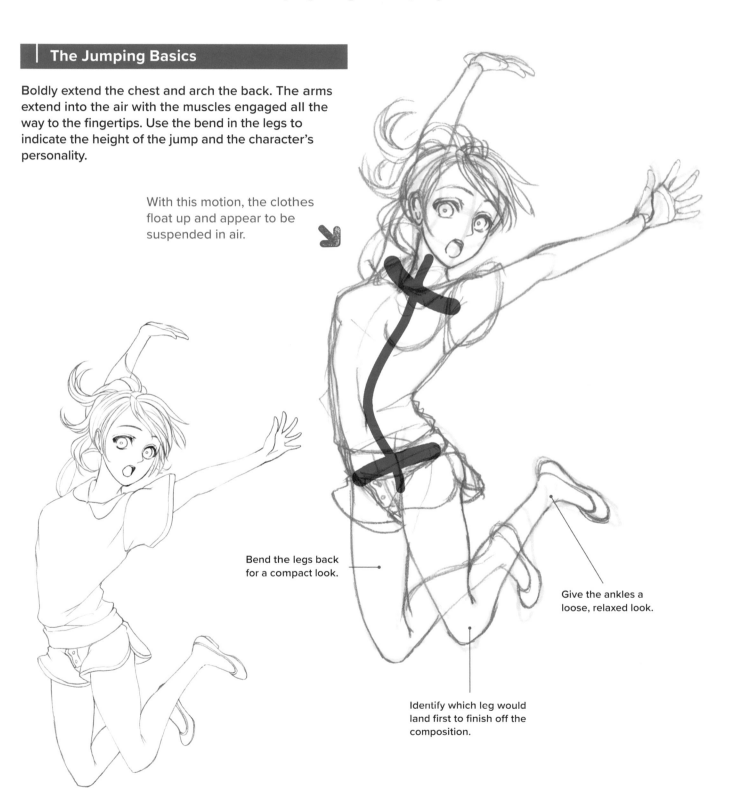

Bend the legs back for a compact look.

Give the ankles a loose, relaxed look.

Identify which leg would land first to finish off the composition.

Variations on the Pose

With typical jumping poses, the arms are kept to the sides and the legs point inward. With typical jumping poses, involving combat or attacks, bring out the tautness of the muscles. Make sure to use different looks for different characters.

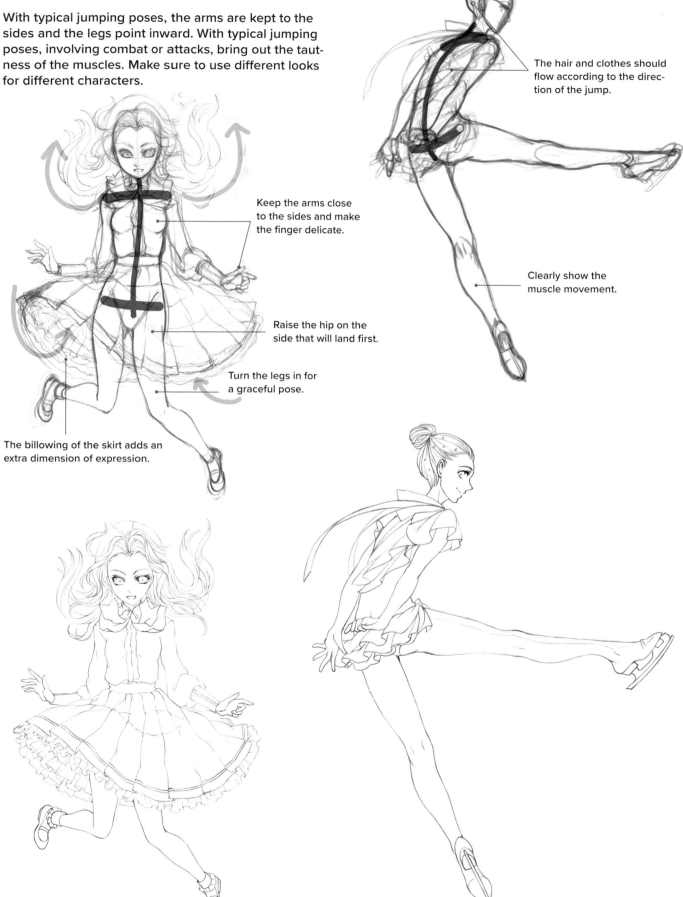

The hair and clothes should flow according to the direction of the jump.

Clearly show the muscle movement.

Keep the arms close to the sides and make the finger delicate.

Raise the hip on the side that will land first.

Turn the legs in for a graceful pose.

The billowing of the skirt adds an extra dimension of expression.

02 | Drawing a Walking Figure

Contrapposto is invaluable in a walking pose, where the shoulders and pelvis are in asymmetrical formation.

Viewed from the Front

The hip rises and the shoulder lowers on the side taking the first step. The use of perspective is important when trying to achieve a realistic look for a walking figure viewed from the front.

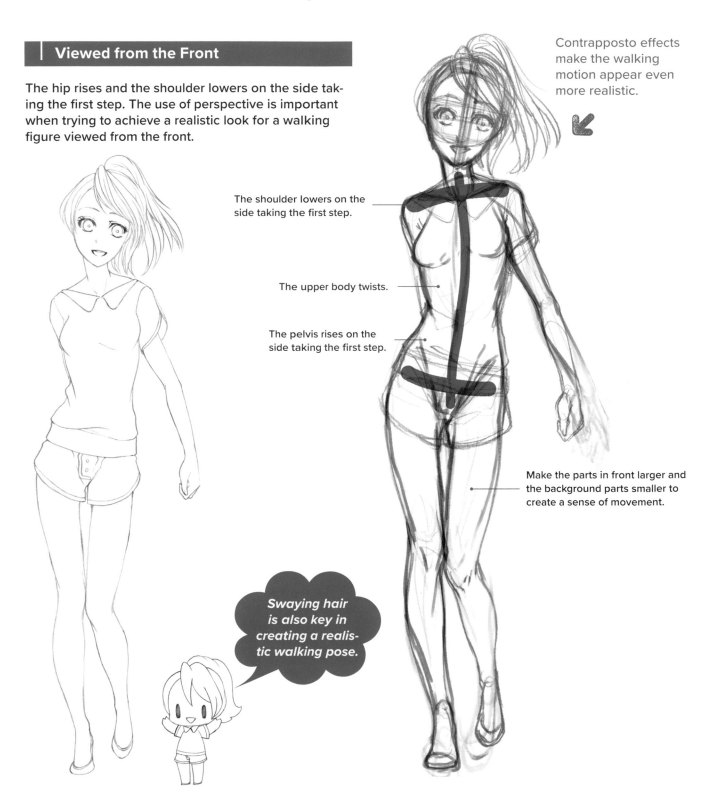

Contrapposto effects make the walking motion appear even more realistic.

The shoulder lowers on the side taking the first step.

The upper body twists.

The pelvis rises on the side taking the first step.

Make the parts in front larger and the background parts smaller to create a sense of movement.

Swaying hair is also key in creating a realistic walking pose.

Variations on the Pose

For a walking figure viewed from the side, make sure the arm and leg on opposite sides are extended. To indicate walking at an easy pace, keep arm movement to a minimum.

When a character's walking slowly, the arms don't move much.

Think of the backbone as an S shape.

Start by picturing how each character will look while walking.

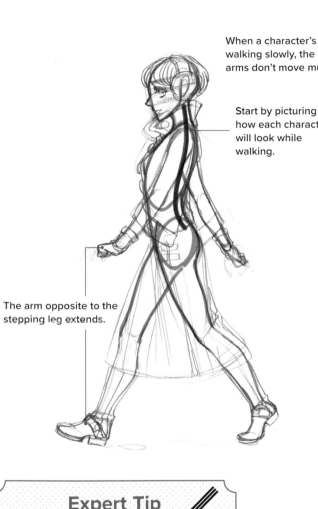

The arm opposite to the stepping leg extends.

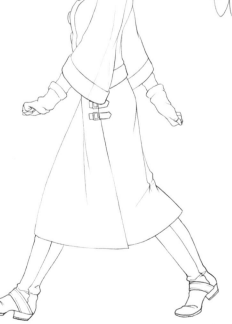

Expert Tip

Natural-looking legs

Remember that both feet are never in complete contact with the ground at the same time when walking. Take care to depict the foot striking the ground heel first to prevent an unnatural pose and appearance.

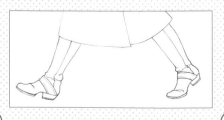

Drawing a Running Figure

For a character who's running, give the arms and legs a larger, wider range of motion than with a figure that's walking.

The Running Basics

The rule when drawing running poses is to not let the heels touch the ground. Shifting the weight to the front foot lends a sense of swiftness and agility to this motion pose.

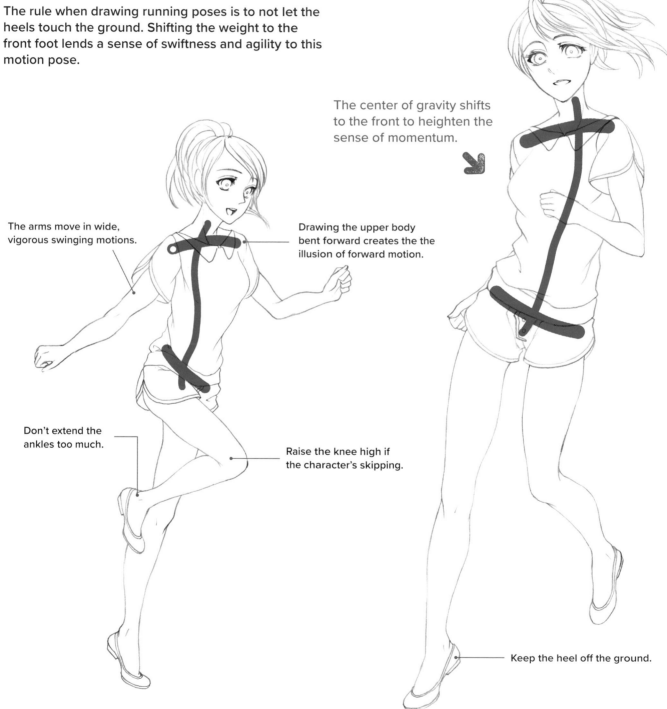

The center of gravity shifts to the front to heighten the sense of momentum.

The arms move in wide, vigorous swinging motions.

Drawing the upper body bent forward creates the the illusion of forward motion.

Don't extend the ankles too much.

Raise the knee high if the character's skipping.

Keep the heel off the ground.

Variations on the Pose

For a running figure viewed from the side, think of the legs as a compass stretched wide apart for a realistic look. For a figure viewed from behind, emphasize the sense of perspective in both legs and add a twist to the upper body.

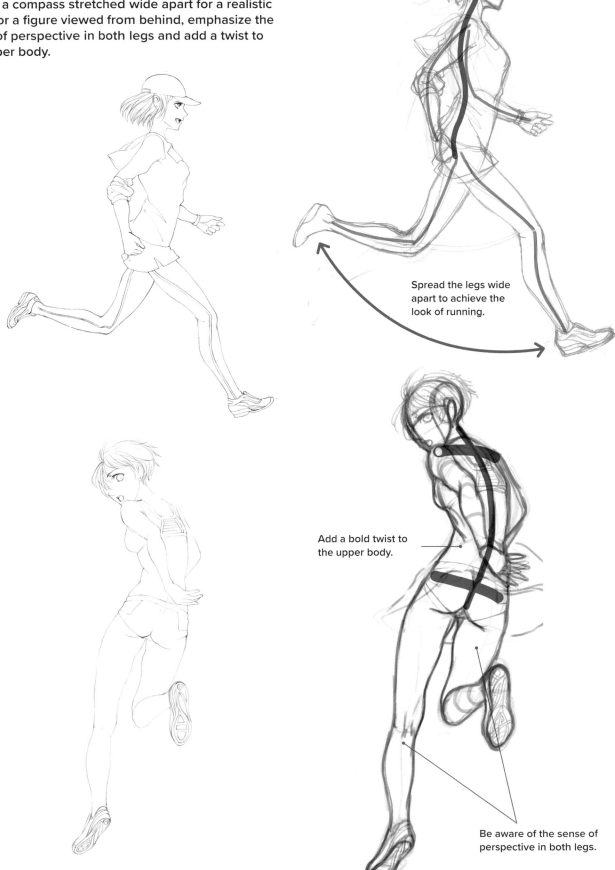

Spread the legs wide apart to achieve the look of running.

Add a bold twist to the upper body.

Be aware of the sense of perspective in both legs.

Stopping Suddenly

When drawing a pose in which the figure has come to a sudden stop, be aware of the power in the leg stepping forward and create a sense of movement in the hair and clothing.

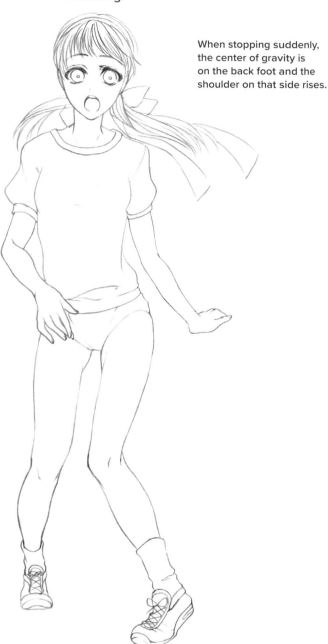

When stopping suddenly, the center of gravity is on the back foot and the shoulder on that side rises.

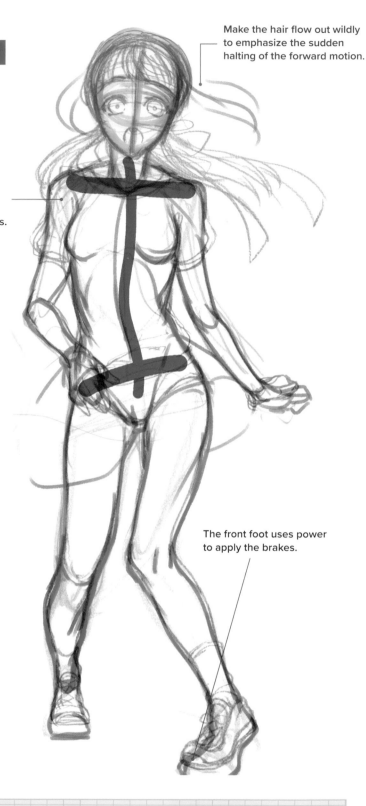

Make the hair flow out wildly to emphasize the sudden halting of the forward motion.

The front foot uses power to apply the brakes.

The Swing of the Arms

The movements of the arms can be used to show a character's personality. Arms swinging boldly from the elbow suggest a forceful, determined character, while those kept close to the sides appear softer, more de-mure. Alternately, the legs can point inward. All kinds of variations are possible, so try some different looks.

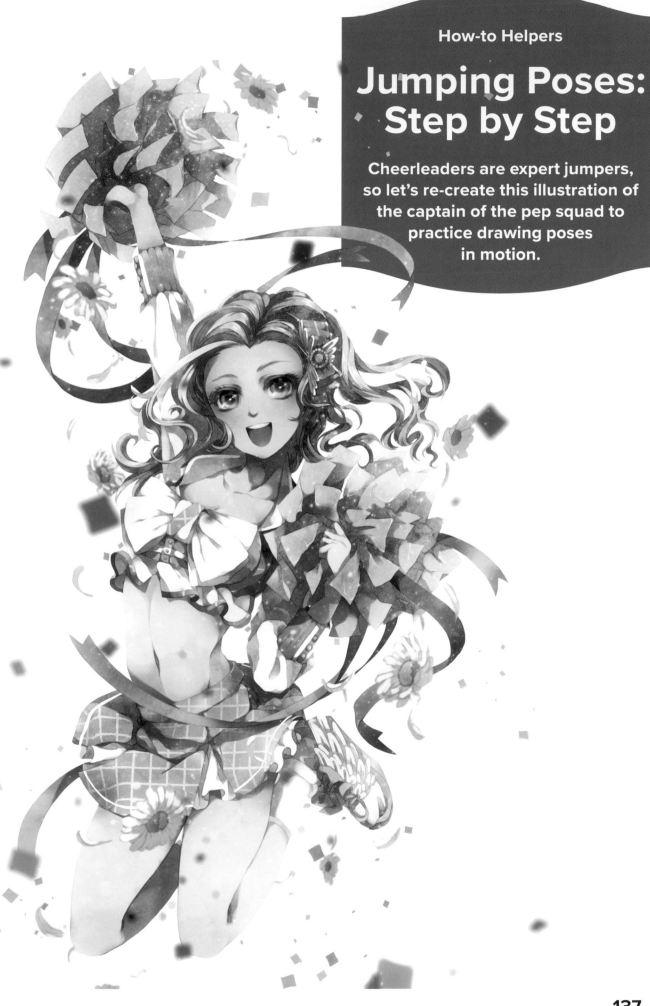

Jumping Poses: Step by Step

Cheerleaders are expert jumpers, so let's re-create this illustration of the captain of the pep squad to practice drawing poses in motion.

Gimme a J!

For a jumping pose, extend and round out the chest, arch the back and raise the arms high for an energetic look!

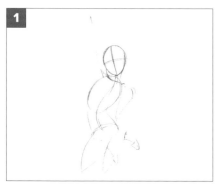

In this case, the character is a cheerleader. Block the figure in, creating a rough contrapposto form as you draw.

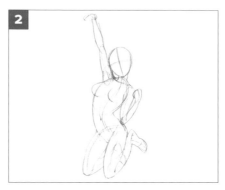

Flesh out the figure a little at a time.

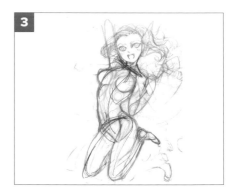

The right arm extends straight up into the air while the left stays close to the side of the chest. Bending both legs together in the jump adds vitality.

Scan the drawing and brush up detailed areas as you enlarge the image on your PC. Work on the size of the pompom, the flow of the hair, the clothing design and elements that move with the body.

Make a rough colored copy and check on the finished form. For an energetic, cheerful character, bright colors typically work best.

Deciding on a dynamic, well-defined pose at this stage makes the tasks that follow easier.

The rough sketch is complete.

Pom Pom Power

Use bright coloring to capture the lively cheerleader's mood. Scatter confetti, petals or whatever you wish over the drawing to bring out a sense of depth.

1

Use the rough colored copy to work out where to place color. The yellow pompoms and pink ribbons add to the fresh blue and white of the uniform to create a cheerleader full of energy.

2
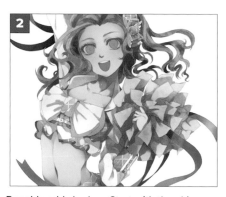

Roughly add shadow. Start with the skin, as it stands out the most. Keep the light source in mind as you work on the shape that the shadows form.

3
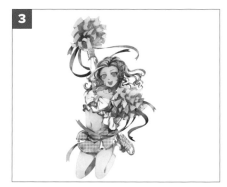

Add texture and textile details. Apply lavender accents as you proceed.

4
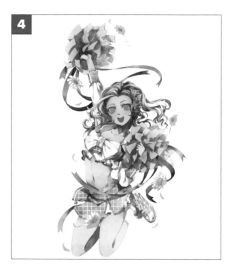

This completes the coloring for the figure, apart from the eyes. Keep checking on the overall image as you draw to achieve a cohesive result. Functions such as tone curve, level correction, hue, saturation and color balance can be used to correct the overall tone and create vivid color.

Fine-tune the flare of the skirt, the swish of the pompom, flow of the ribbons and the movement of the hair.

5
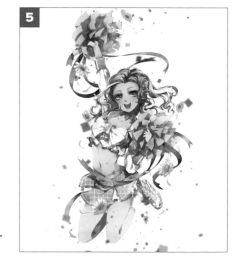

A Little Advice

Where's the Focus?

Be aware that—just like in a photograph—an illustration has a focal point. Train the focus on the main character but blur the clothing to balance out the look. The petals and confetti are used as effects, so don't draw them in as much detail as the main figure.

Add the irises and highlights to the eye to complete the work and scatter soft-focus confetti over the illustration to highlight the figure. Finish by adding dots of sparkling light as texture.

6
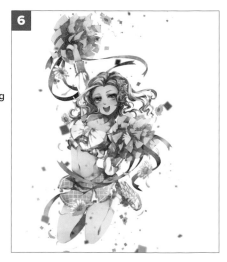

Drawing Children and Chibi Characters

The methods of drawing children and chibi figures are fundamentally different.
Take care not to confuse them.

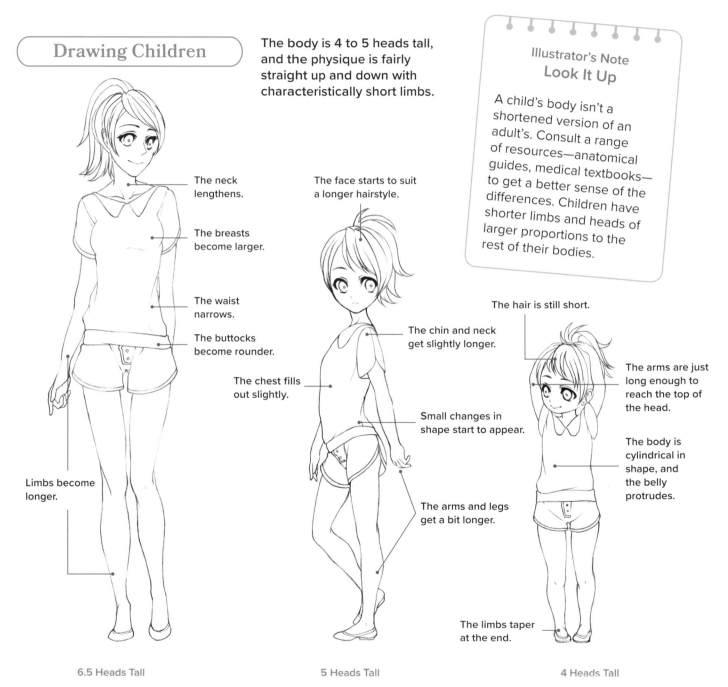

Drawing Children

The body is **4 to 5 heads tall,** and the physique is fairly straight up and down with characteristically short limbs.

The neck lengthens.

The breasts become larger.

The waist narrows.

The buttocks become rounder.

Limbs become longer.

The face starts to suit a longer hairstyle.

The chest fills out slightly.

The chin and neck get slightly longer.

Small changes in shape start to appear.

The arms and legs get a bit longer.

Illustrator's Note
Look It Up

A child's body isn't a shortened version of an adult's. Consult a range of resources—anatomical guides, medical textbooks—to get a better sense of the differences. Children have shorter limbs and heads of larger proportions to the rest of their bodies.

The hair is still short.

The arms are just long enough to reach the top of the head.

The body is cylindrical in shape, and the belly protrudes.

The limbs taper at the end.

6.5 Heads Tall

From about the age of 17, the torso and limbs become longer in comparison with the face and the overall physique becomes more angular. The breasts and buttocks become larger, adding curves to the body.

5 Heads Tall

From about the age of 10, the face starts to get longer, as do the neck, limbs and fingers. Various hairstyles become possible.

4 Heads Tall

At about five years old the head is large with a round face and small chin. The arms can reach to just above the head. There is no definition in the body and the stomach sticks out.

Drawing Chibi Characters

The body is about 4 to 5 heads tall and relatively straight up and down, with small limbs.

Illustrator's Note
Chibi Proportions

Despite their exaggerated or altered size, chibi bodies have the same basic structure and proportions throughout. They may look easier at first glance, but chibi characters require the same understanding of body structure, muscle shape and balance as other figures in order to look realistic in their own way.

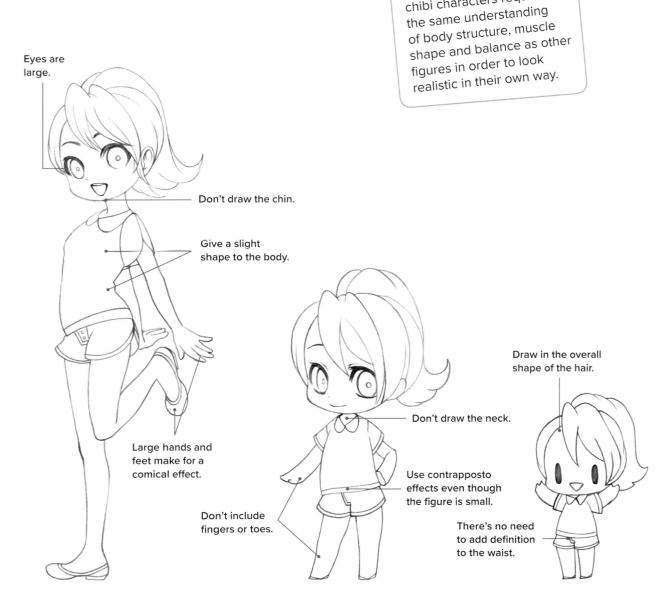

Eyes are large.

Don't draw the chin.

Give a slight shape to the body.

Large hands and feet make for a comical effect.

Don't draw the neck.

Use contrapposto effects even though the figure is small.

Don't include fingers or toes.

Draw in the overall shape of the hair.

There's no need to add definition to the waist.

3.5 Heads Tall	2.5 Heads Tall	2 Heads Tall
While the fullness in the chest, roundness in the buttocks and narrowing in the waist create shape in the body, the large head in comparison with the body creates a comical impression.	Make the head large and emphasize the look on the face. Get rid of the neck. It's fine to skip detail in the clothing, hands and feet.	Draw the head and body to be equal in height and simplify all body parts. Omit creases and simplify the flow of the hair.

Color, Brightness, Contrast and Saturation Effects

Color, brightness, contrast and saturation effects can significantly alter the look of an illustration. Understand the effect of light and shadow in order to create charming, appealing characters.

Use Color to Capture the Illustration's Vibe

Use overall tone and hues, including shadow, to control the impression an illustration makes. Strong red tones create a warm feel, while strong blue tones make for a cool impression.

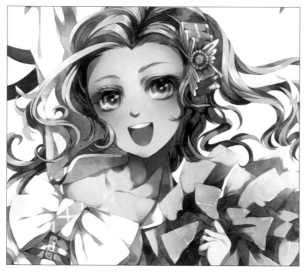

Red-tinged shadow creates the impression of warmth, evoking a sunny, natural air. When depicting a situation involving a sunset, using warmer tones makes for a more realistic appearance, so be sure to give it a try.

Blue-tinged shadow lends a metallic air and a fresher feel, creating a cool-toned impression. In night scenes or situations involving being in water, using cool tones for the shadows will bring out the desired feel.

Using Brightness, Contrast and Saturation to Maximum Effect

Think about these three elements and factors and how they'll suit the character you're trying to portray.

Lower Contrast ◄───────────────────────────► **Higher Contrast**

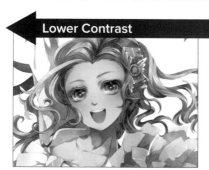

Lowering the contrast and saturation reduces the difference between light and shadow, lending an out-of-focus effect. This creates an airy feel for works with a natural or old-fashioned vibe.

In this illustration, medium levels of contrast and saturation have been used. Adjust them to suit the taste of each of your works.

Boosting the contrast and saturation makes the differences between light and shadow starker, creating the look of artificial light. This works well for illustrations with a pop art, glitzy or energetic feel.

View! Draw! Create projects!
The communication service connecting
people through pictures.

pixiv

What Is Pixiv?

Pixiv is an illustration communication site for the purposes of enjoying drawing. Registration is free. Apart from being able to post their own illustrations, manga, novels and so on, users can read, critique and comment on other users' works, bookmark their favorites and connect using My Pic, with all interactions conducted via the works on the site.

http://www.pixiv.net

pixiv	Search

← Ilustration by Vania600

⬇ Illustration by kyachi

⬇ Illustration by Fuzichoco

← Illustration by JH Studios

Published by Tuttle Publishing, an imprint of Periplus Editions (HK) Ltd.

www.tuttlepublishing.com

UGOKI NO ARU POSE NO EGAKIKATA JOSEI CHARACTER HEN
© kyachi 2013
English translation rights arranged with GENKOSHA Co.
through Japan UNI Agency, Inc., Tokyo

Library of Congress Cataloging-in-Publication Data in process
ISBN 978-4-8053-1608-5

Distributed by

North America, Latin America & Europe
Tuttle Publishing
364 Innovation Drive
North Clarendon, VT 05759-9436 U.S.A.
Tel: 1 (802) 773-8930; Fax: 1 (802) 773-6993
info@tuttlepublishing.com
www.tuttlepublishing.com

Asia Pacific
Berkeley Books Pte. Ltd.
3 Kallang Sector, #04-01
Singapore 349278
Tel: (65) 67412178; Fax: (65) 67412179
inquiries@periplus.com.sg
www.tuttlepublishing.com

Japan
Tuttle Publishing
Yaekari Building, 3rd Floor
5-4-12 Osaki
Shinagawa-ku
Tokyo 141 0032
Tel: (81) 3 5437-0171; Fax: (81) 3 5437-0755
tuttle-sales@gol.com

23 22 21 20 10 9 8 7 6 5 4 3 2 1

Printed in Singapore 2011TP

Books to Span the East and West

Our core mission at Tuttle Publishing is to create books which bring people together one page at a time. Tuttle was founded in 1832 in the small New England town of Rutland, Vermont (USA). Our fundamental values remain as strong today as they were then—to publish best-in-class books informing the English-speaking world about the countries and peoples of Asia. The world is a smaller place today and Asia's economic, cultural and political influence has expanded, yet the need for meaningful dialogue and information about this diverse region has never been greater. Since 1948, Tuttle has been a leader in publishing books on the cultures, arts, cuisines, languages and literatures of Asia. Our authors and photographers have won many awards and Tuttle has published thousands of titles on subjects ranging from martial arts to paper crafts. We welcome you to explore the wealth of information available on Asia at www.tuttlepublishing.com.